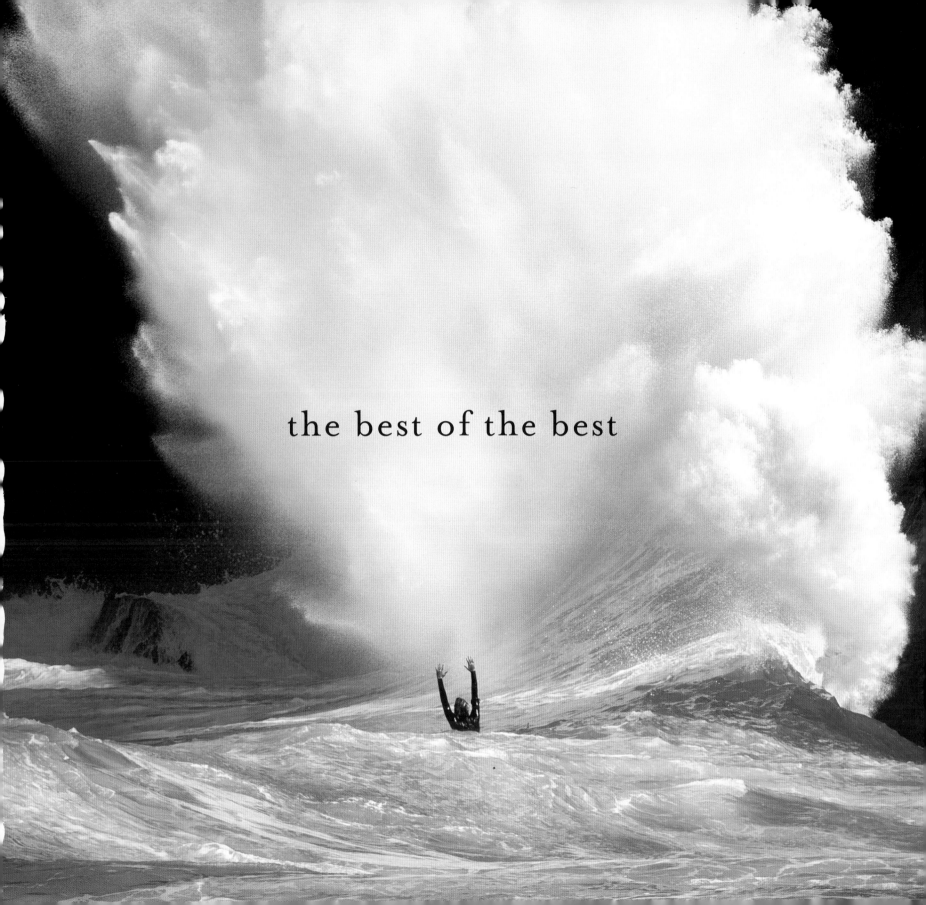

the best of the best

the best of the best

Australia's greatest surf photographers

NIKON SURF PHOTOS OF THE YEAR 2013–2017

Nikon is incredibly proud to celebrate its 100th anniversary in an association with Surfing Australia, which commemorates the passion and emotion of astoundingly beautiful and dramatic surfing images from the annual Nikon Surf Photo competition.

Nikon, which has always been at the heart of Australia's surfing heritage and culture, looks forward to continuing to celebrate future surf photographers and videographers as they capture action-packed moments, admired and appreciated by people all over the world.

WHEN I WAS AROUND FIFTEEN YEARS OLD, I was given a wonderful book full of beach and ocean photography for Christmas. On the page with each photo there was a quote by writers, poets or the photographers themselves. But one photo that has stuck with me forever was an image taken right up close to the shoreline in Hawaii. Tropical colours filled the page, with a royal blue ocean, pastel blue sky and bright, foamy whitewater launching up high over a classic yellow Hawaiian sand mound. The moment of surprise before the water hit the camera. The foam still frozen in the air, like a fluffy cloud had floated down and stayed hovering just above the sand, leaving a darker shade of yellow, a shadow from the wave.

Of course with my limited knowledge of cameras and what they could do, I always wondered if the artist used a housing or if he was willing to risk the timing, try to take a shot and pull away in time to avoid splashing his gear. I would lie in our lounge room and just stare at it, imagining the process the photographer went through to capture the image. Maybe he was lying on the beach reading a book one day and a wave washed up over onto his beach towel, and he was able to turn his frustration into an idea. Something so small and simple that happens along every continent's coastline millions of times per hour, he managed to make still and so grand. The quote that sat alongside the image was from my favourite guitarist, Jimi Hendrix, about castles made of sand, melting into the sea ... eventually. Jimi was right, we really do (all melt into the sea eventually), but at least our photos will live on for much longer, especially the photos in this book. Five years of groundbreaking and iconic surf imagery that will take you where no other photography has.

There is one major star in this book. And I'm sure I speak on behalf of most of the photographers that she may be our greatest love. We'll travel far and change our vision occasionally, but we keep coming back to the subject that just keeps on giving. The ocean. Humans are wonderful to photograph, so are landscapes with changing skies and other elements, but nothing really compares to the expressions of water. The depth and dangers, the colours and creatures, the warmth, joys, power and wonder are endless.

With camera gear so incredible these days, and the best photographers in the world throwing themselves into the madness of the huge swells, letting their passion override their fear, we are being taken into the belly of the beast. It's one thing to have an image transport you to a different place, but to actually make you feel like you're on a surfboard riding in the barrel behind one of the world's best surfers on a gnarly wave is another level of 'best'!

To find a new perspective on something we surfers see every day, this talented community of photographers are always challenging themselves physically and creatively to capture a unique vision and it's incredibly inspiring, to say the least. This is a wonderful book and I can't wait for it to inspire the next person to pick up a camera and capture some magic, the same way it did for me.

Stephanie

Stephanie Gilmore
6x World Champion

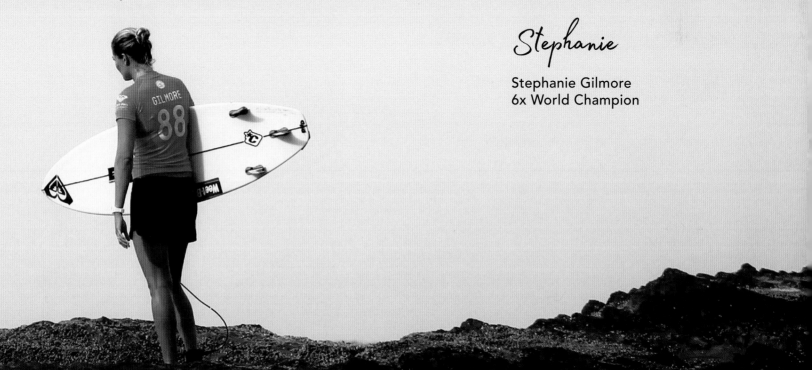

2017

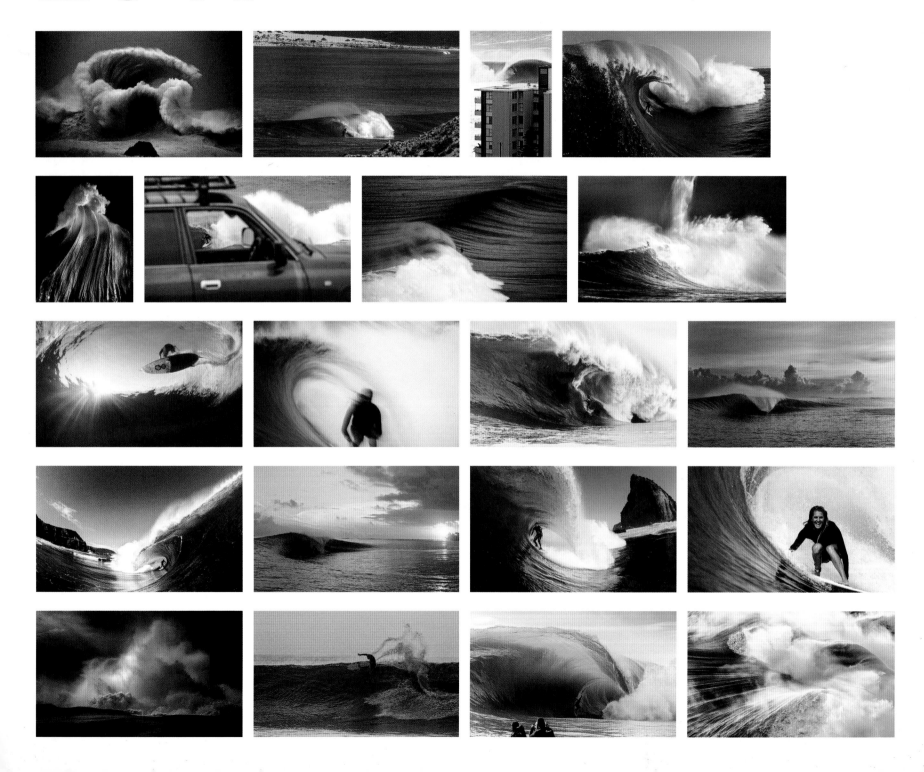

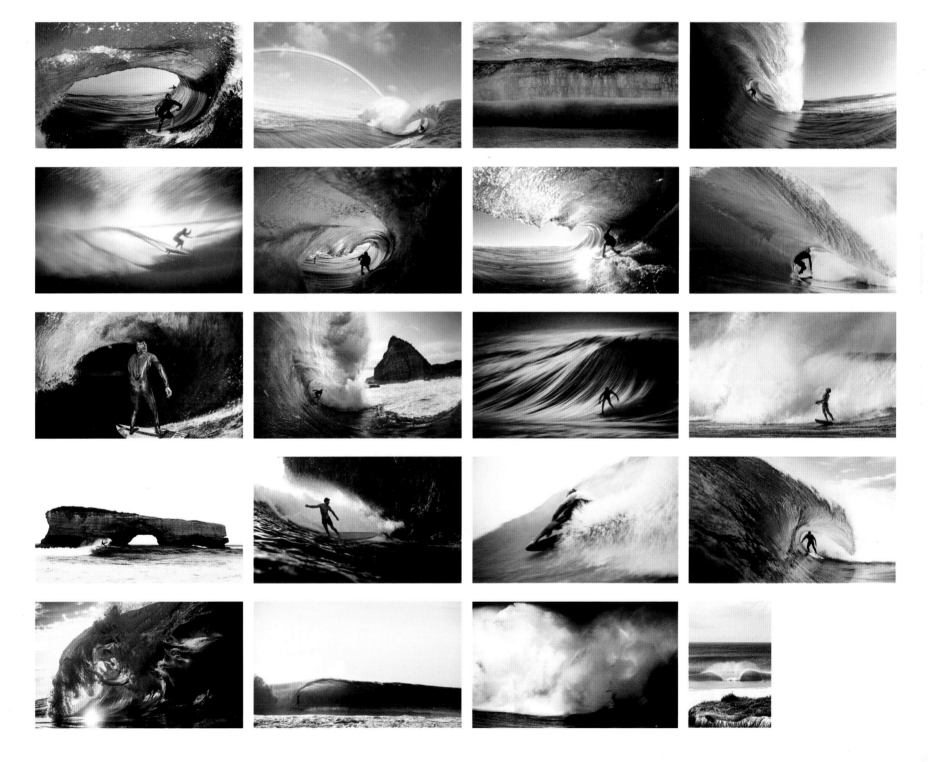

2016

2015

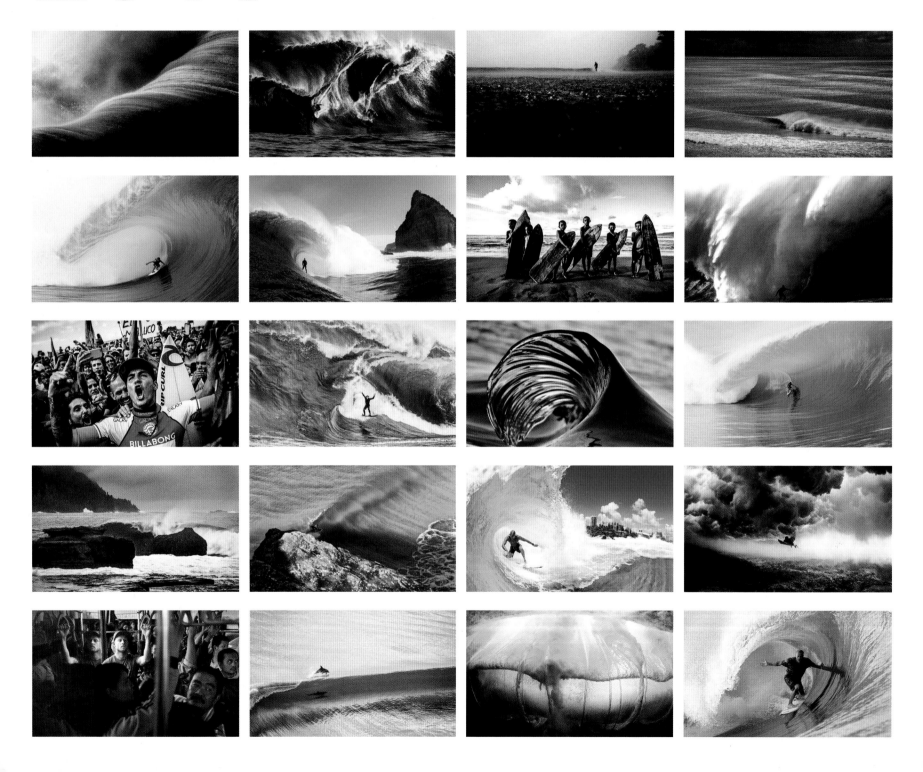

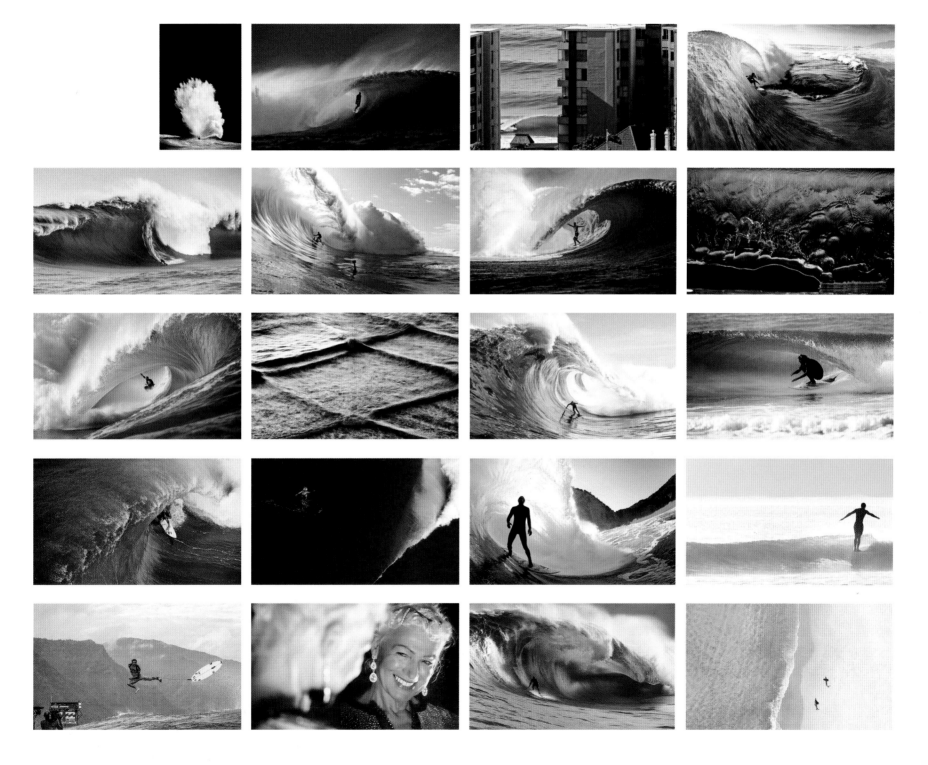

2014

2013

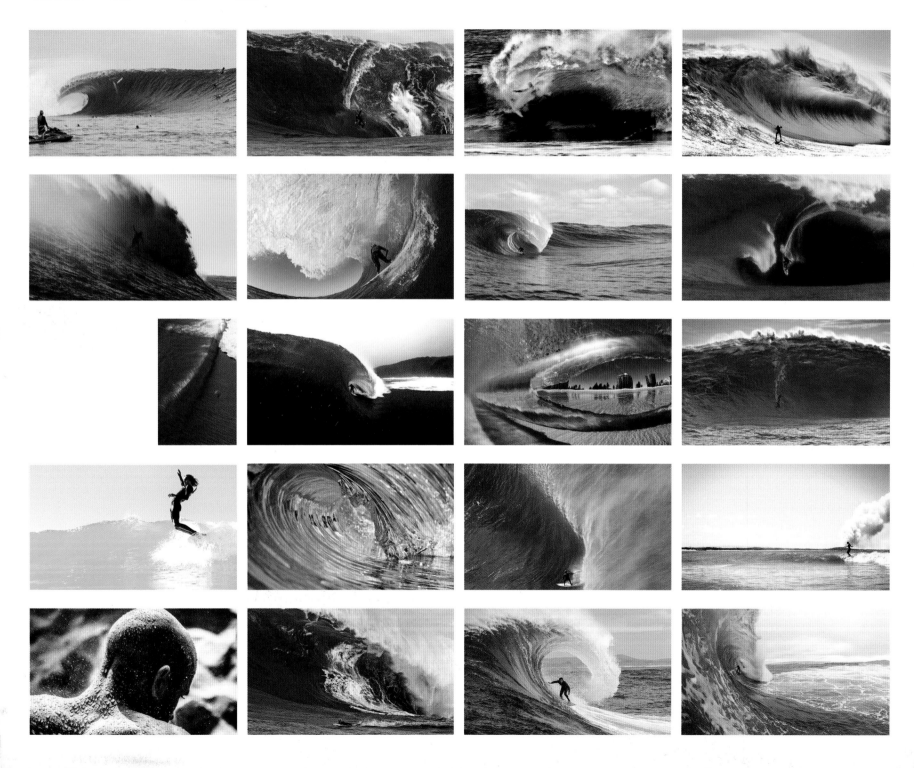

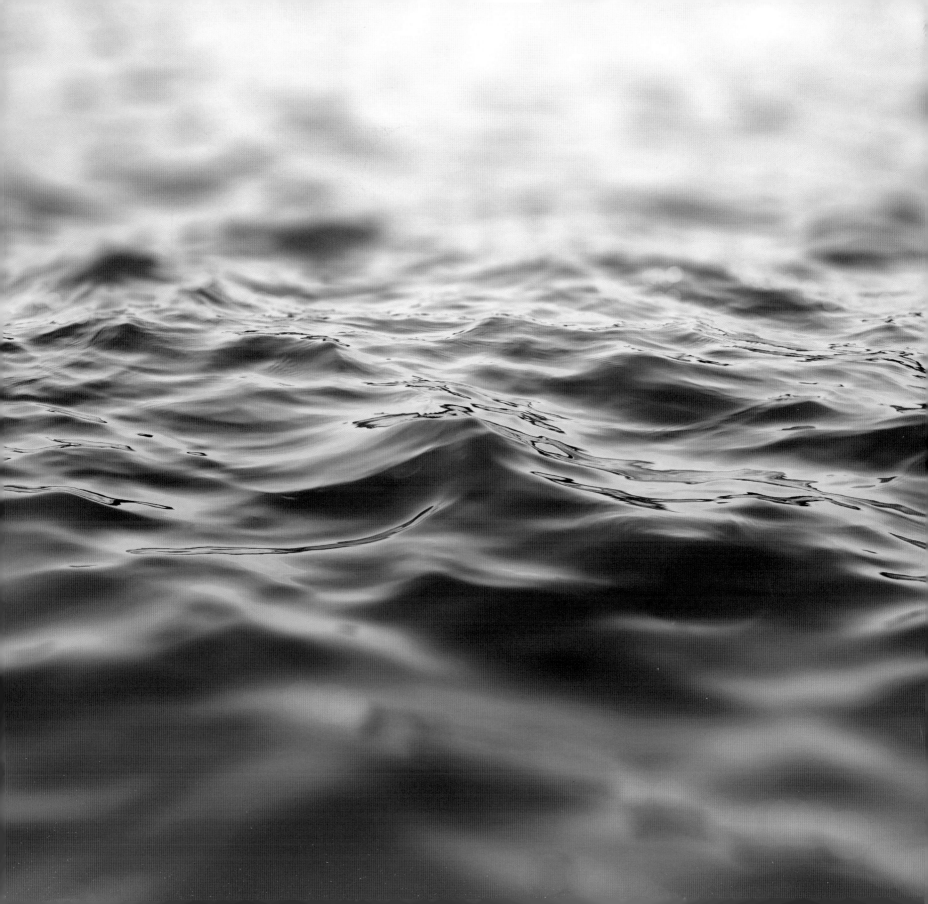

Maelstrom 1
LUKE SHADBOLT

Shot during the volatile El Niño season of 2016, Maelstrom 1 offers a cursory glimpse of the exchange, cycle and balance of power fundamental to the functioning of our planet and its oceans.

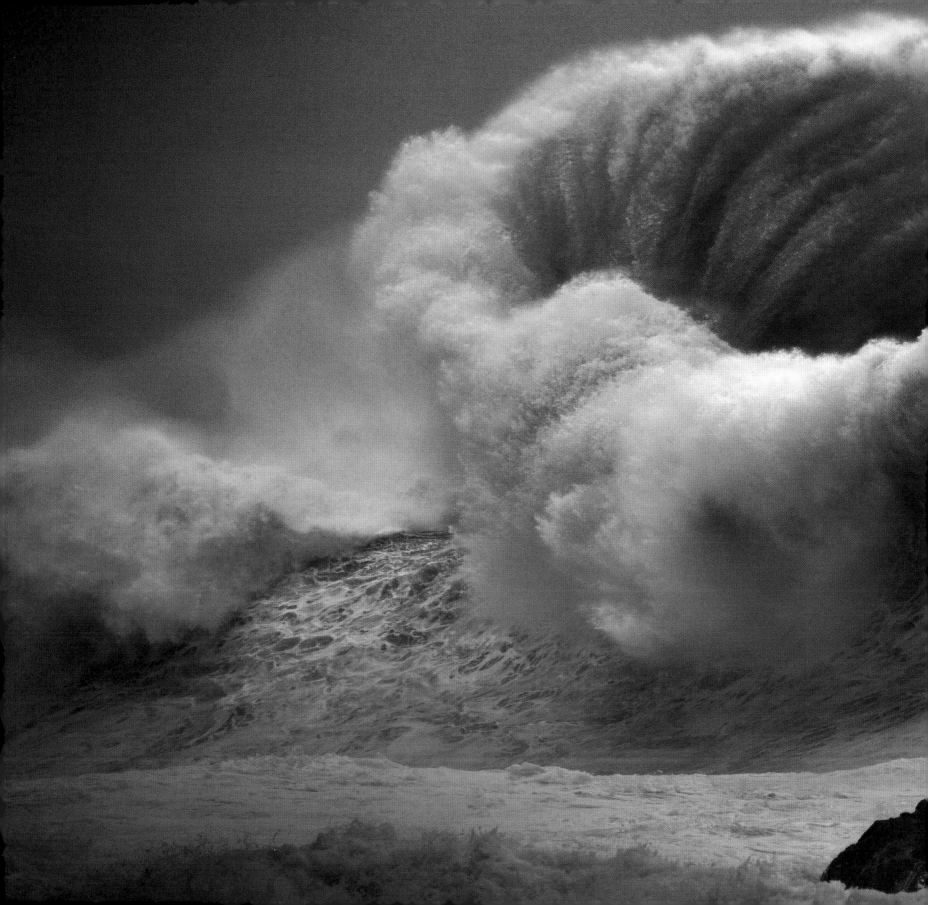

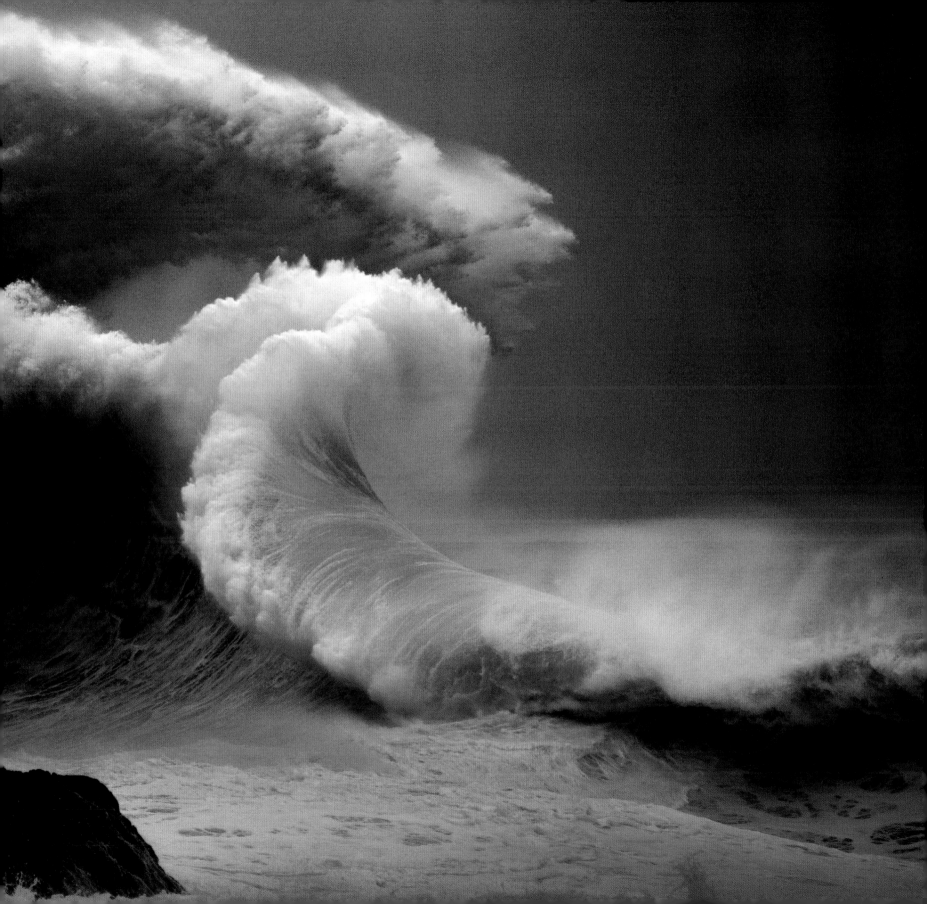

2

South Australia
RICH

Open spaces.

2017

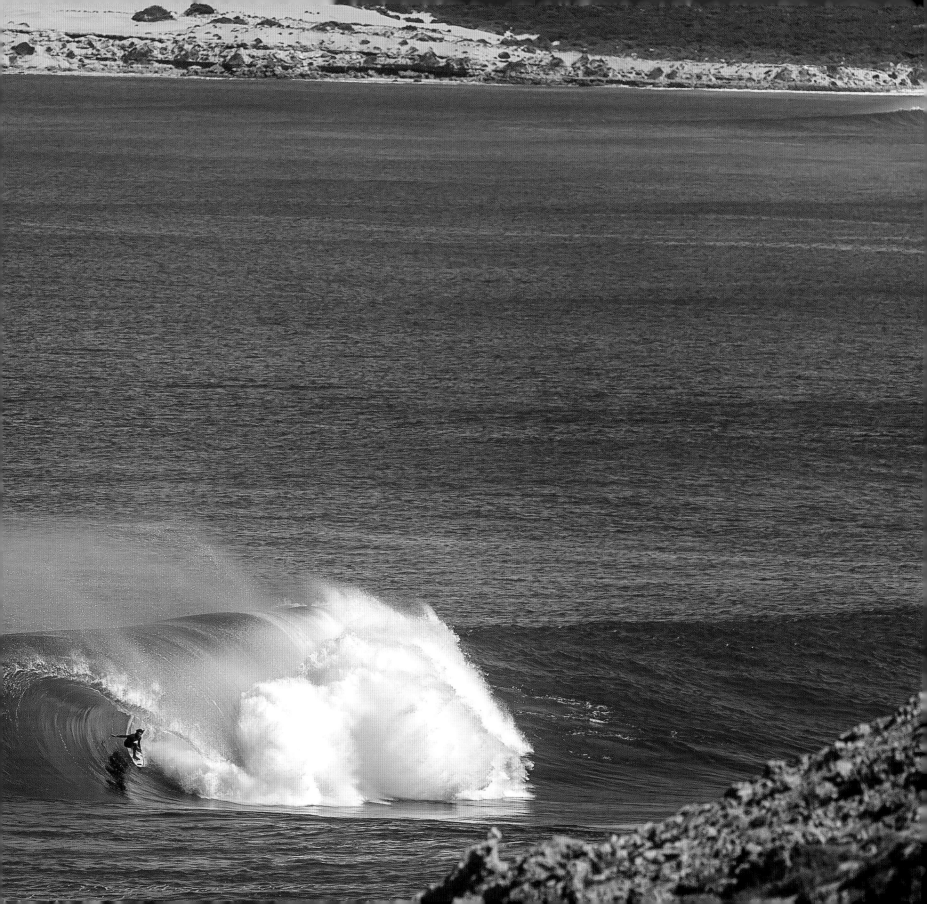

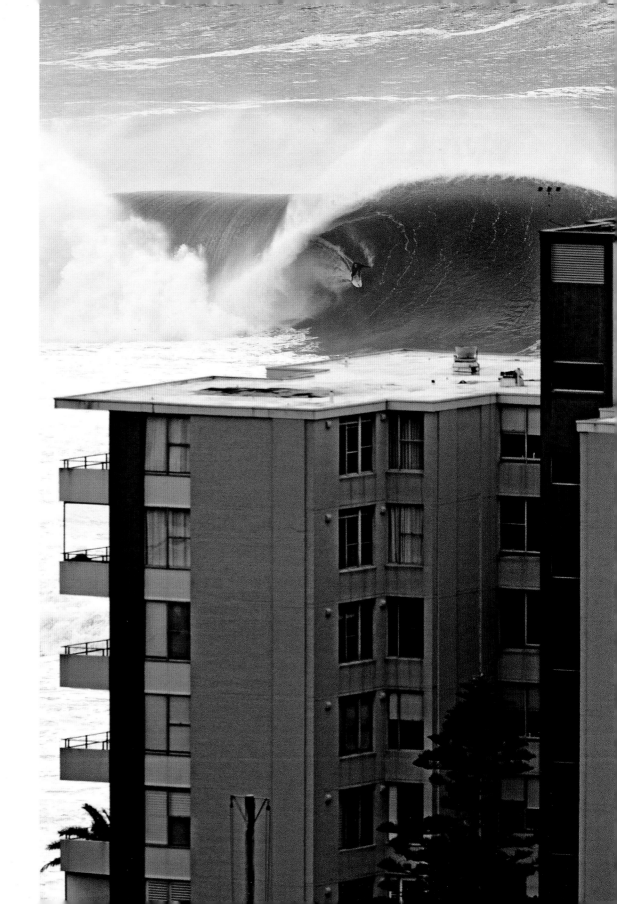

3

Four Floors of Fun

MARK ONORATI

Matt Dunsmore riding the 'black nor'east' swell that destroyed the beachfront homes at Narrabeen on 6 June 2016.

2017

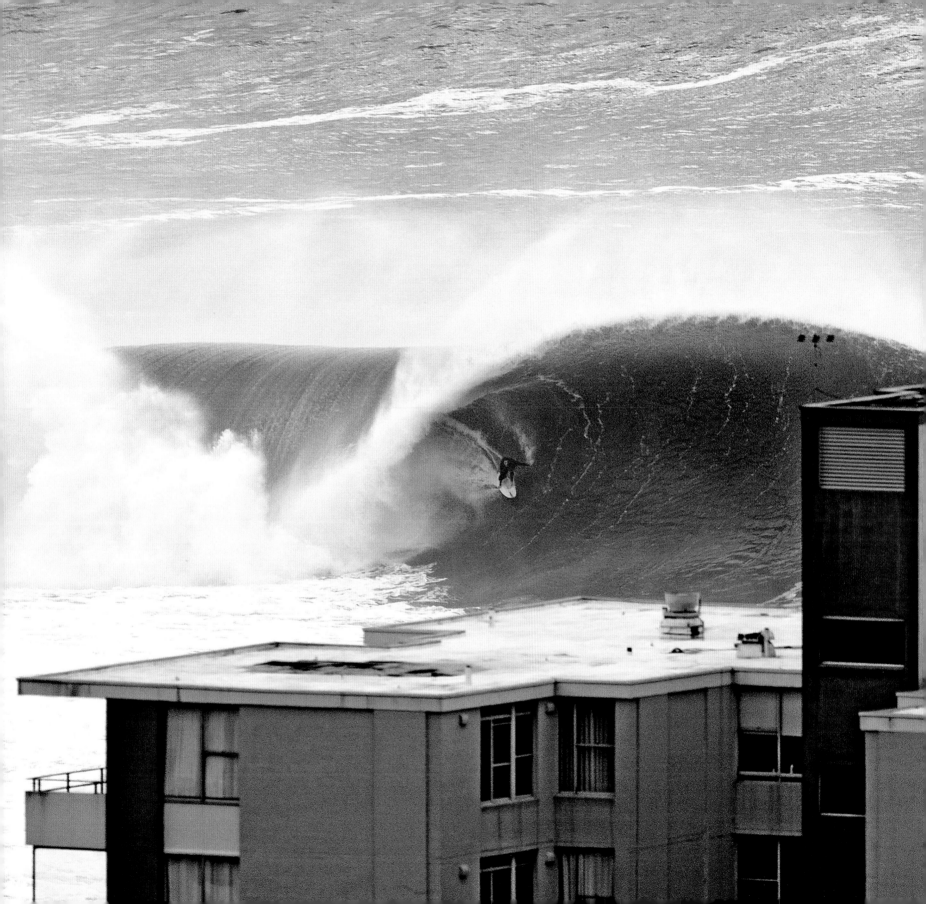

4

Dan Ryan – The Right, WA 'Fisheye'

RUSSELL ORD

Swimming up close and personal with a 16mm at The Right in WA, for me it's more than a moment, it's the photographer's moment and what goes into getting the shot.

2017

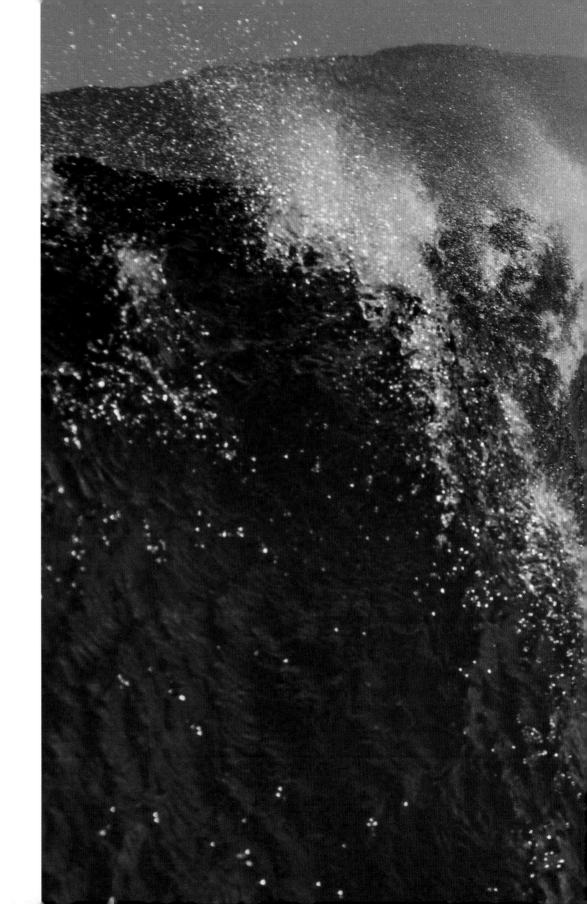

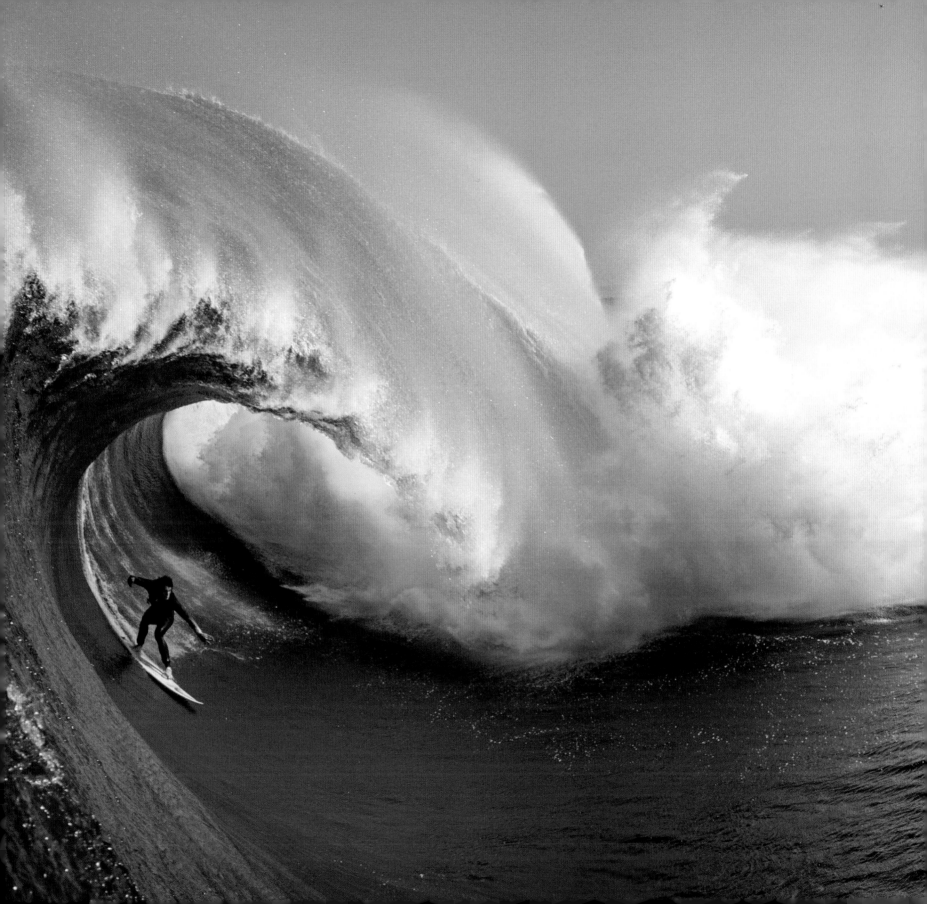

Convergence

RAY COLLINS

From the vantage point of God.

2017

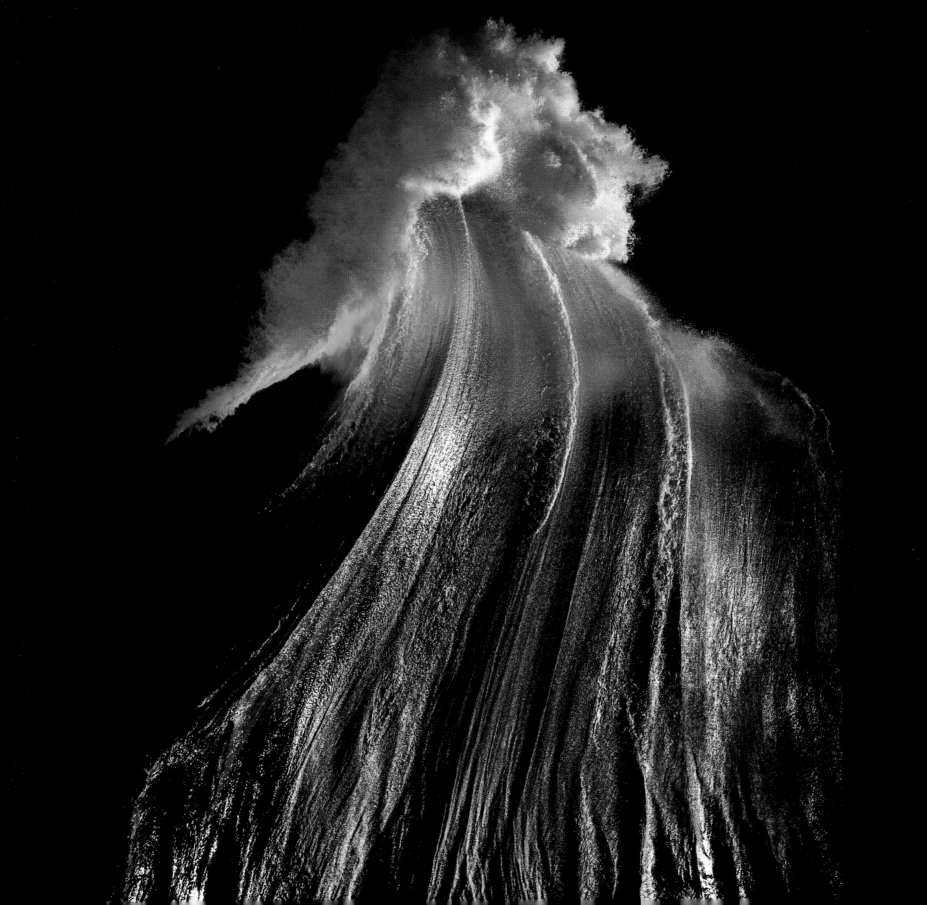

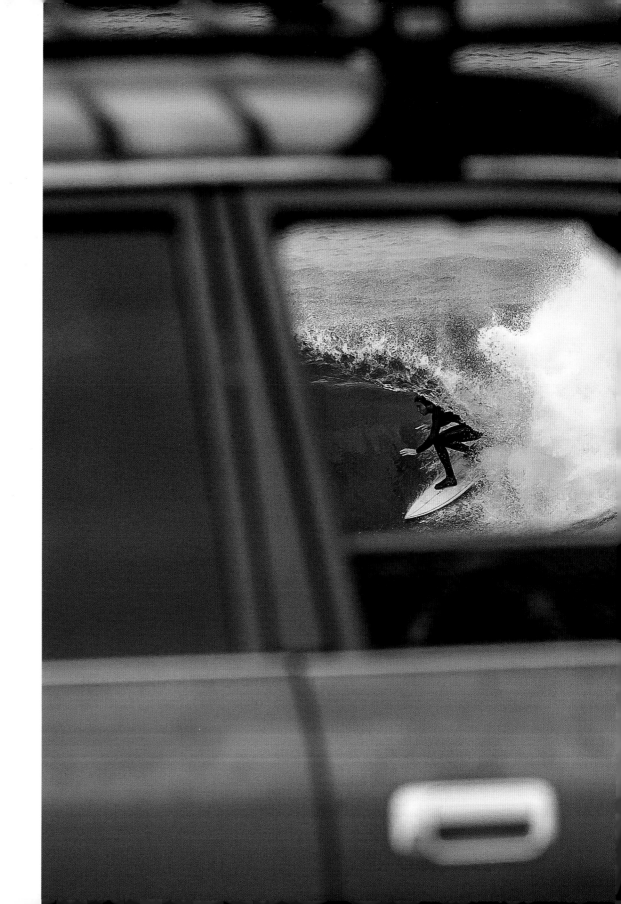

6

Beau Foster

RICH

The 80 series GXL and Beau.

2017

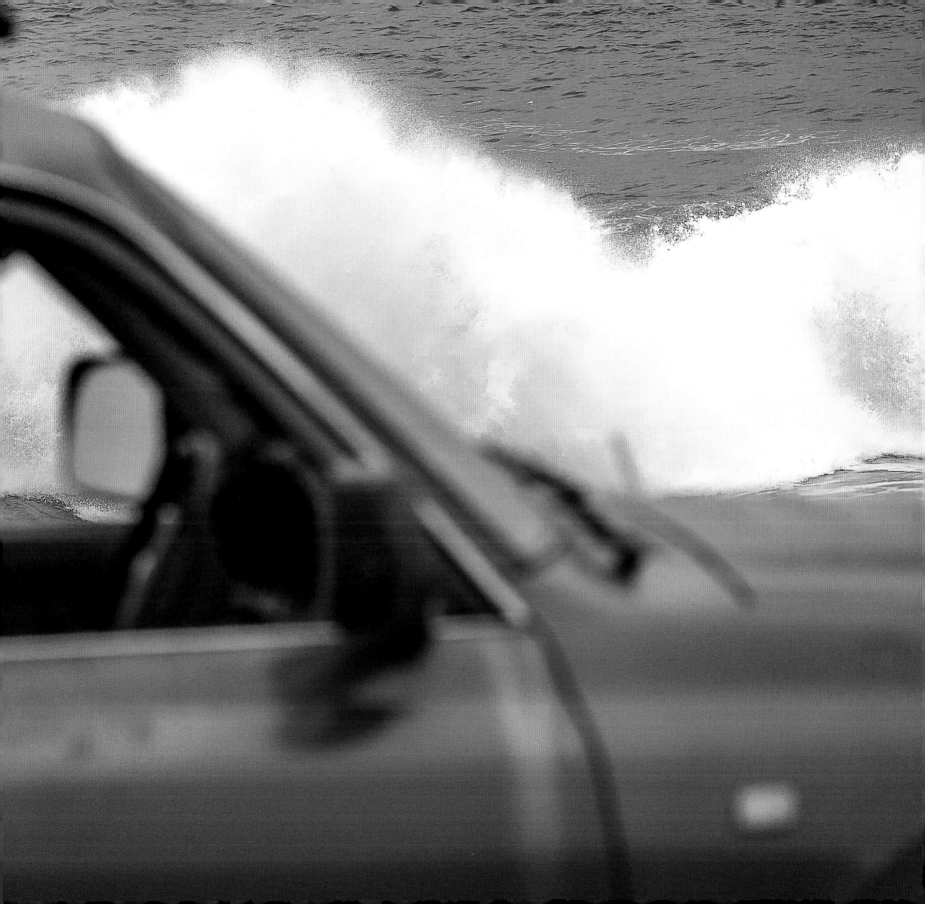

7

East Coast Low 1
LUKE SHADBOLT

The largest, cleanest swell to hit the east coast of Australia in over 15 years saw once-in-a-lifetime conditions for surfers all along the coast. Initially, the violent storms, high winds and king tides saw devastation along the eastern-facing coastline. Waves crashed over cliff faces and houses were washed off the beachfront in Sydney.

2017

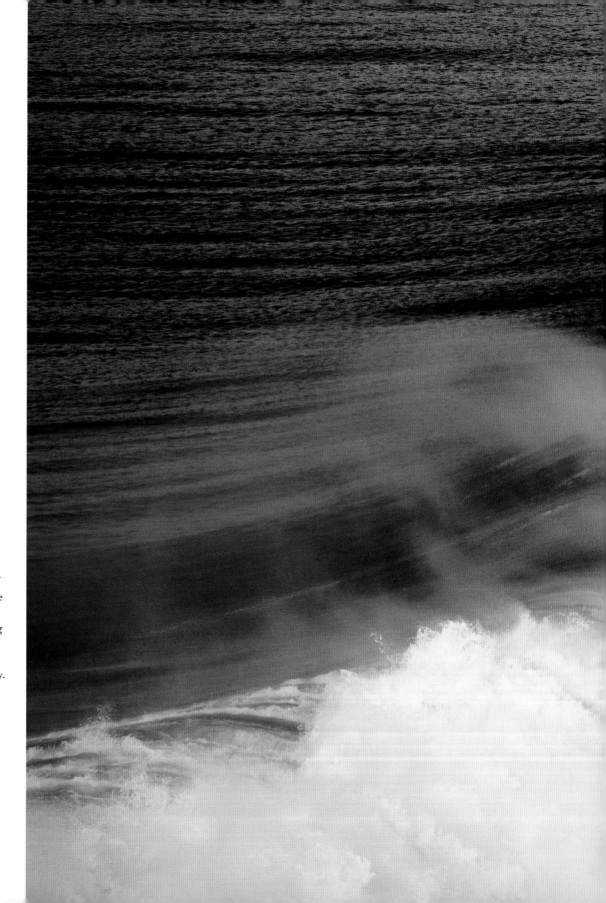

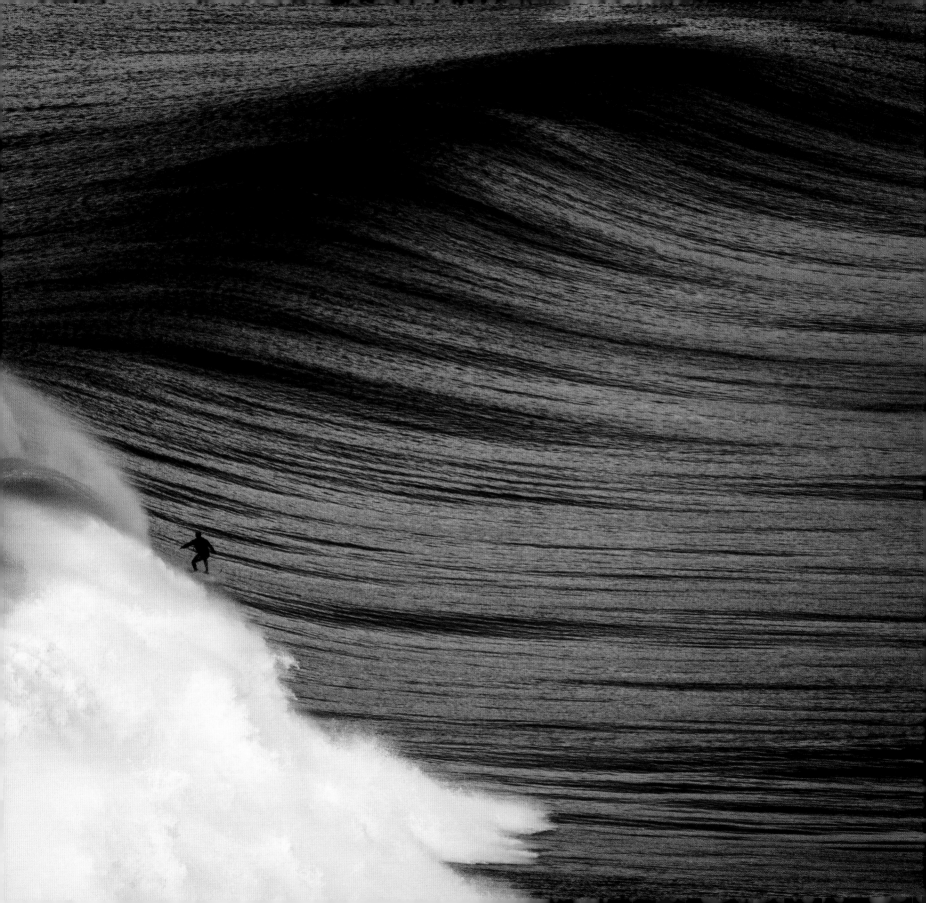

8

Expulsion
LEROY BELLET

Russell Bierke teeters on the edge of an explosive Australian wave. The skyrocketing white plumes dwarf him and contrast against a brooding storm front behind.

2017

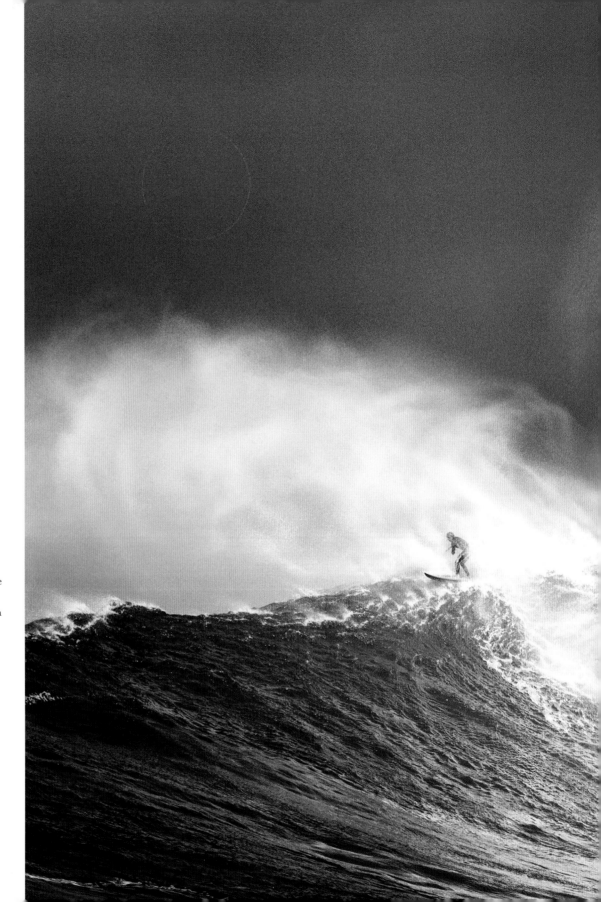

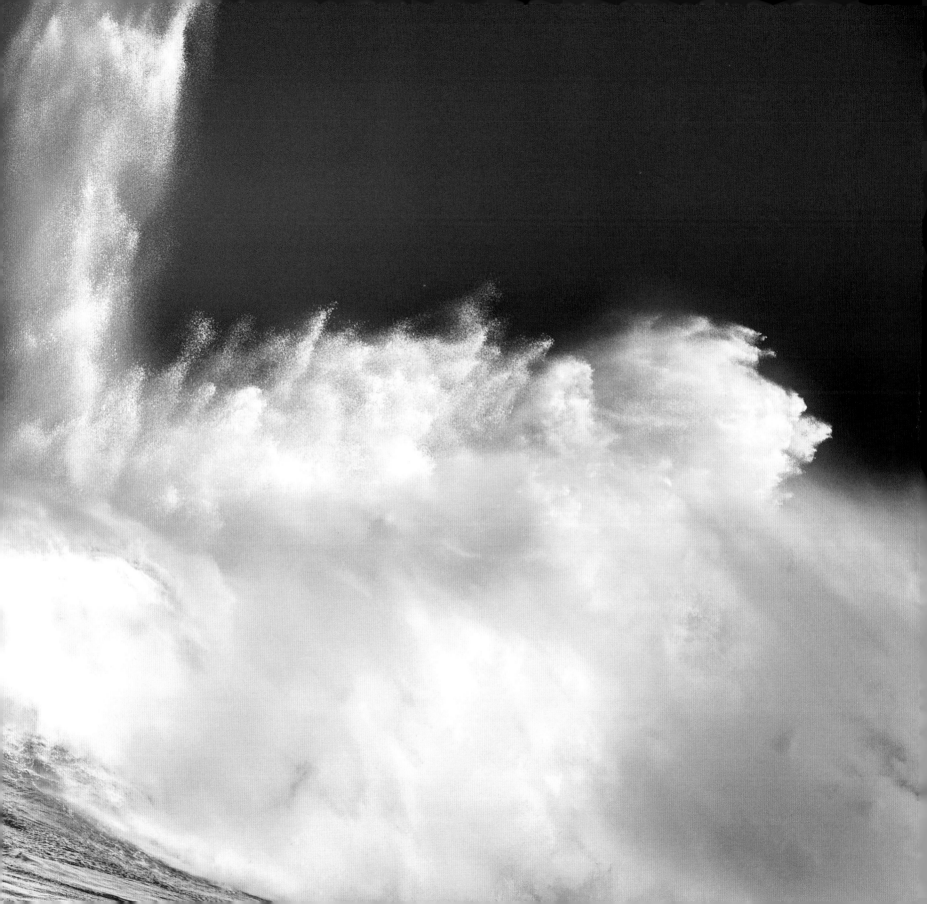

9

Adam Melling
STU GIBSON

Shot at sunrise at Cloudbreak, in some of the
best underwater conditions I'd seen that day.

2017

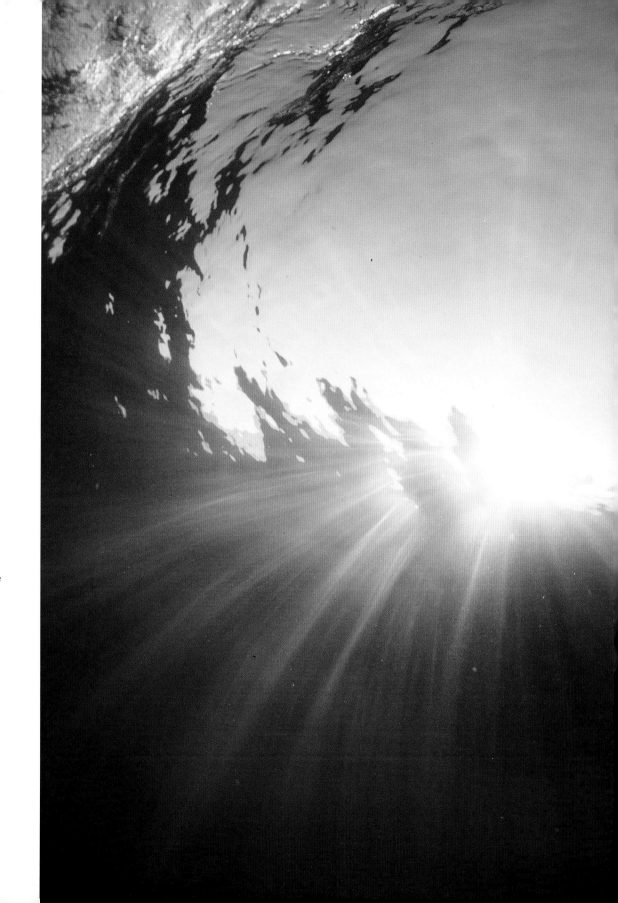

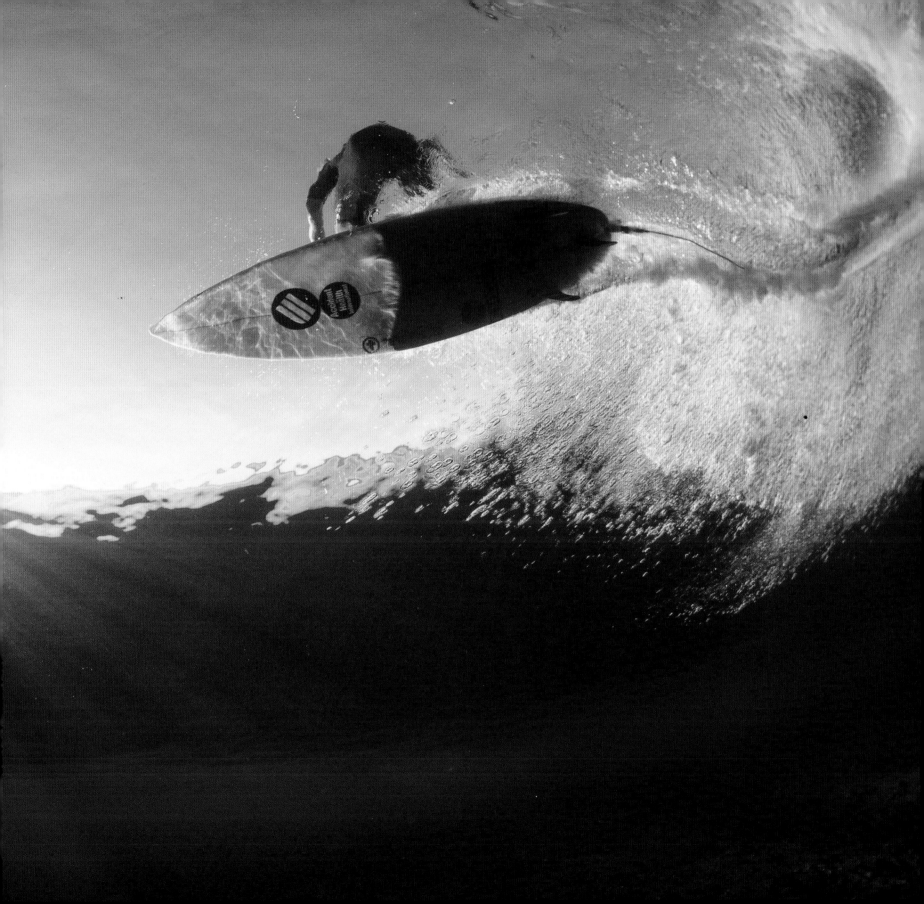

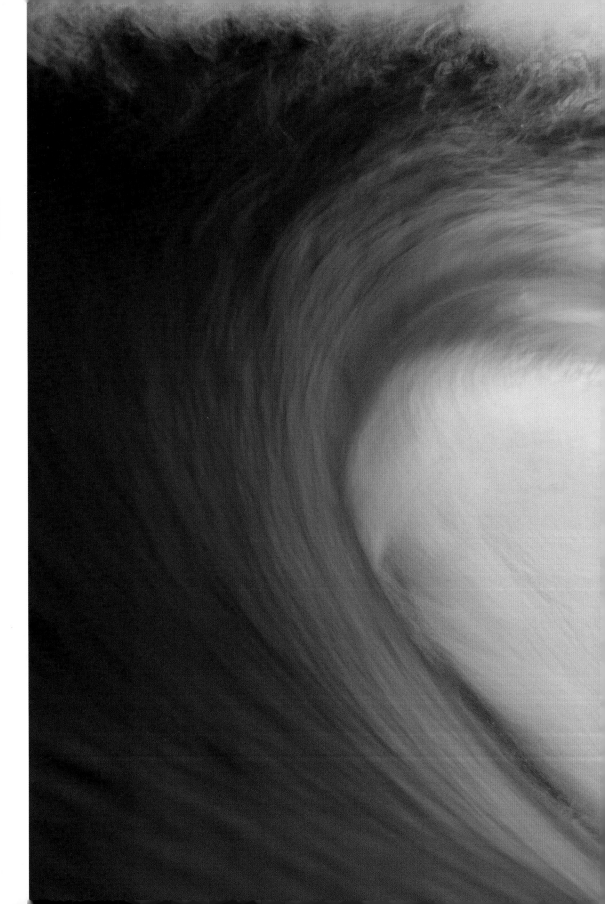

10

The Tempest
CHRIS GURNEY

Steph Gilmore rides into the darkness on
the last wave of the evening in Indonesia.

2017

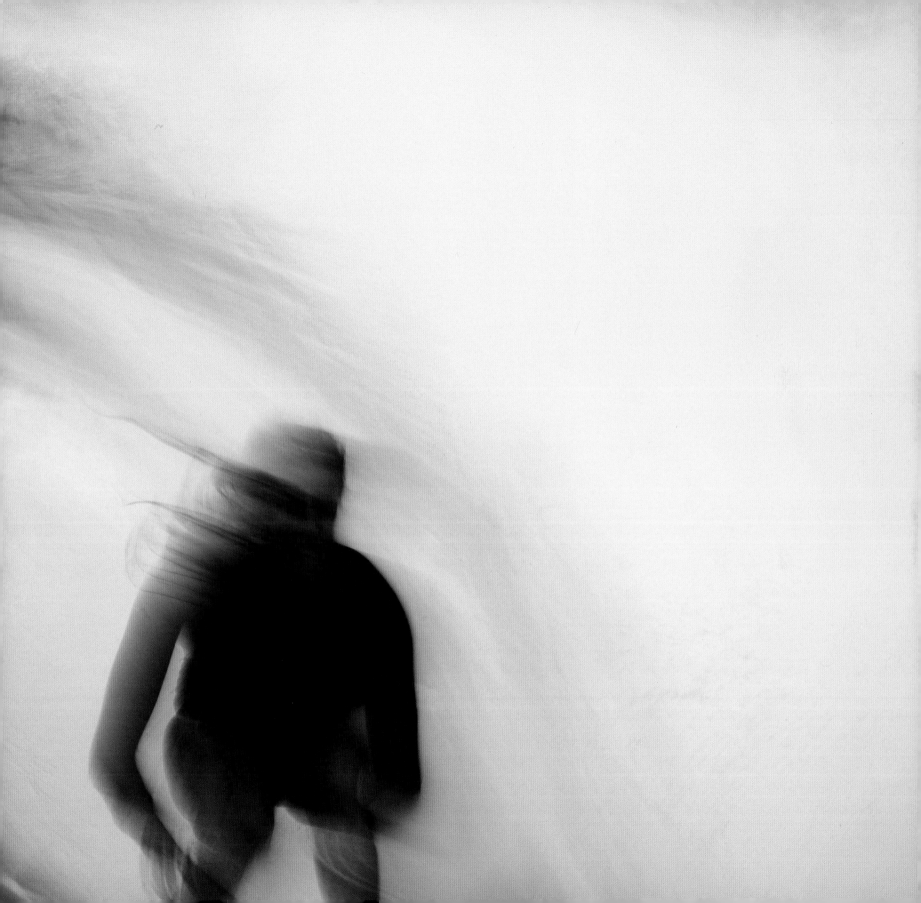

11

Fine Line

ANDREW CHISHOLM

One of the biggest swells we had ever surfed at Shipstern Bluff – the tide was too low and most waves were unrideable. For Mike Brennan to be able to pick one that wasn't a cascading river and not go dry was pretty phenomenal. He drove the perfect line into an imperfect wave, managed to complete one of the most insane bottom turns you will ever see and pull into a monster pit.

2017

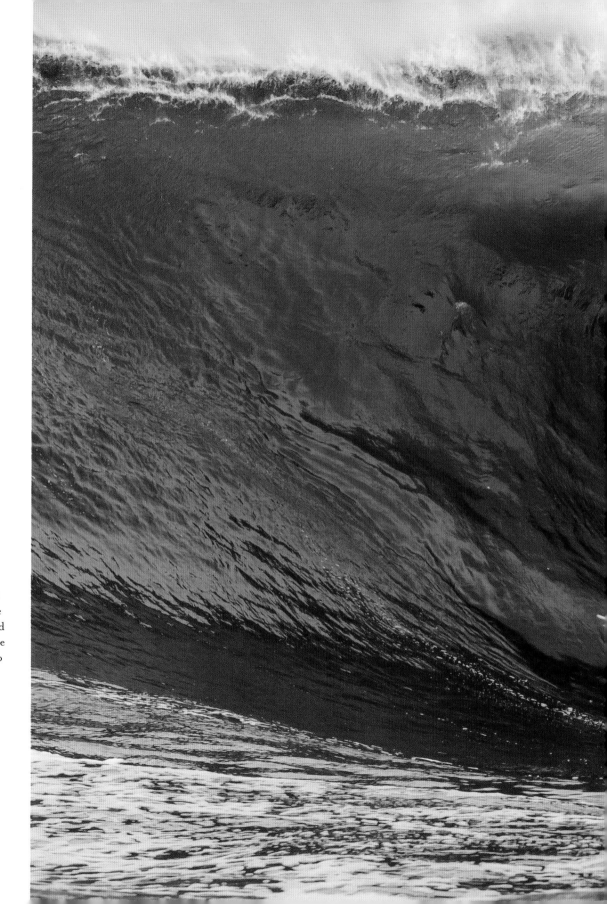

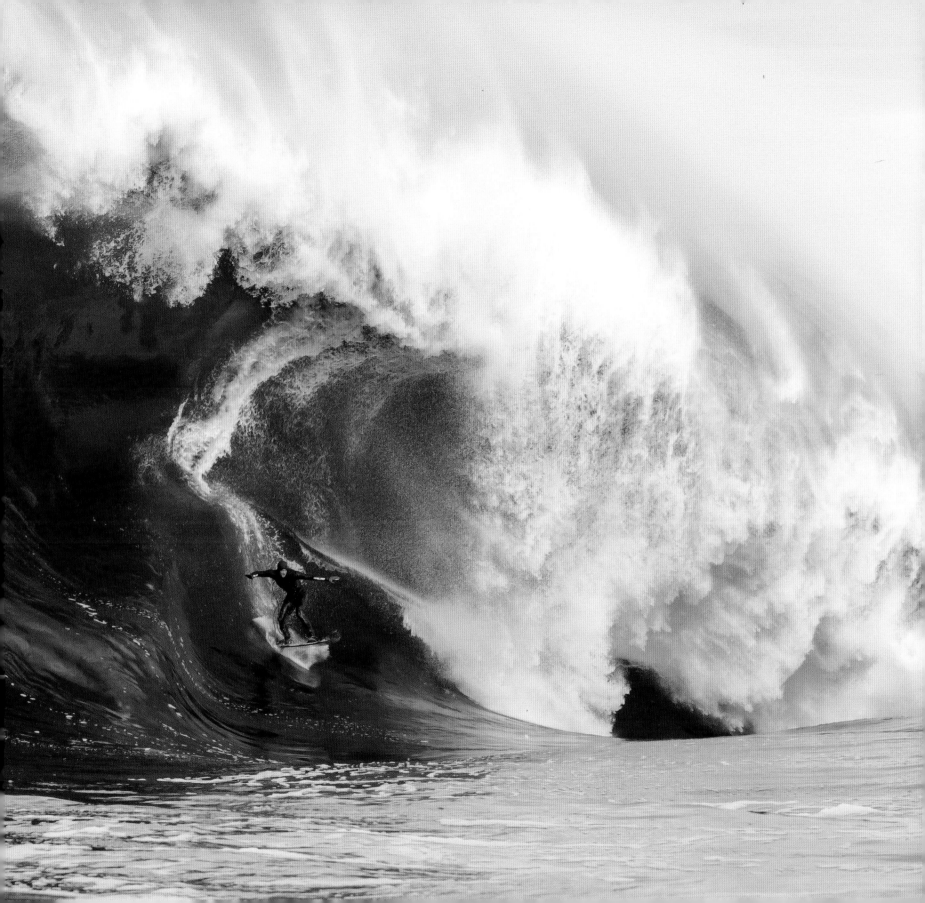

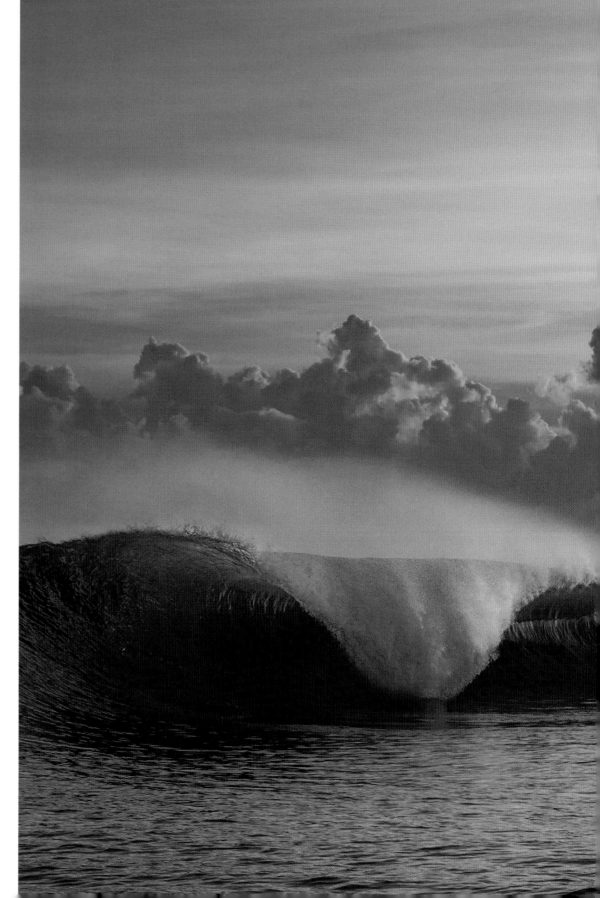

12

Day Sorted
CHRISTOPHER PEEL

The swell wasn't on the charts, but when this
rolled through we forgot about the charts. There
wasn't much talk, just a hell of a lot of screaming.
Indeed, a day to be remembered.

2017

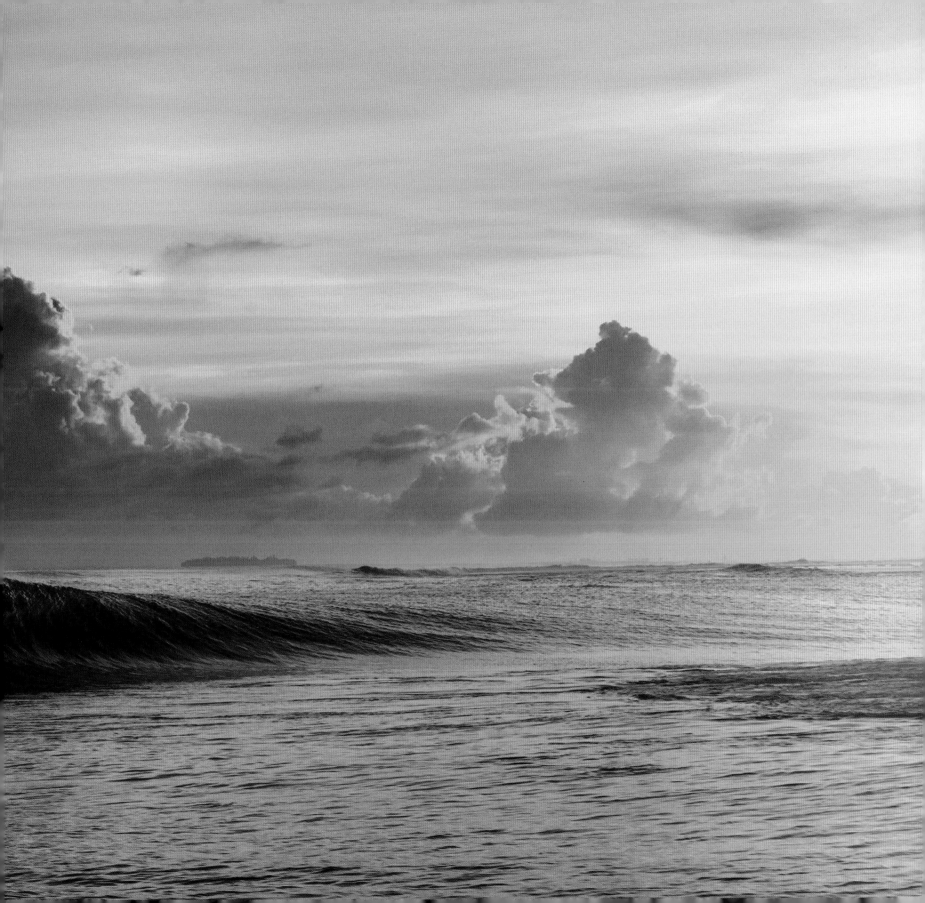

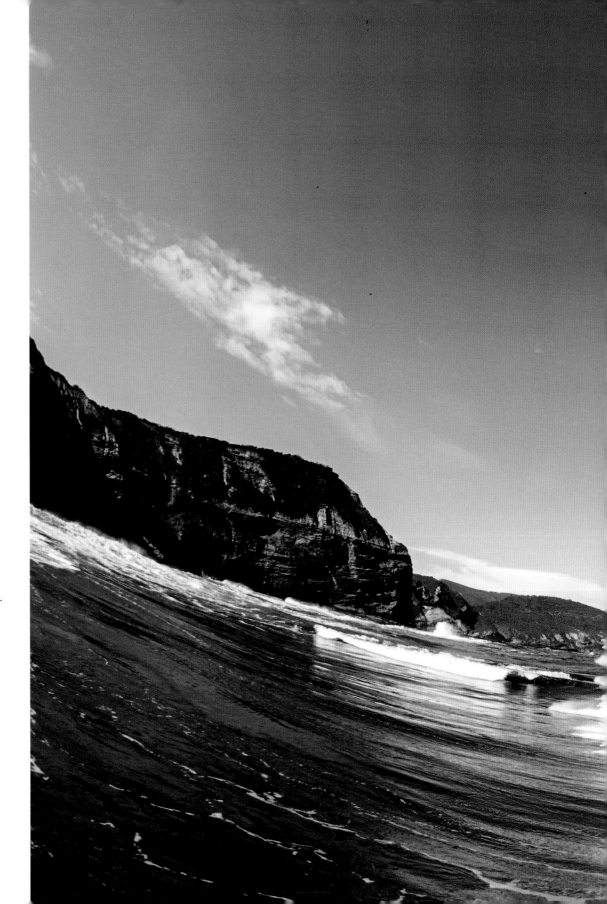

13

Dance Alone
LEROY BELLET

Craig Anderson dances alone and graceful through a violent ballroom in remote Australia. Cliffs, clouds and shadows await outside.

2017

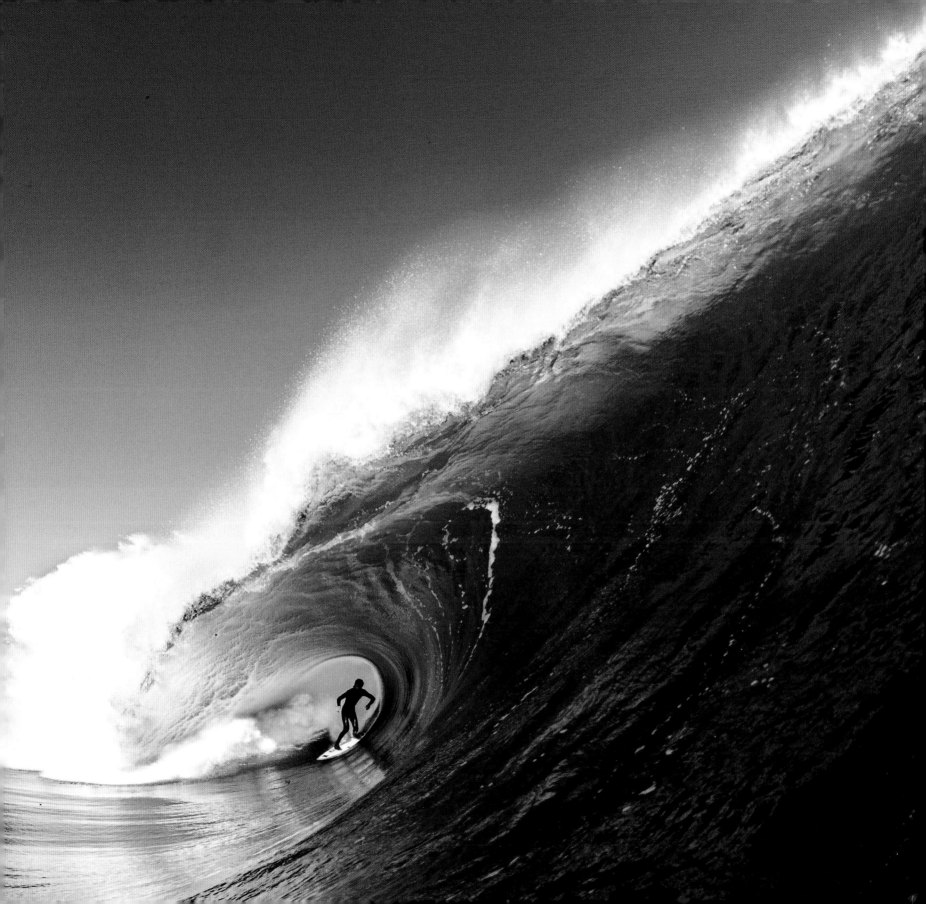

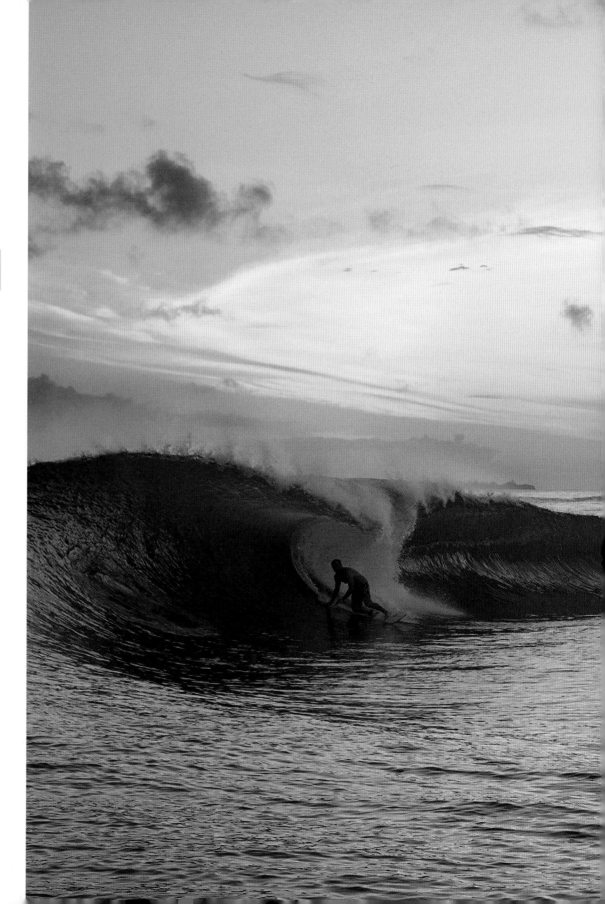

14

Dream Time
CHRISTOPHER PEEL

Andrew Rigby has a dream ride with some of
those waves you used to draw at school.

2017

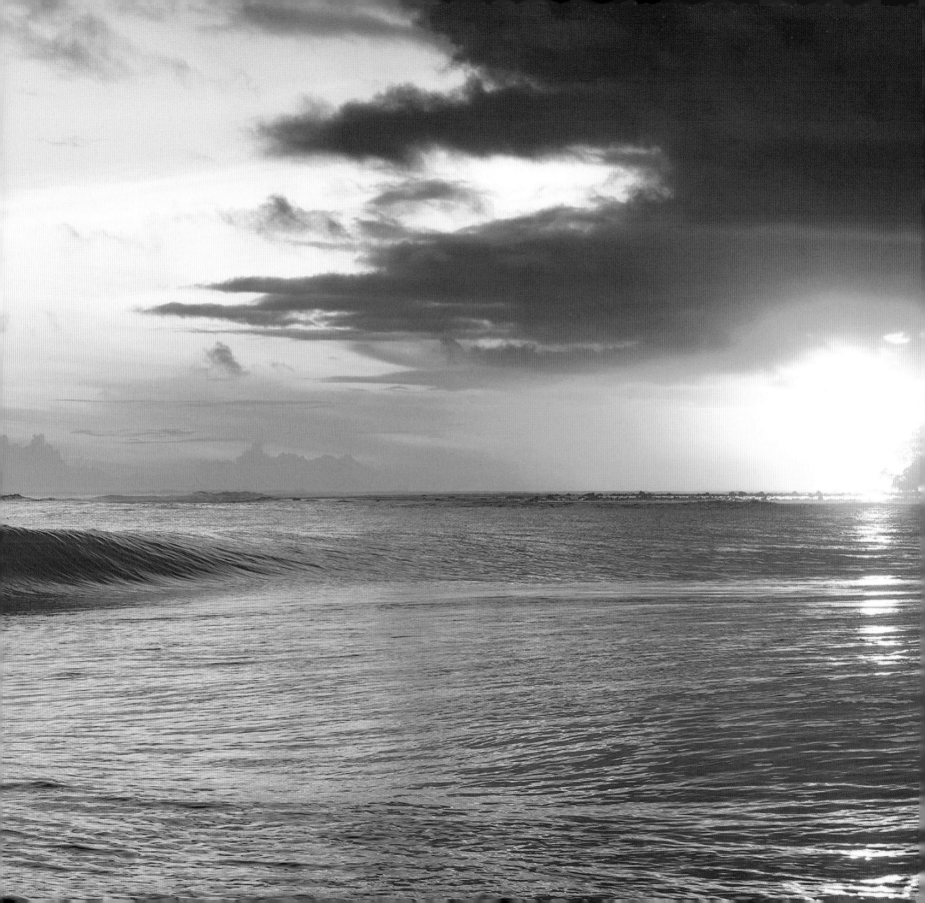

15

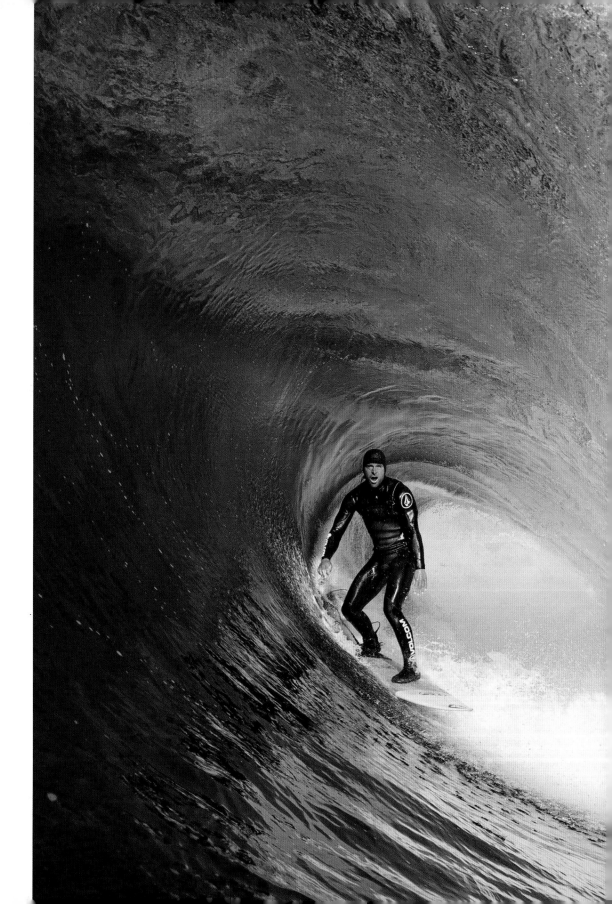

Marti Paradisis

STU GIBSON

Shipstern Bluff, bluebird day.

2017

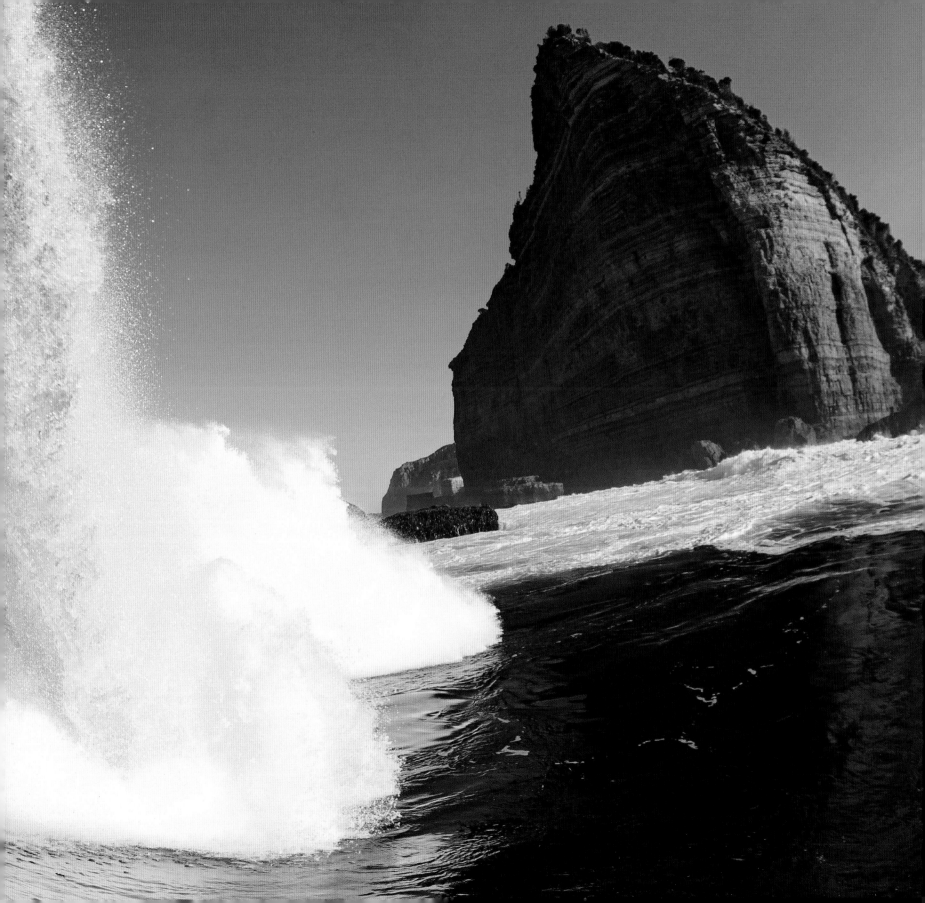

16

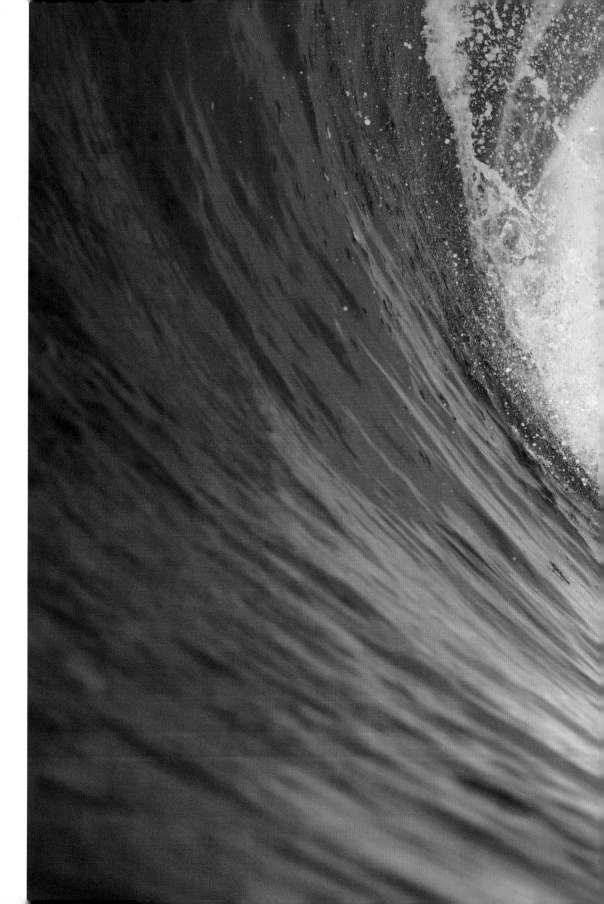

Happy Gilmore

CHRIS GURNEY

Steph Gilmore smiles on her way out of
the tube, somewhere just north of the equator.

2017

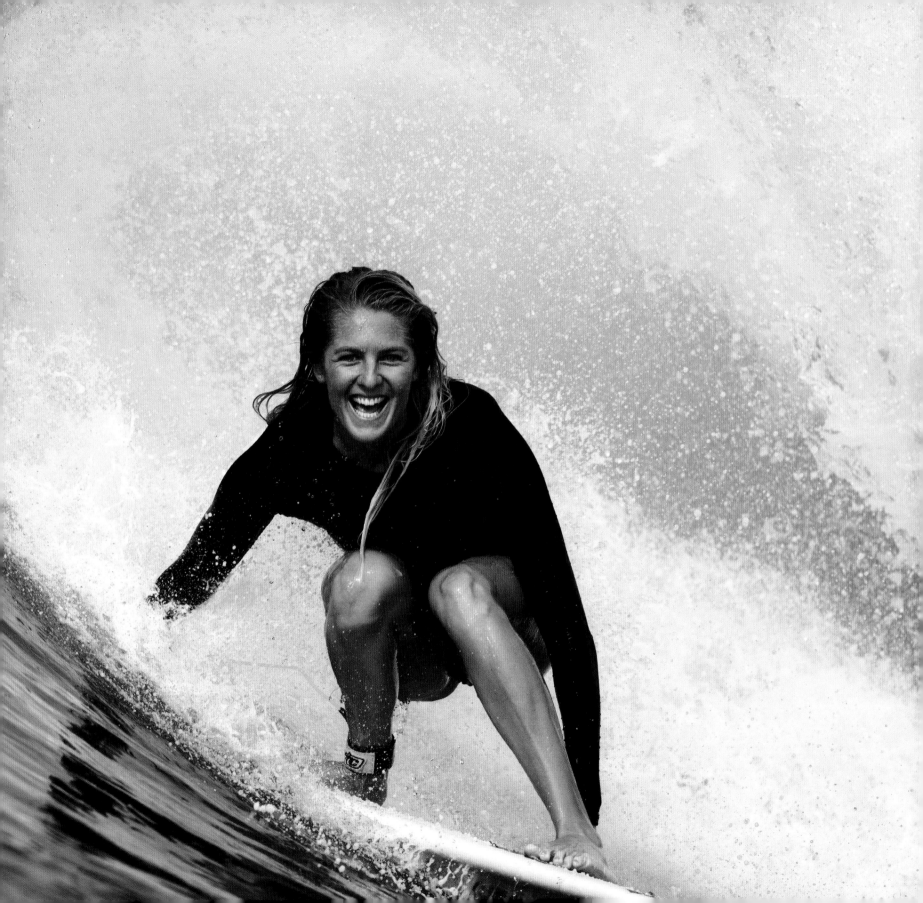

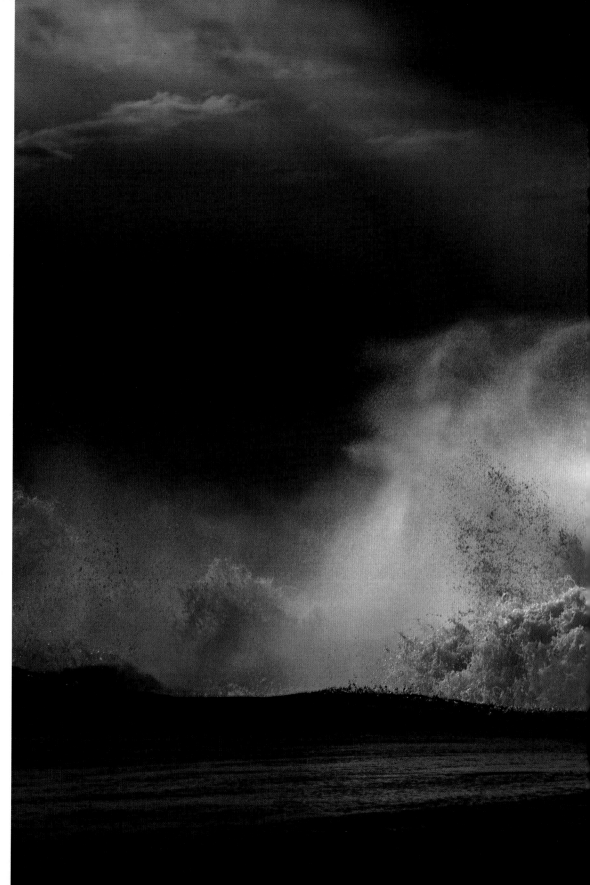

17

Impetus

RAY COLLINS

The end of a wave's journey.

2017

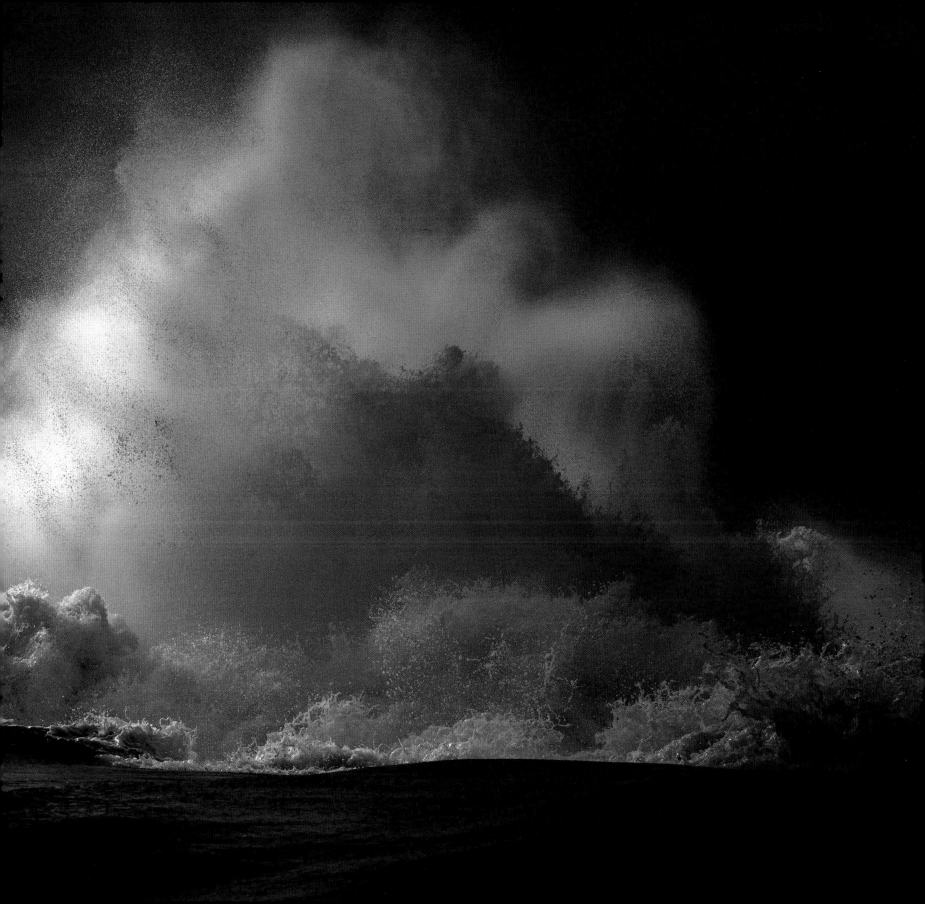

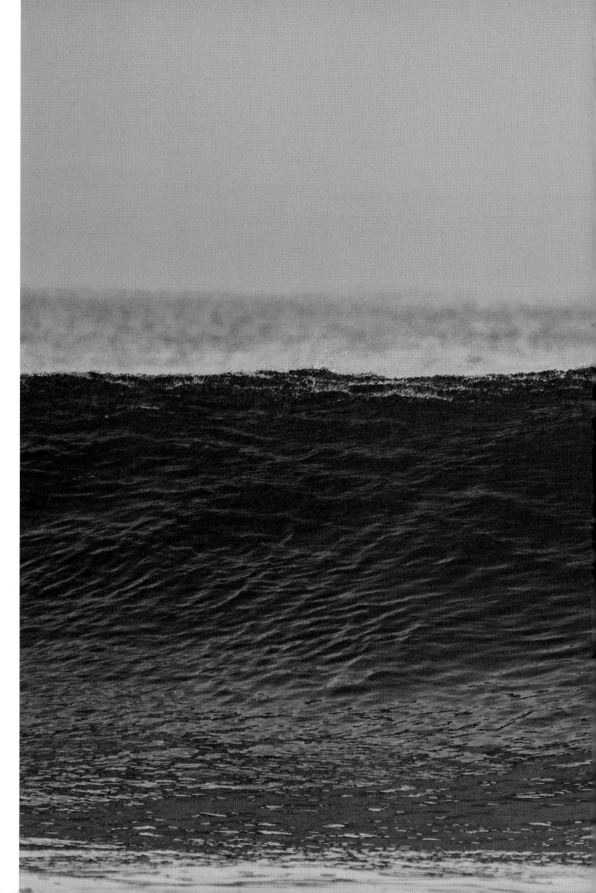

18

Mick Fanning Pre-dawn, Bells Beach

PETER JOLI WILSON

Mick Fanning only entered a handful of contests in 2016 and the Rip Curl Pro at Bells Beach was one of them. This was shot just before dawn as Mick was warming up for the day's heats.

2017

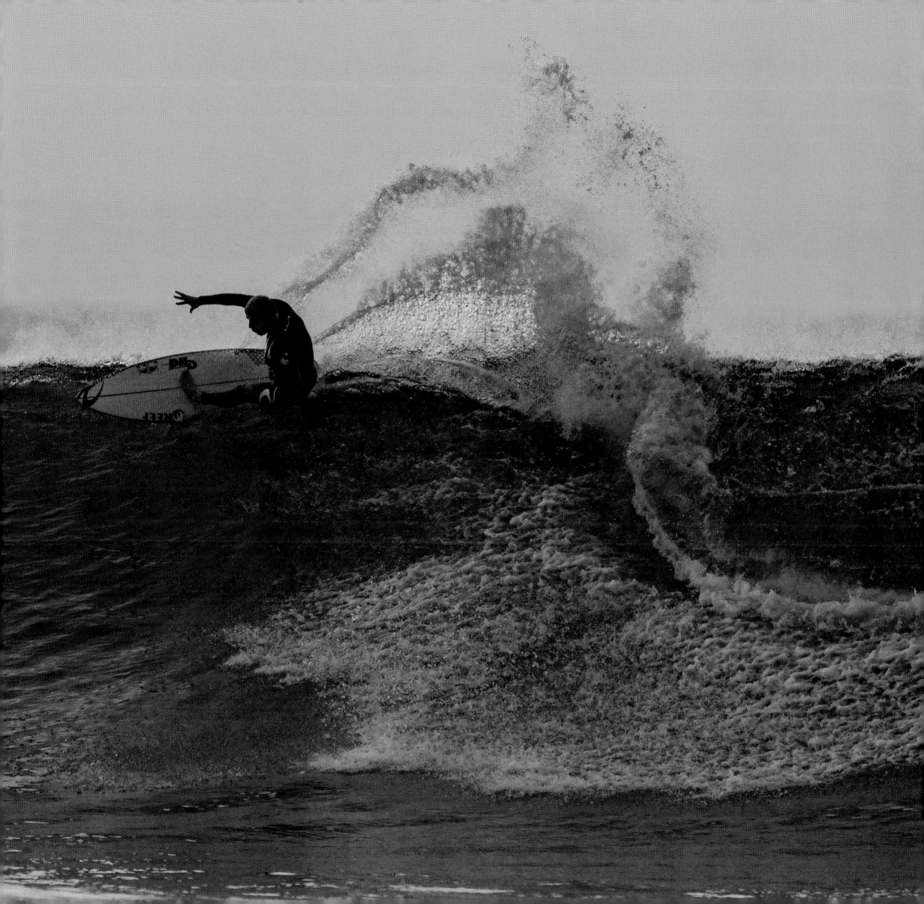

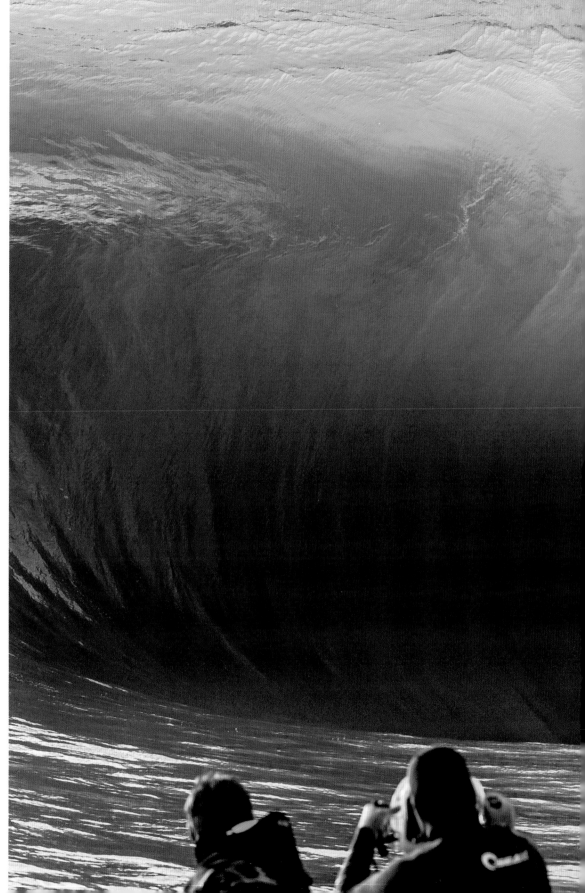

19

Beast

ANDREW CHISHOLM

Every few years we get to surf this wave.
Even if we could surf the spot each week,
Danny Griffiths would want every set,
no matter how big!

2017

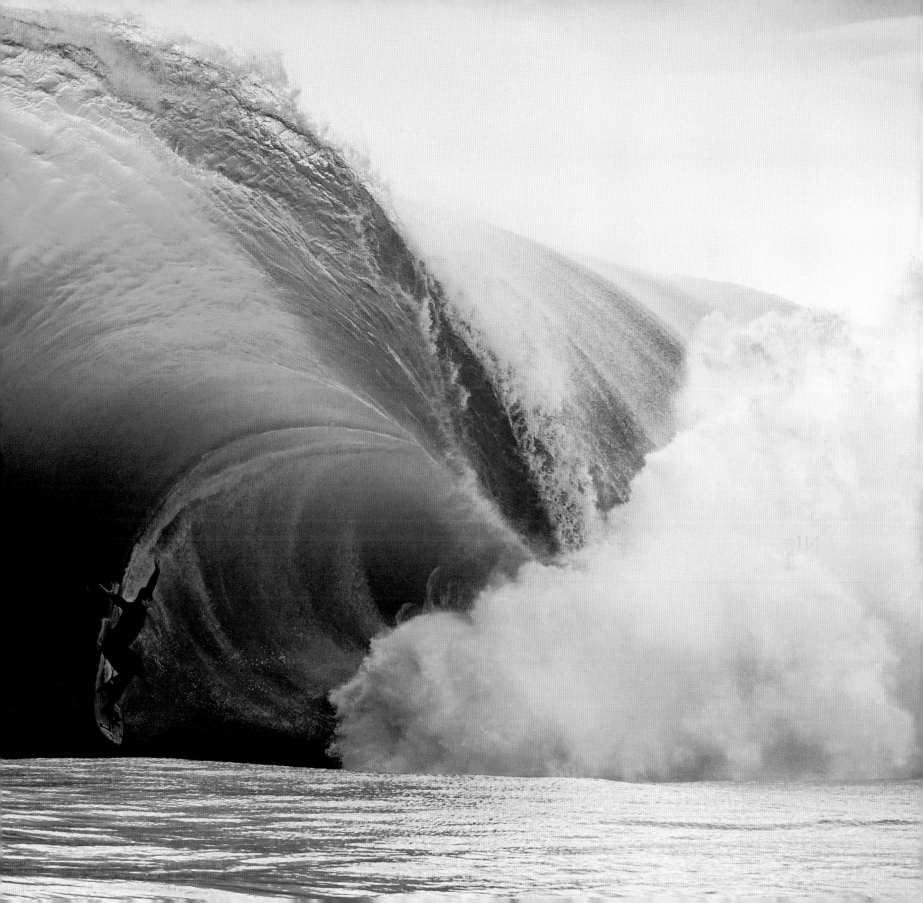

20

Vertigo
CHRIS GURNEY

A never-before-seen angle of a rarely seen wave in Southern Australia. Due to its remote offshore location, this wave had never been photographed at sunset. A helicopter made the journey possible, and also allowed a unique view of what goes on as the wave breaks.

2017

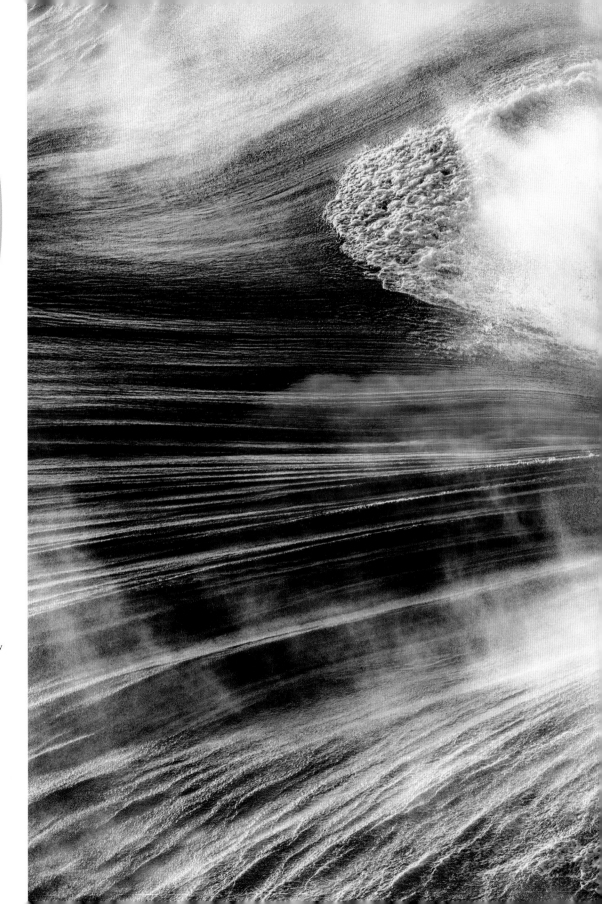

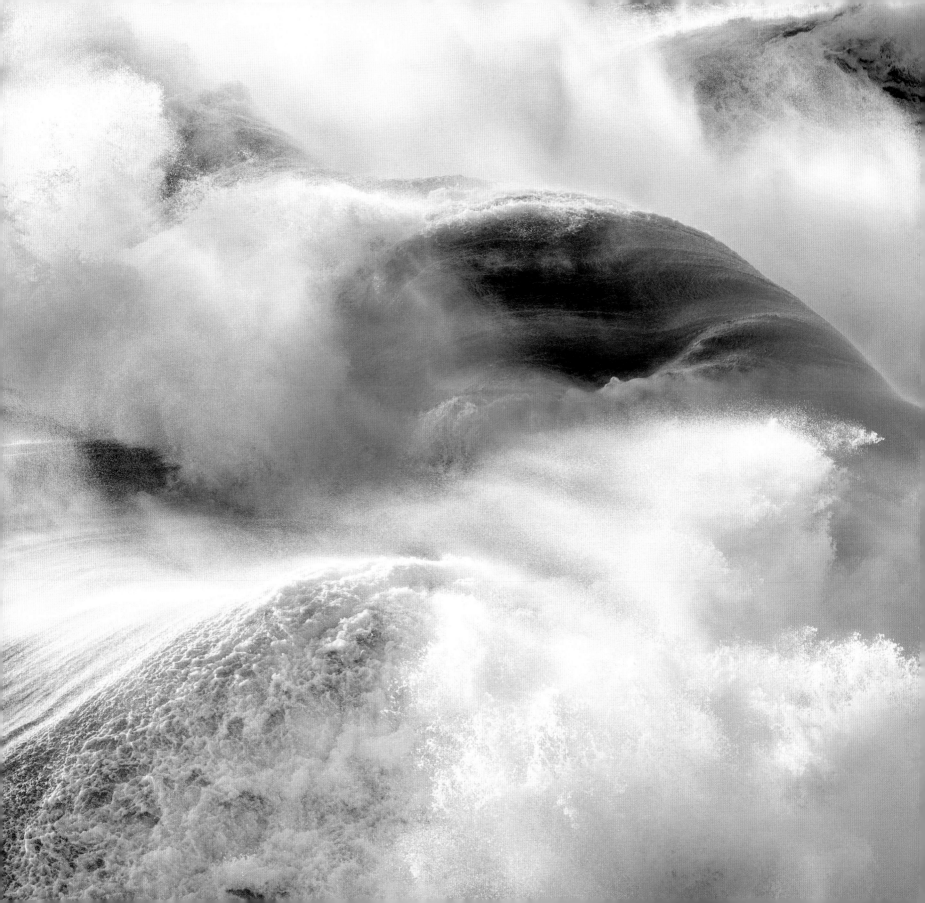

Ephemeral
LEROY BELLET

Russell Bierke adjusts his centre of gravity to prepare for the upcoming mid-face step. This image was captured while surfing behind Russell, at sunrise, on the NSW South Coast of Australia. The Nikon SB-910 speedlight was used to illuminate Russell from behind, while utilising the natural light of the winter sunrise. Moments like this only come around so often: the surfer claiming on the shoulder, lighting, positioning … I couldn't have scripted it any better in my dreams. After over 200 intentional wipeouts, it's nice to look back on this split second, take a deep breath and brace for impact.

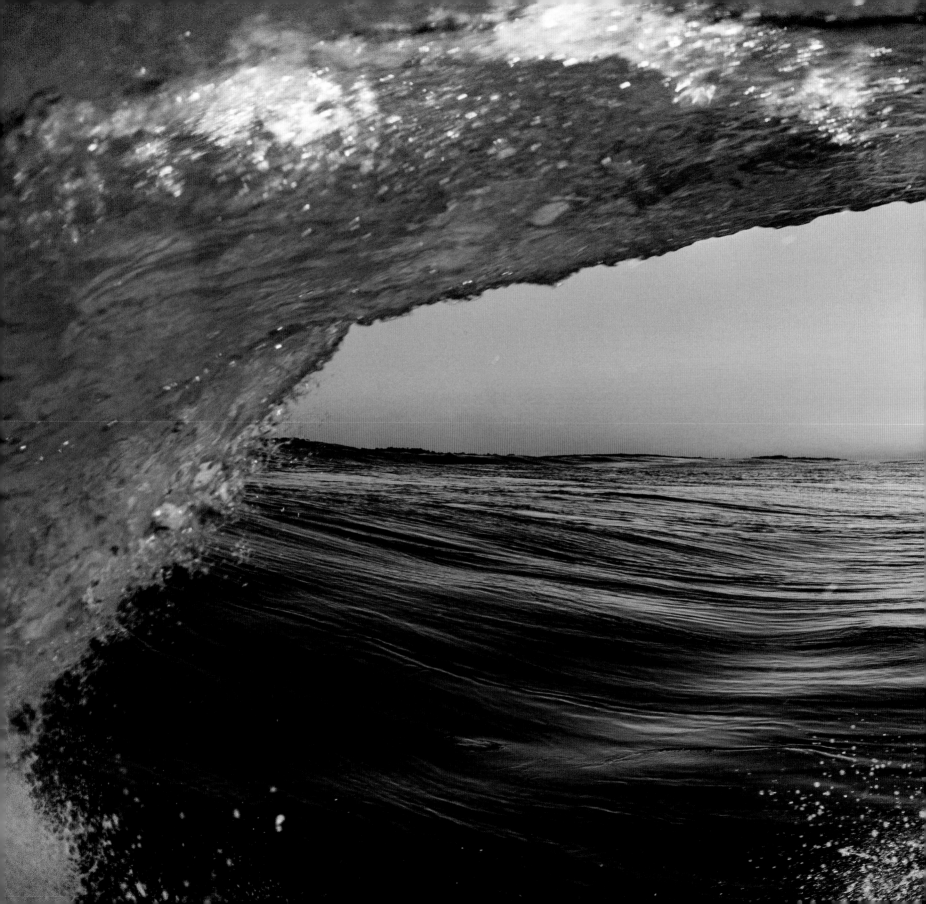

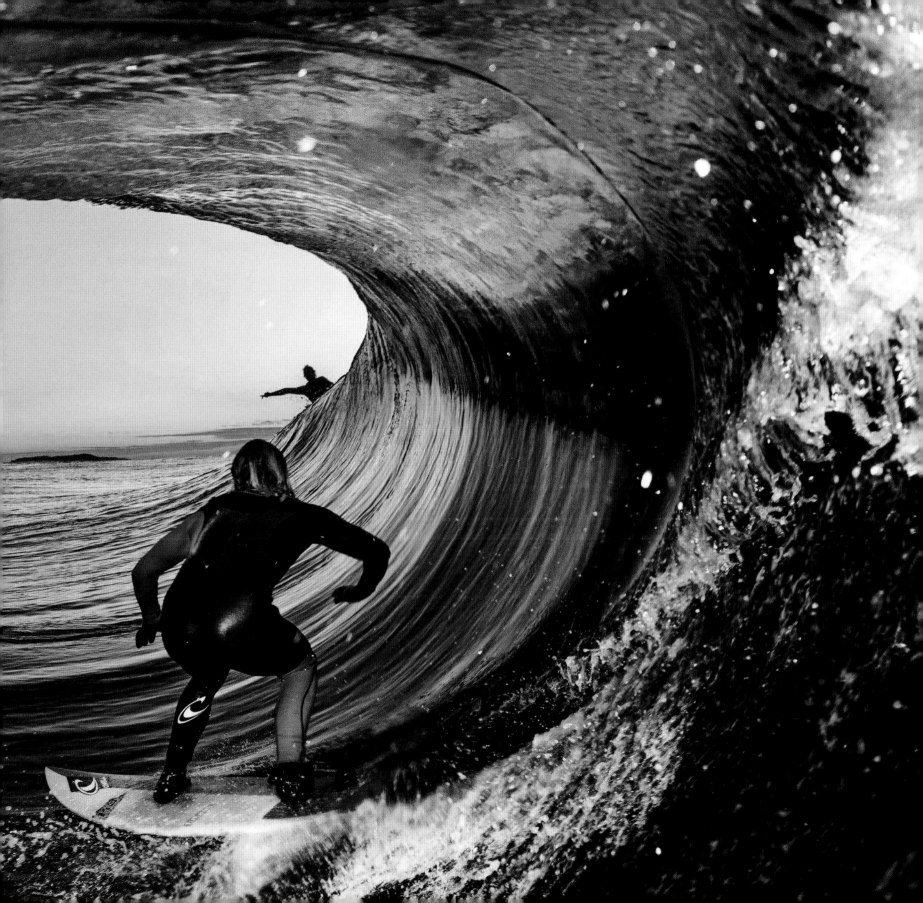

2

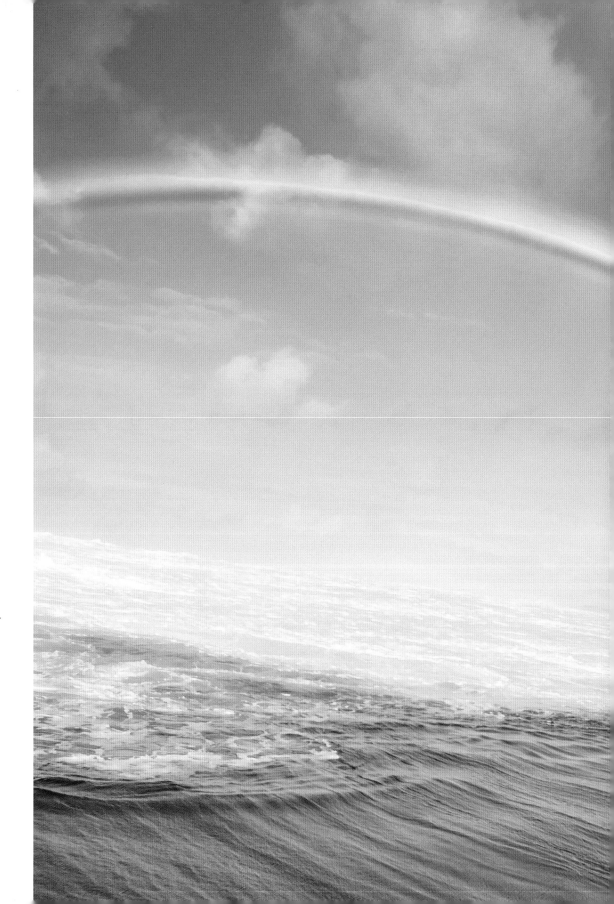

Fine Line
LUKE SHADBOLT

An afternoon tropical storm creates a moment of contrasts between the warping west bowl of Teahupo'o and the peaceful rainbow overhead. At the same time, a local Tahitian sits in the barrel treading a fine line between pleasure and pain.

2016

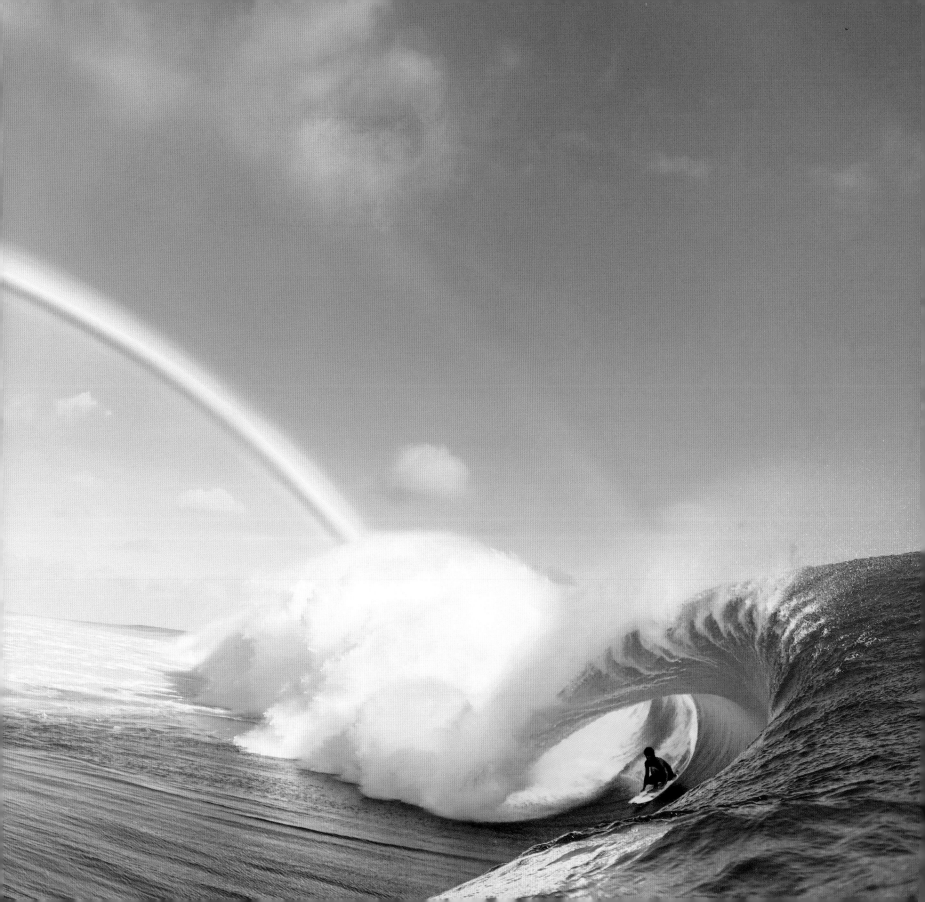

3

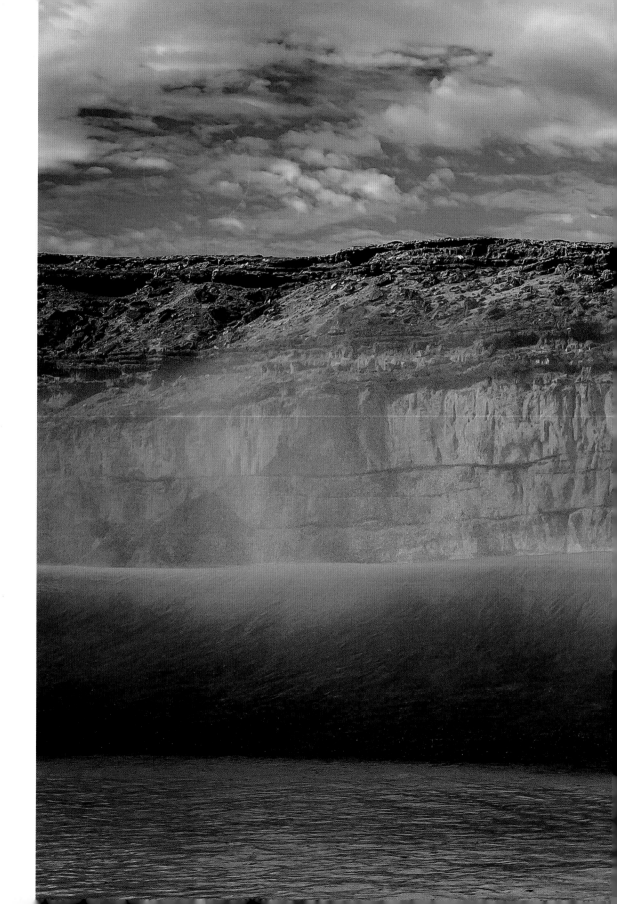

Swells End
RICH

Taken on a Nikon D3 50mm and
embracing the moment.

2016

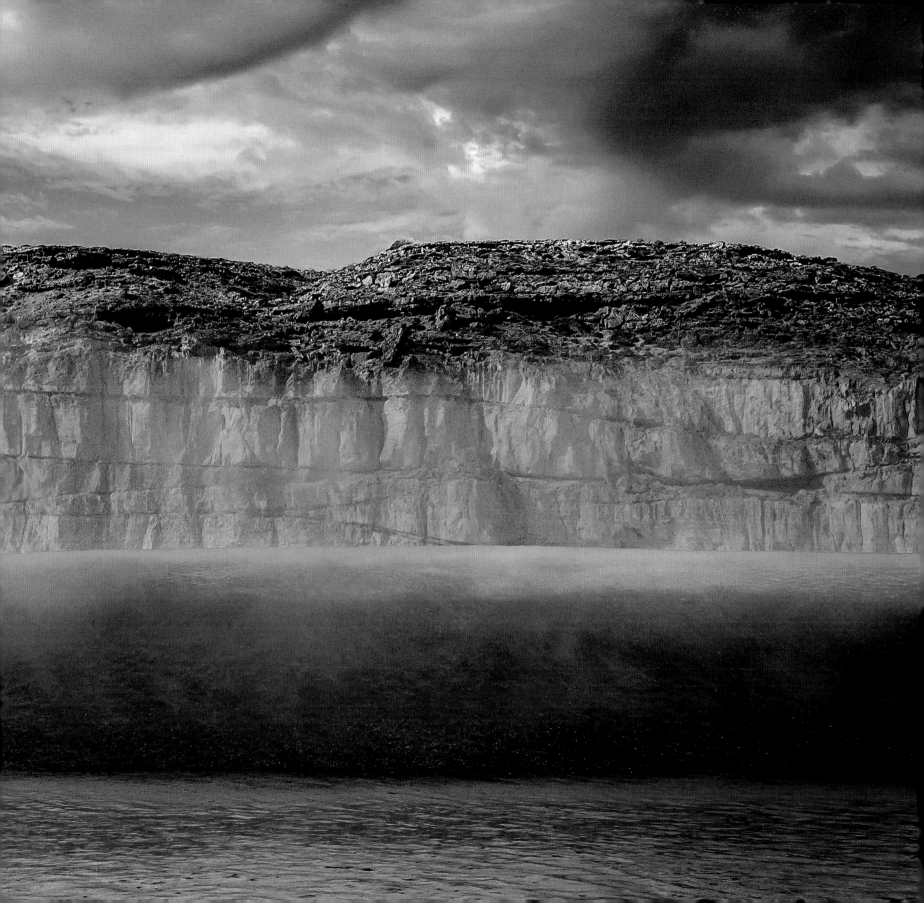

4

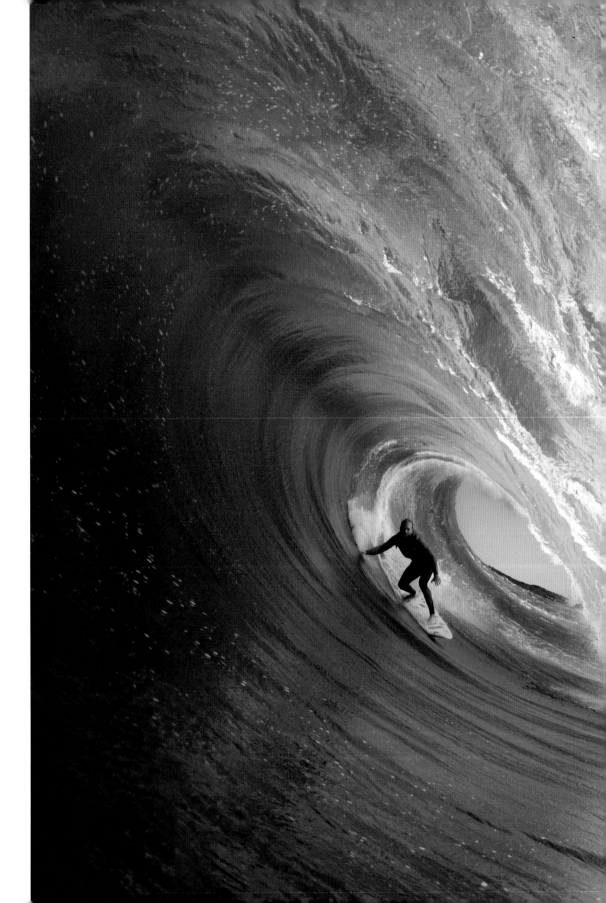

Mark Mathews

See Through

RUSSELL ORD

Fisheye shot of Mark Mathews at WA's
The Right — still the only one to have
a shot like this out there …

2016

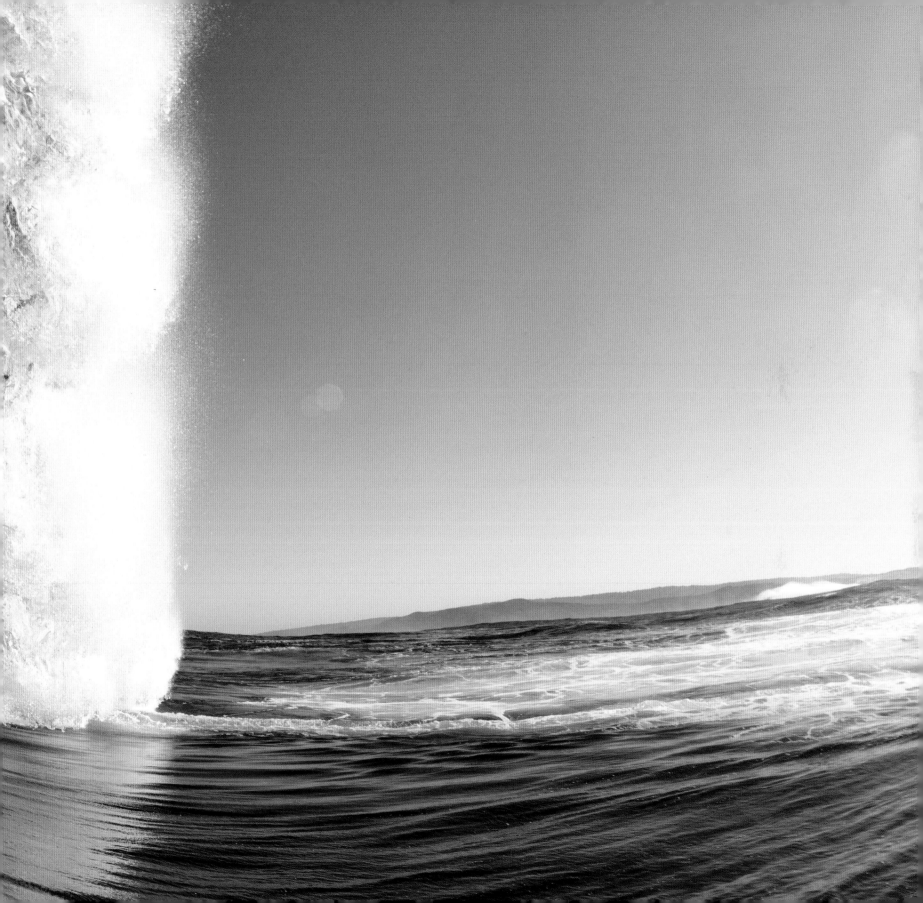

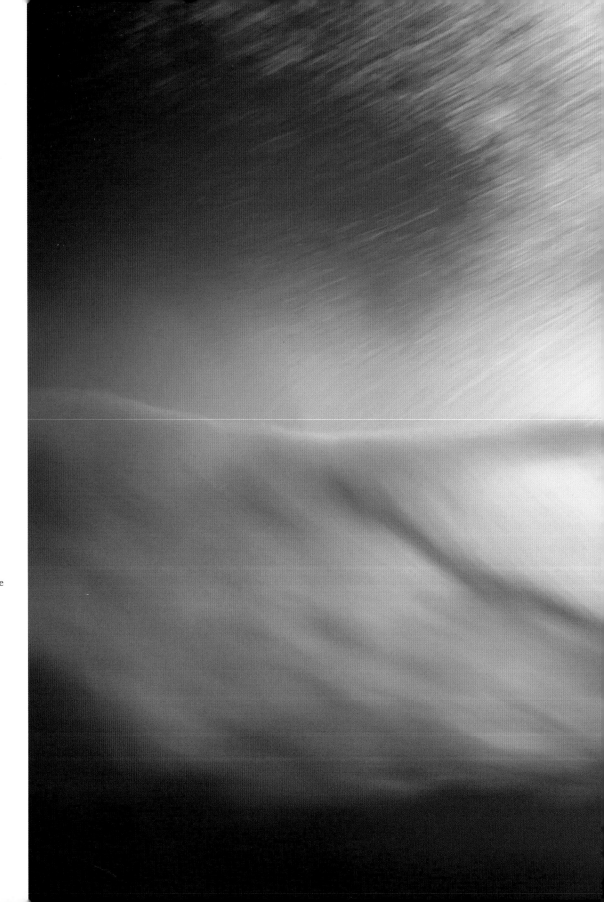

5

Infinity Wall #1
LUKE SHADBOLT

The inner workings of a barrelling wave, and the form and function of a surfer riding inside it. Dave Wassel shot at Backdoor, January 2015.

2016

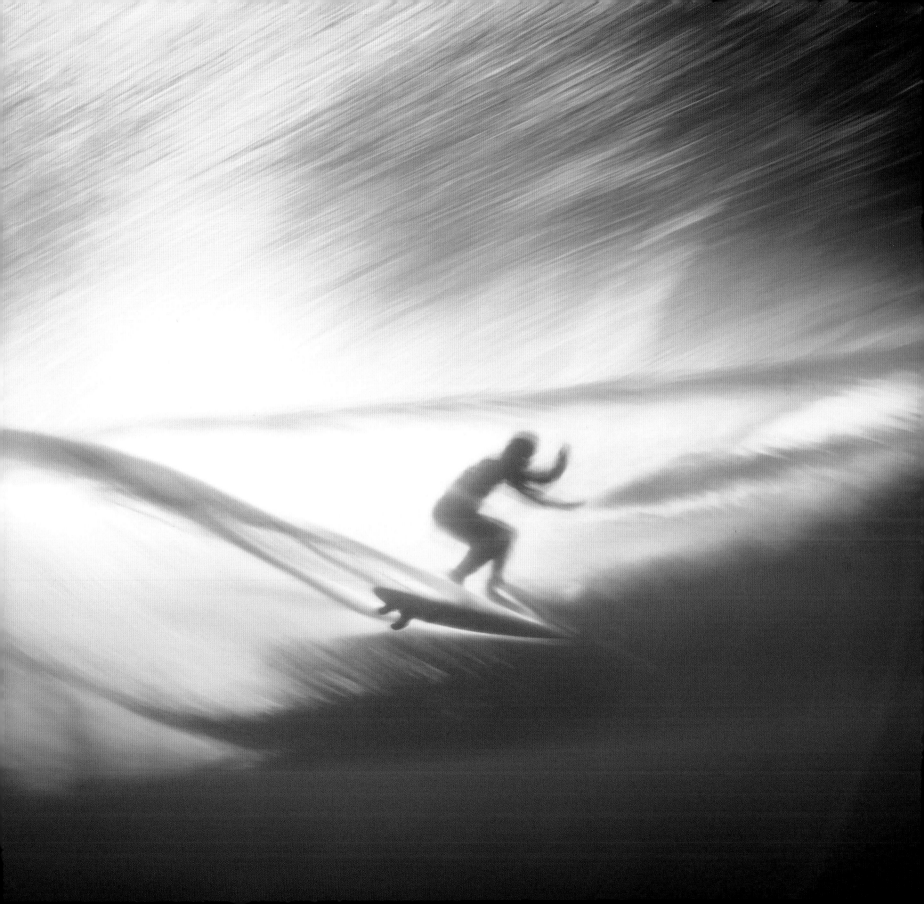

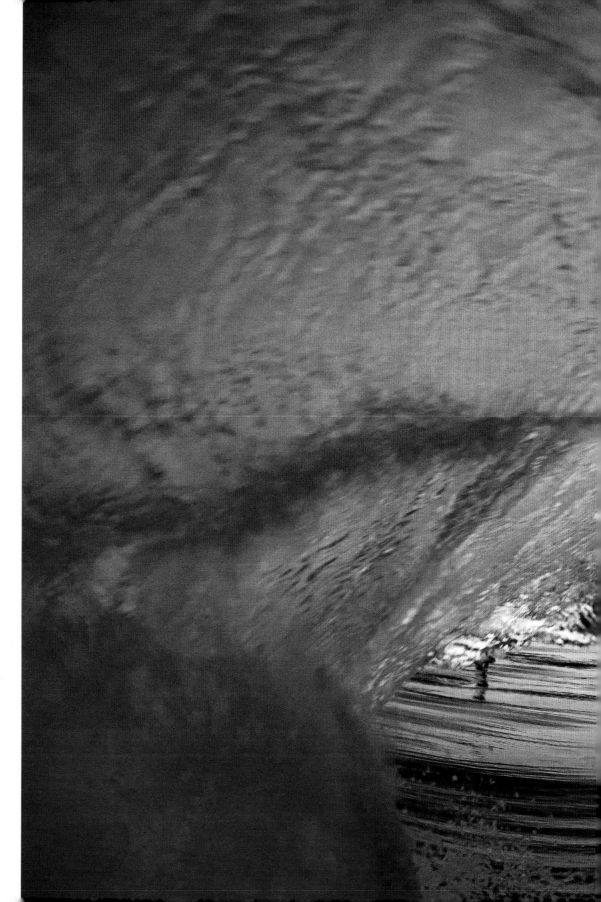

6

Kaleidoscope
LEROY BELLET

A silhouetted Scott Dennis racing through the barrel and a kaleidoscope of morning colours. This image was captured while surfing behind Scott, at dawn, on the NSW South Coast of Australia. On this morning, we were concerned about the tide getting too low and making each wave significantly shallower and more dangerous. Coming into this exact wave, I could see the reef gurgling near the surface and knew I could get hurt. I also knew that we were both positioned perfectly and the light was spectacular, so in the heat of the moment, we both went for it.

2016

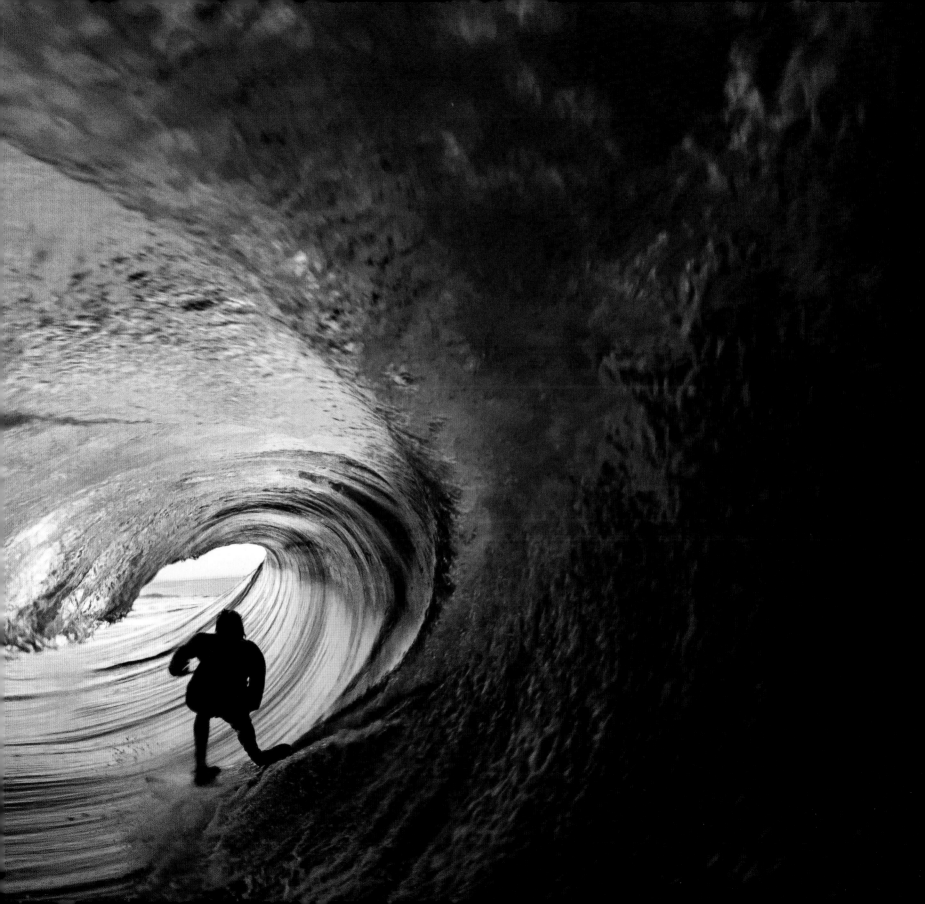

7

Chatoyant
LEROY BELLET

Scott Dennis high-lining into the lustre of
a winter gem on the NSW South Coast of
Australia. Captured on the Nikon D810 while
surfing behind Scott, this image displays the
natural survival instincts that a surfer utilises
when trying to ride and make a barrel. I feel like,
as a surfer, this natural body language is what
makes the photo unique and engaging.

2016

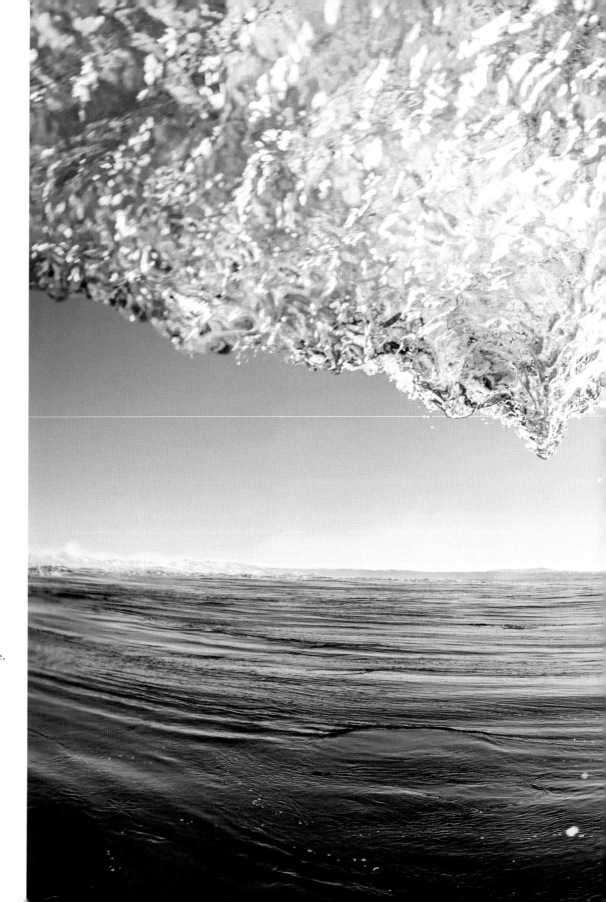

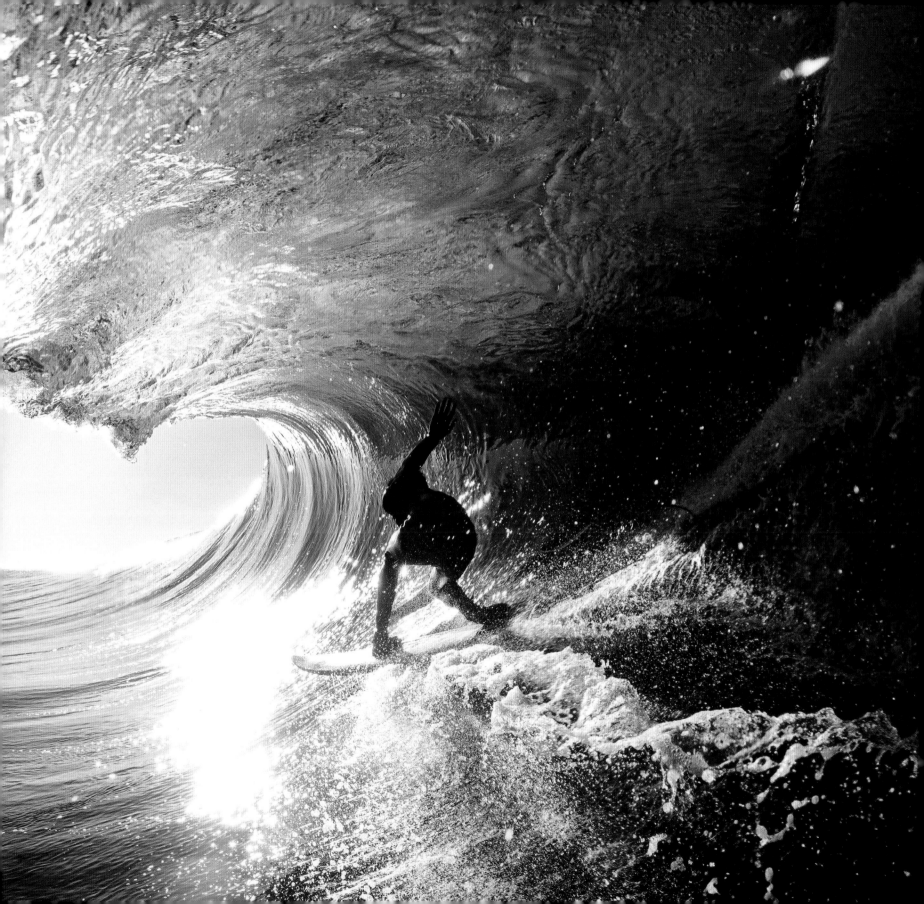

8

People Who Live in
Glass Houses #1

LUKE SHADBOLT

Owen Wright puts on one of the most impressive displays of backhand tube riding I've ever witnessed in Wollongong. He left this session and went straight to the airport, flying to West Oz and proceeding to put on a backhand tube riding clinic at The Box during the Margaret River Pro.

2016

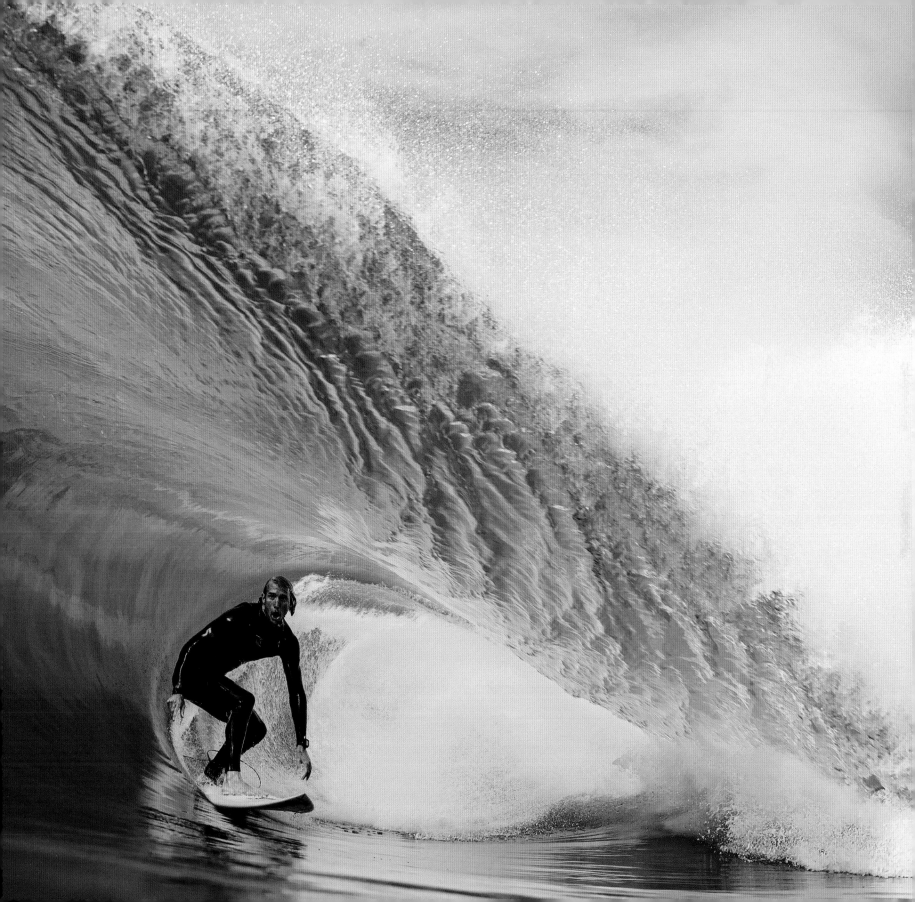

9

Spectre

LEROY BELLET

Scott Dennis illuminated in a night-time barrel, from behind. This image was captured while surfing behind Scott, before dawn, on the NSW South Coast of Australia. Surfing at night was one of the most intimidating yet surreal experiences of my life.

2016

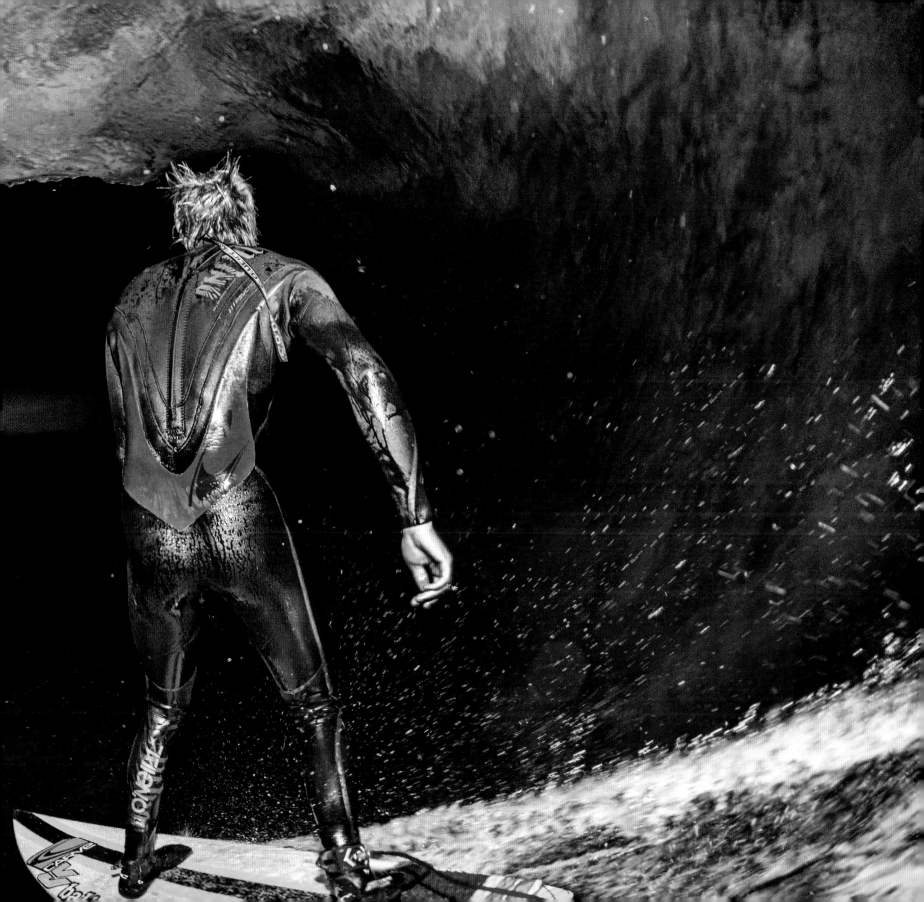

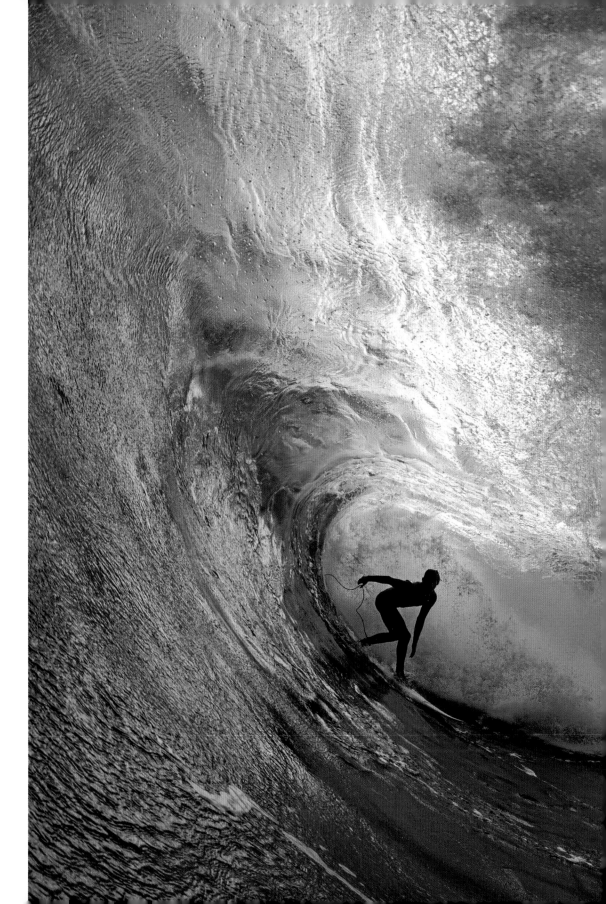

10

Kyle Cooper, 'Stern

STU GIBSON

The power and beauty of Shipstern Bluff.

2016

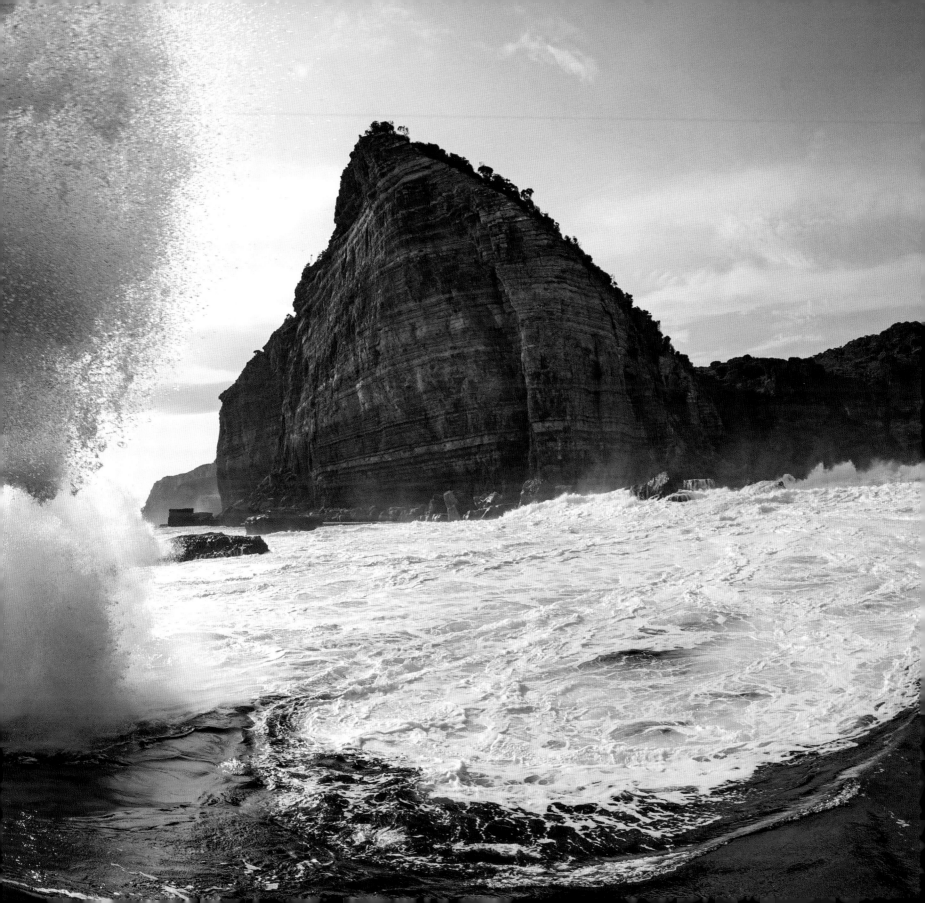

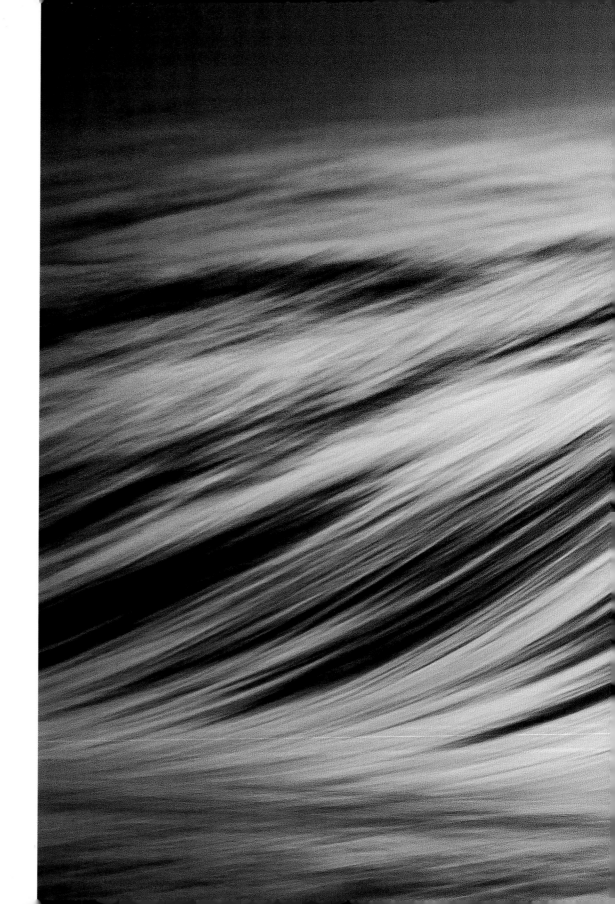

11

Silver Surfer
PHILIP THURSTON

The anticipation of a powerful wall of ocean power building before you is a feeling only a surfer can know.

2016

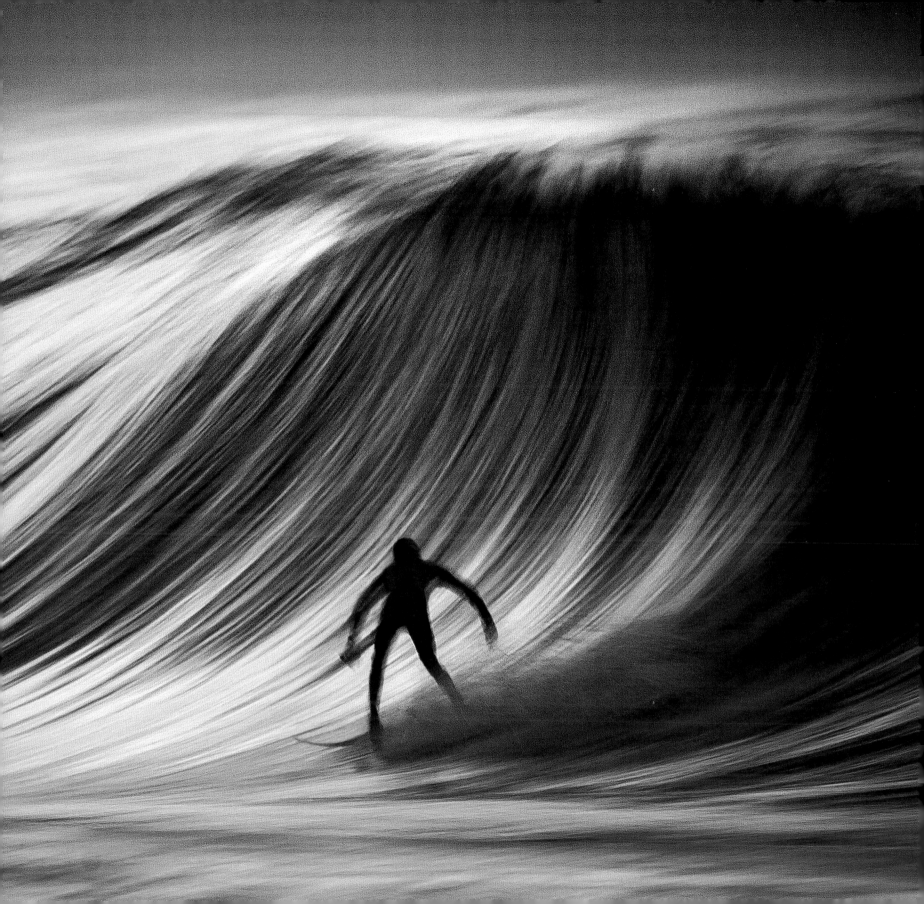

12

Mick Fanning
PETER JOLI WILSON

Mick Fanning after emerging from the Pipeline barrel that won him the 'Super Heat' against John John Florence and Kelly Slater. Fanning, going for World Title #4, is dealing with immense pressure from the media and fans after learning of the death of his brother just hours before. Looking skywards, he seems to be thanking a 'higher power' for helping him win the heat and keeping his World Title hopes alive.

2016

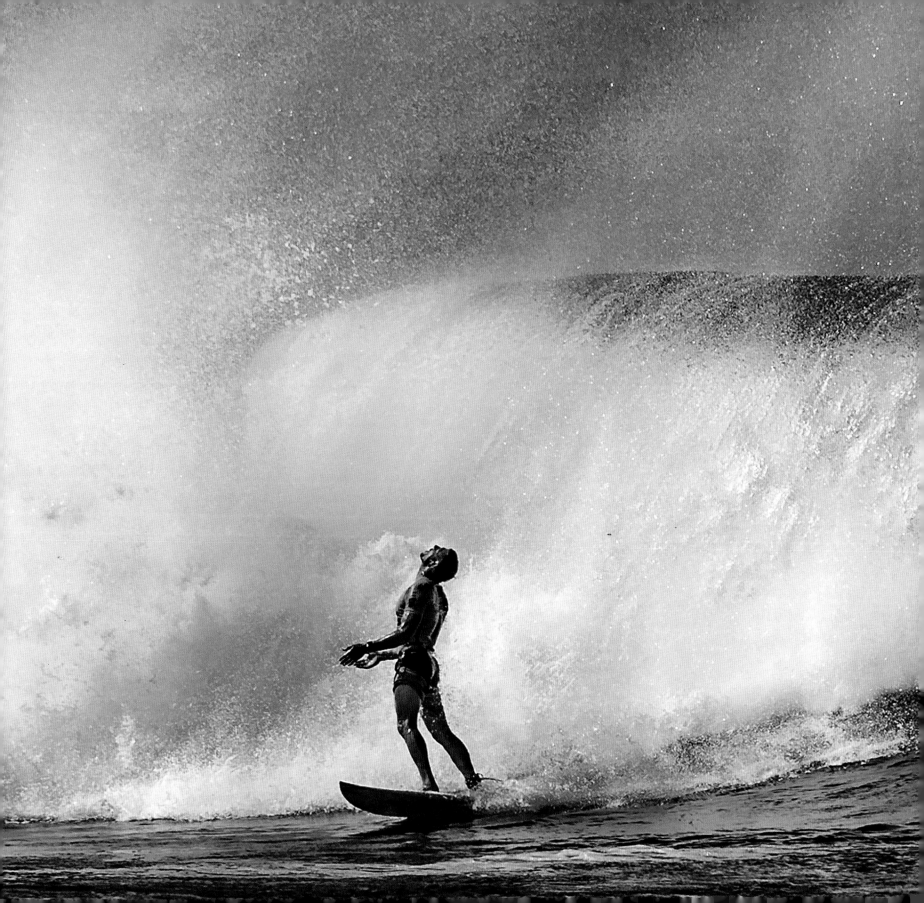

13

Stacked
ED SLOANE

Craig Anderson doing what he does
in very unique surrounds.

2016

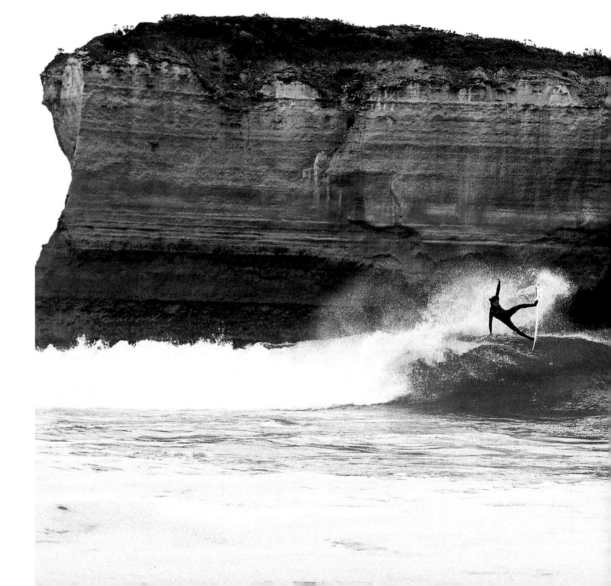

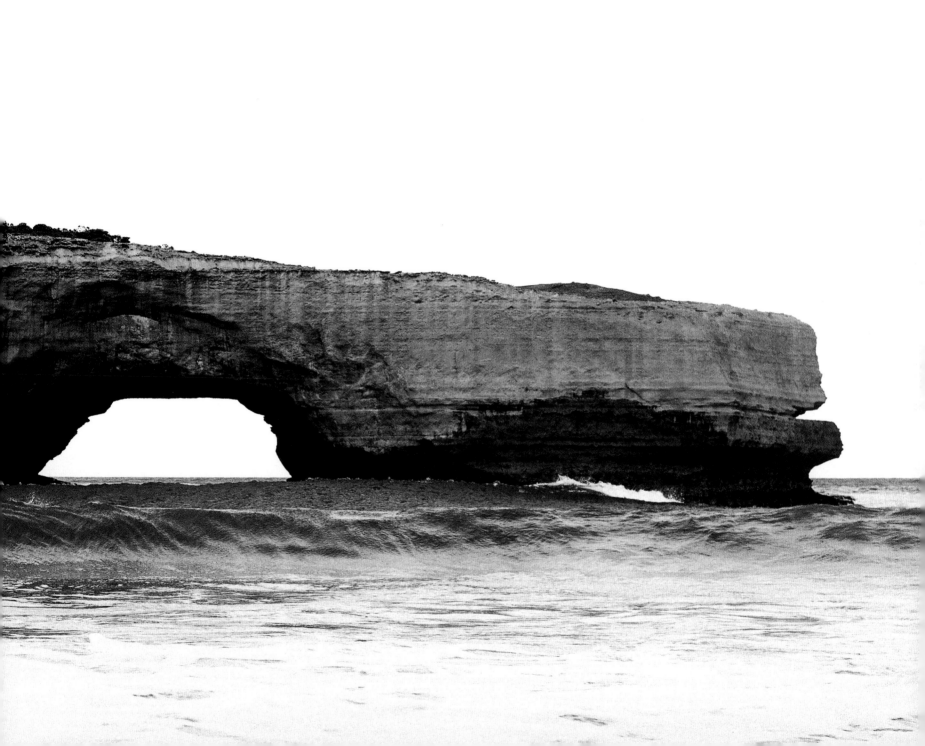

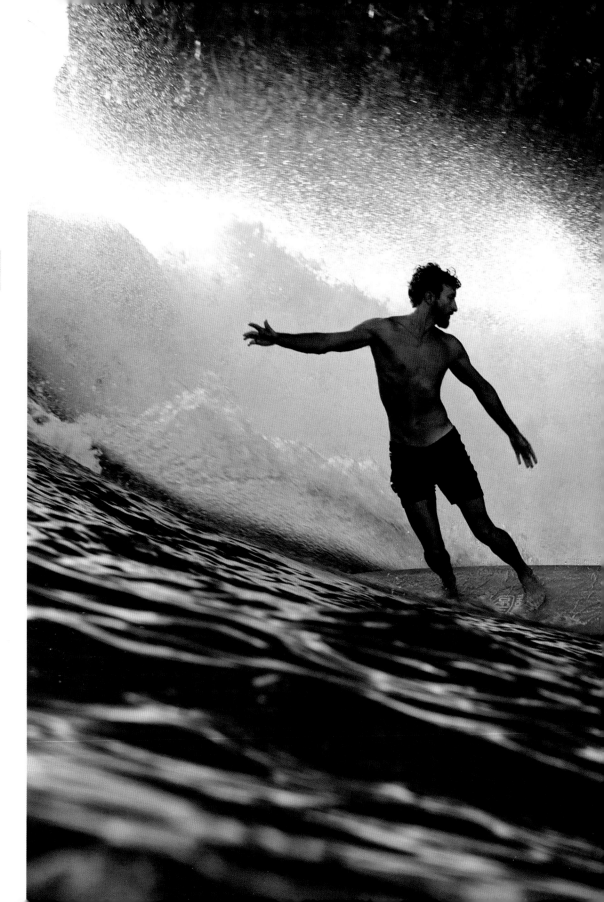

14

Batu
WOODY GOOCH

Matt Cuddihy navigating his elegant ways
through claustrophobia.

2016

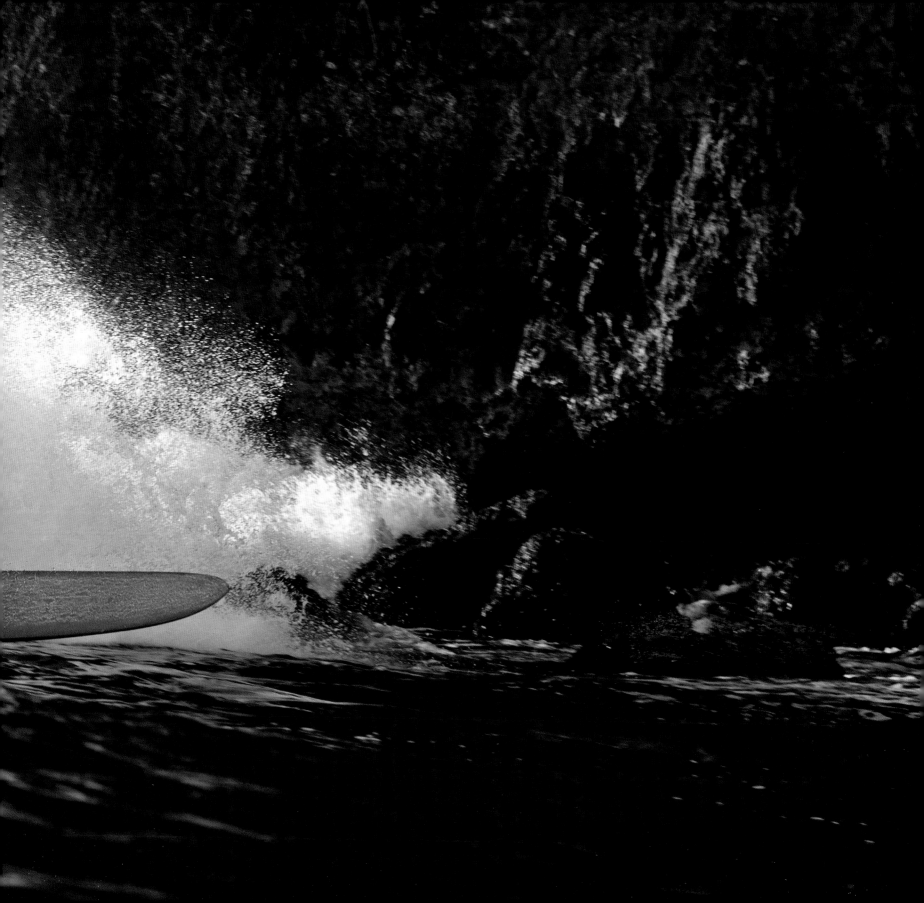

15

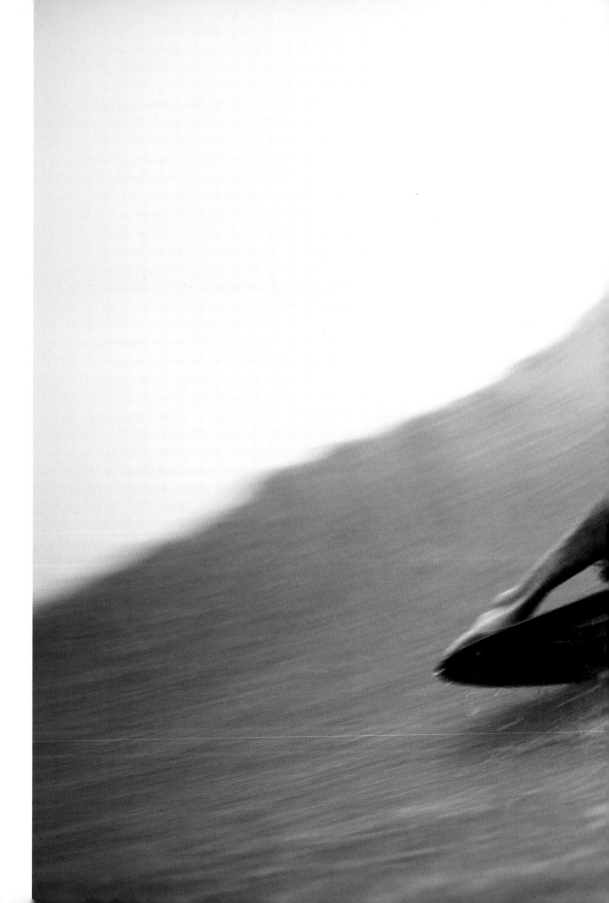

Harrison Roach, Java

WOODY GOOCH

Harrison Roach full throttle down the
Javanese highway.

2016

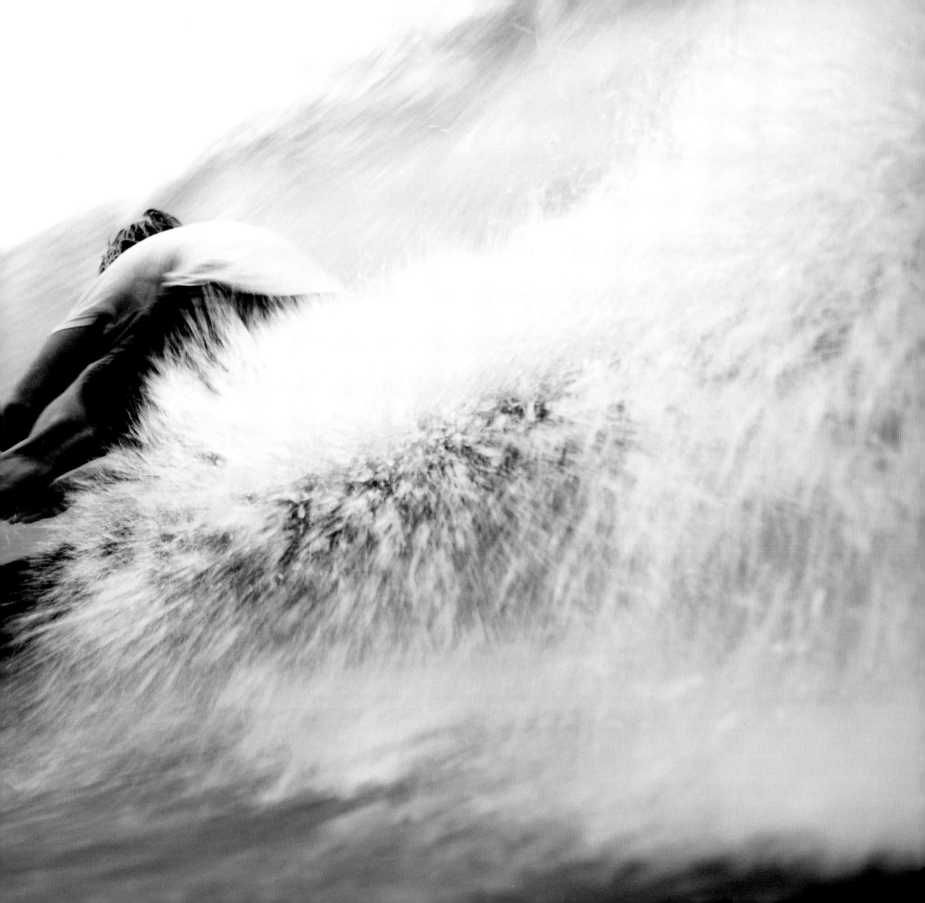

16

People Who Live in Glass Houses #2

LUKE SHADBOLT

Mikey Wright teetering on as little rail as possible in an east coast slab.

2016

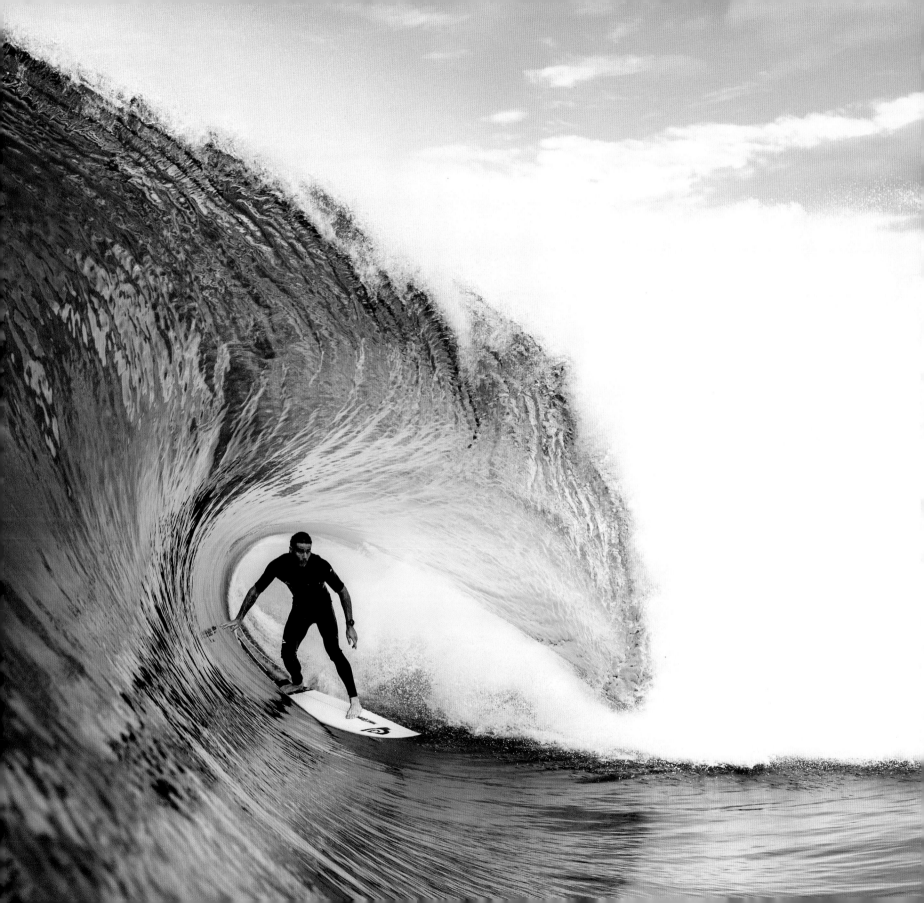

17

Monster

PHILIP THURSTON

An untameable and indescribable creature
emerging from the depths.

2016

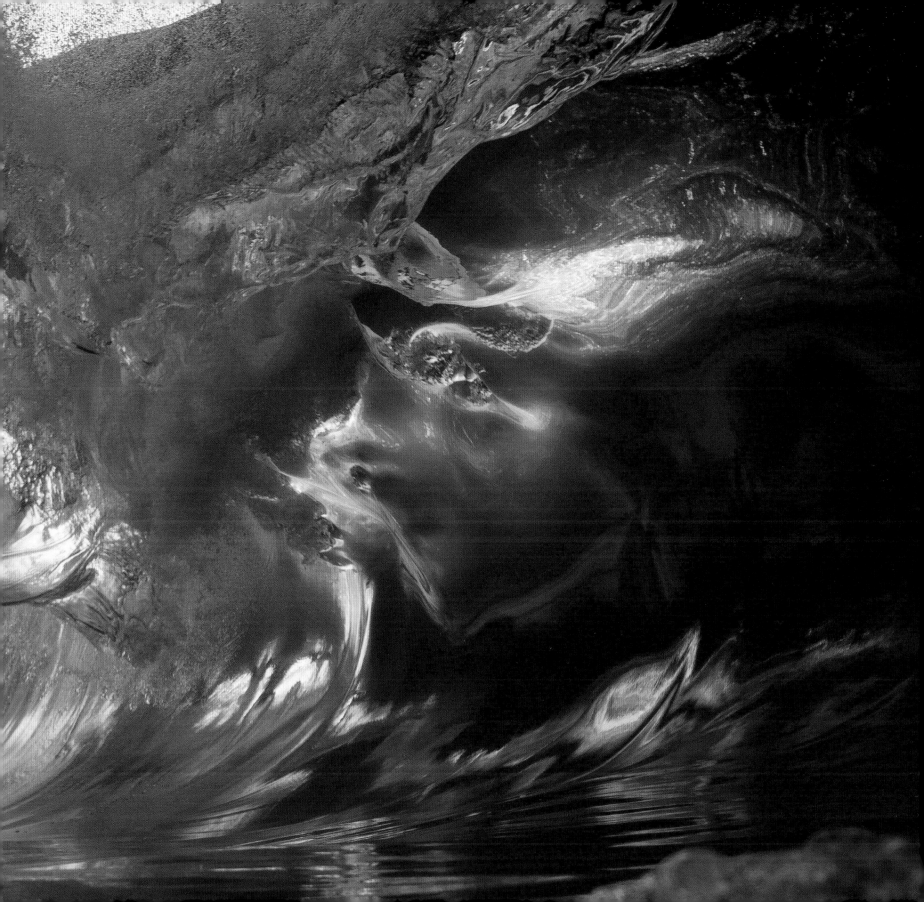

18

Ian Cosenza
WOODY GOOCH

Ian standing tall and doing it right.

2016

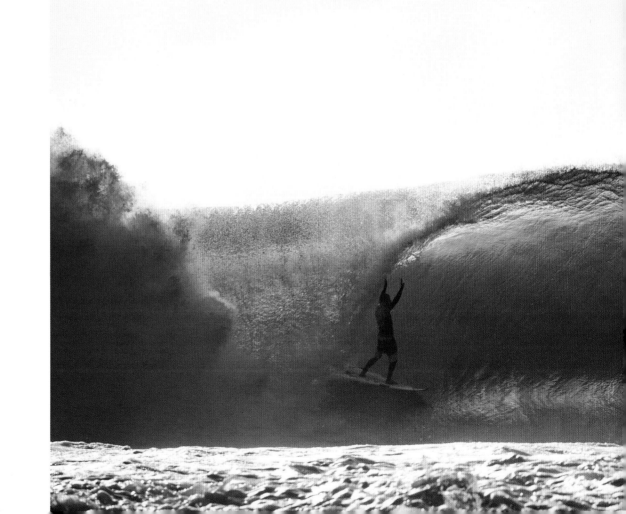

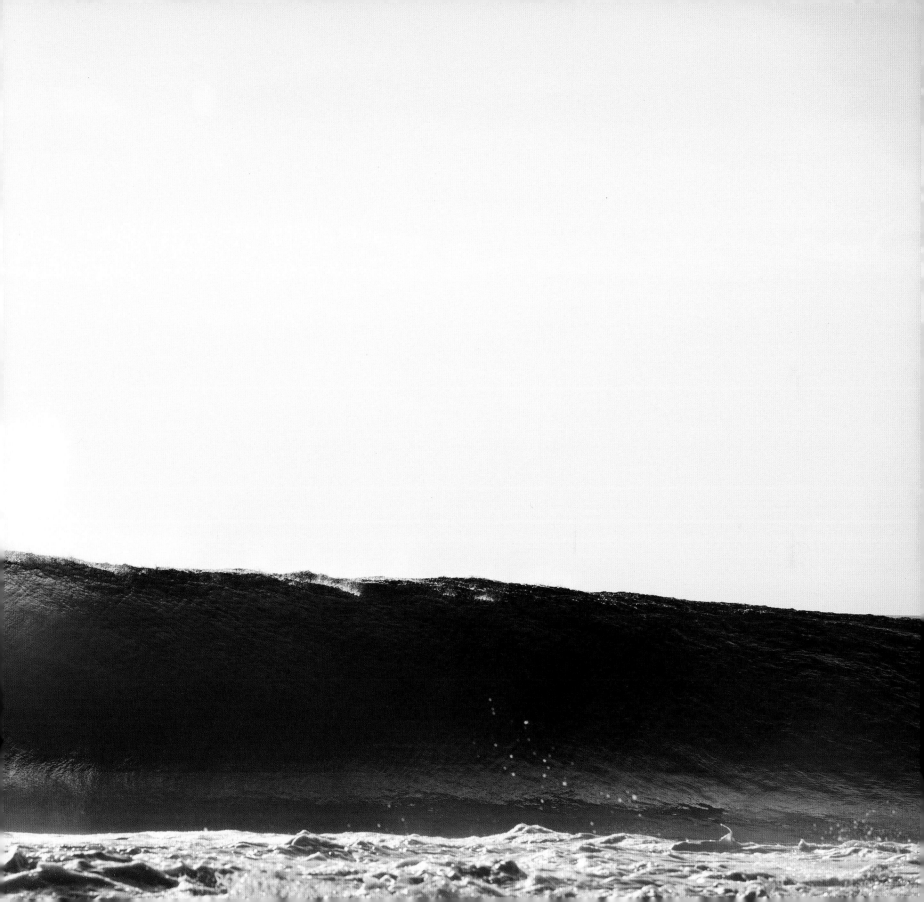

19

Spectre
LUKE SHADBOLT

Jack Robinson emerges from a shroud of spit from Teahupo'o. Jack's uncanny ability and relaxed approach to these waves was nothing short of ridiculous.

2016

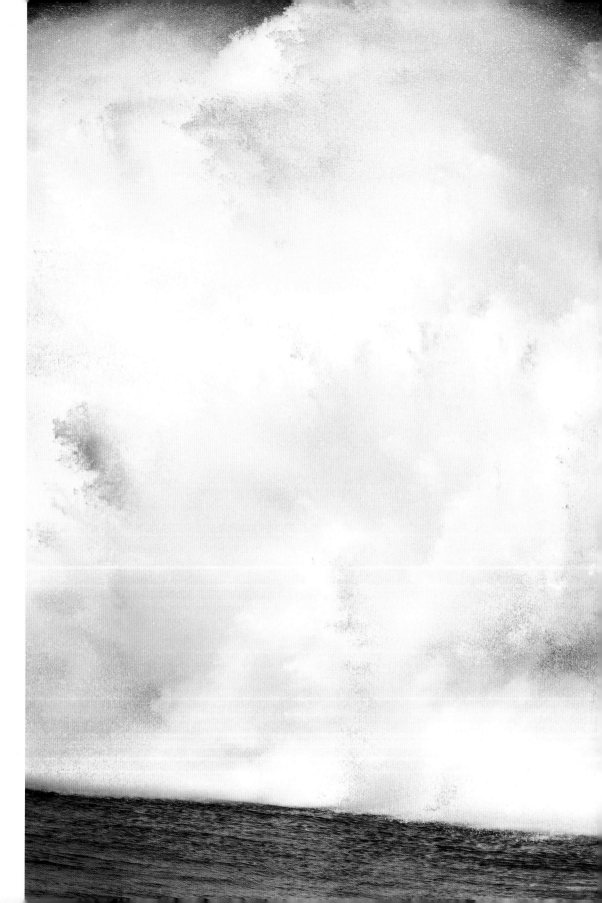

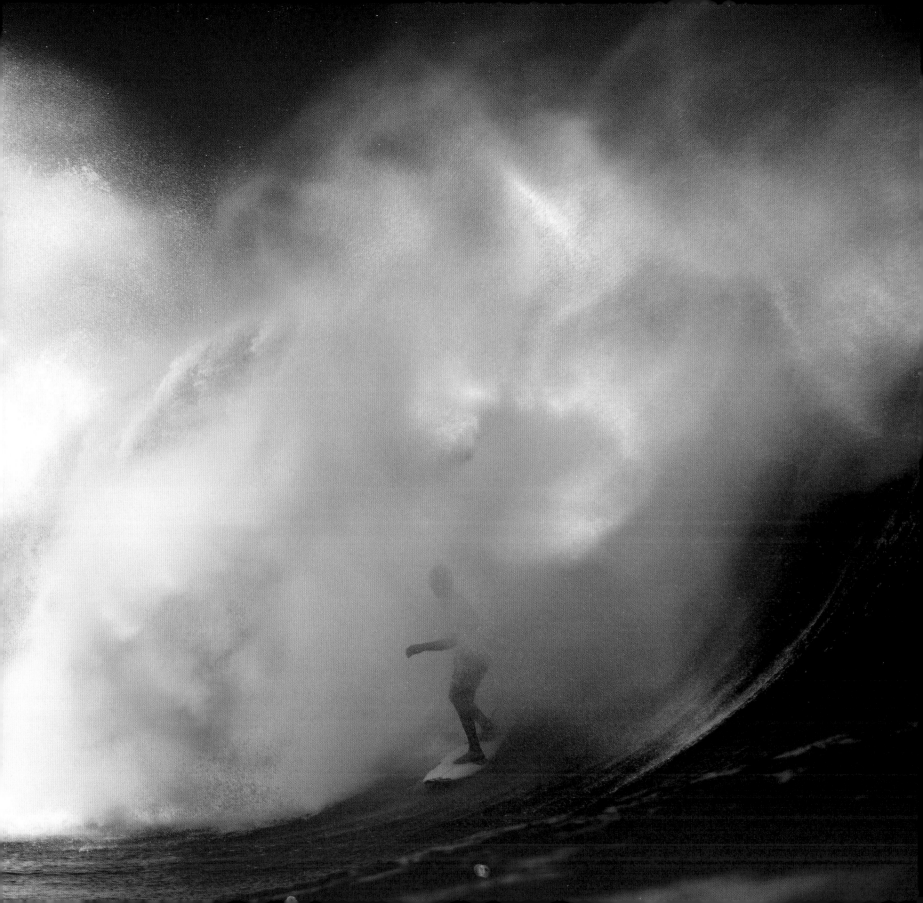

20

The End of the Earth

ED SLOANE

Peaking bliss on a remote stretch of
Southern Australia.

2016

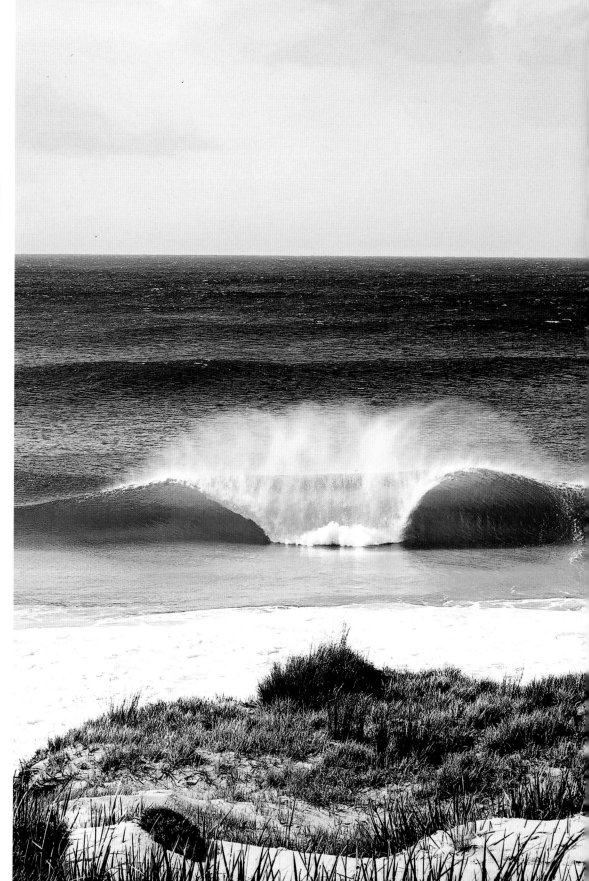

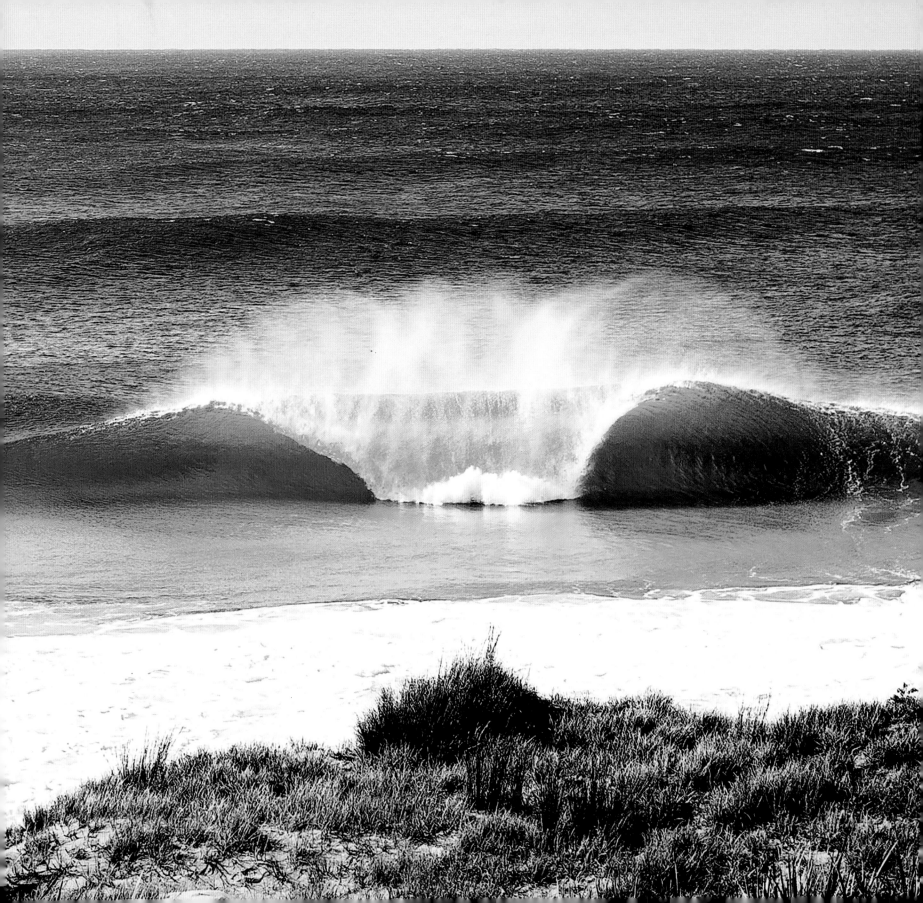

1

Convection
RAY COLLINS

The force of a breaking wave on this
particular spot's busiest day of the year.
Observed from a helicopter.

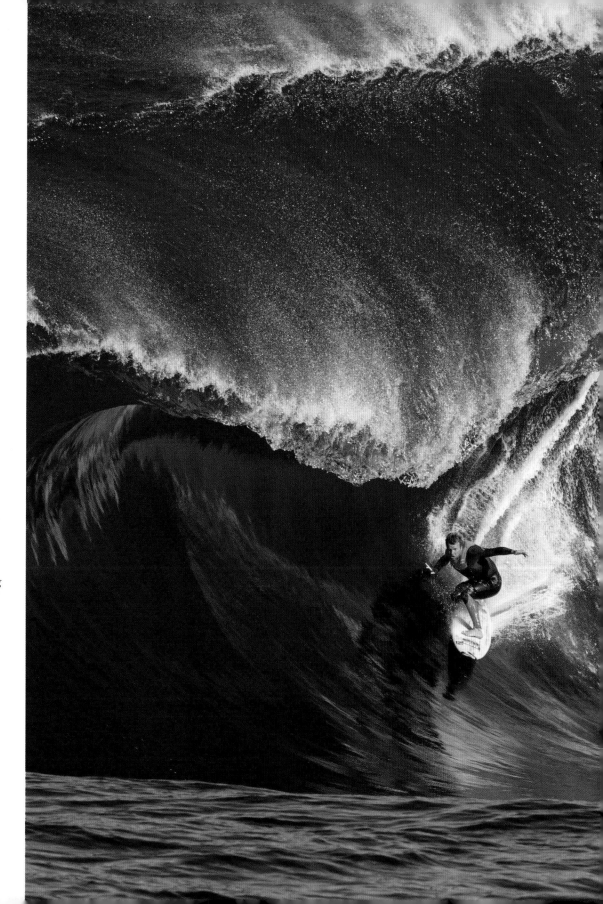

2

Double Up
RUSSELL ORD

Taj Burrow and Mark Mathews: caring is sharing
even in extreme circumstances, probably one of
the craziest moments of 2014.

2015

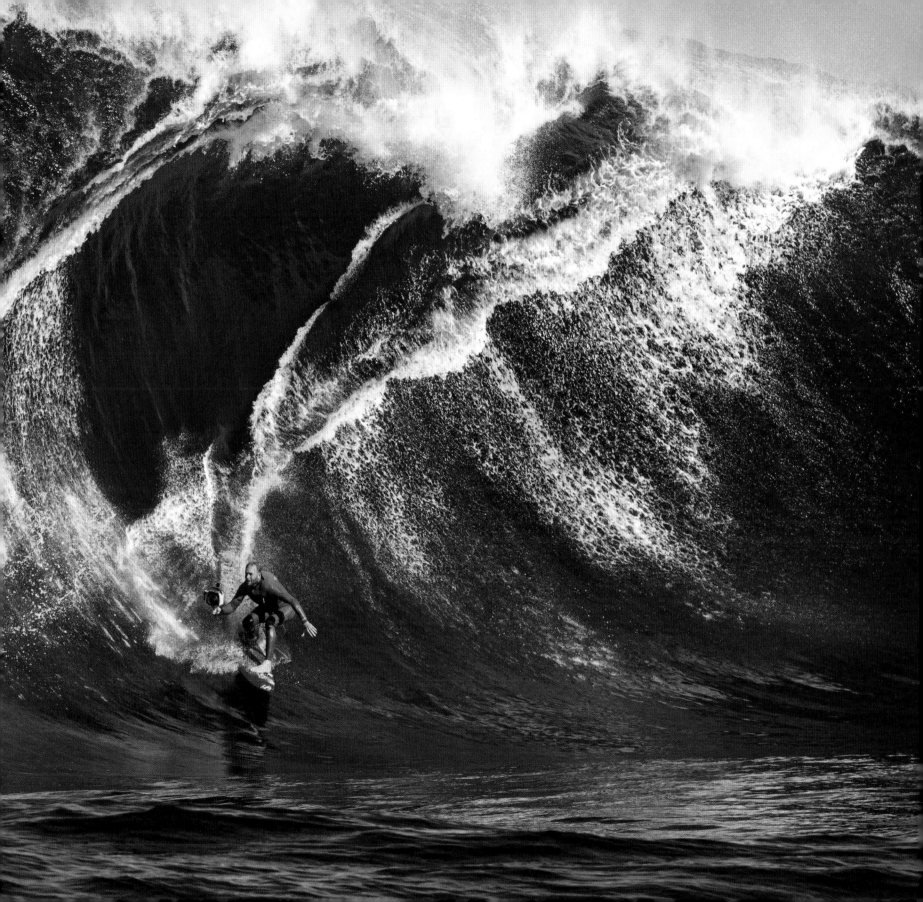

3

Summer Rain

JACK DEKORT

Shot during a tropical downpour at
Noosa Heads.

2015

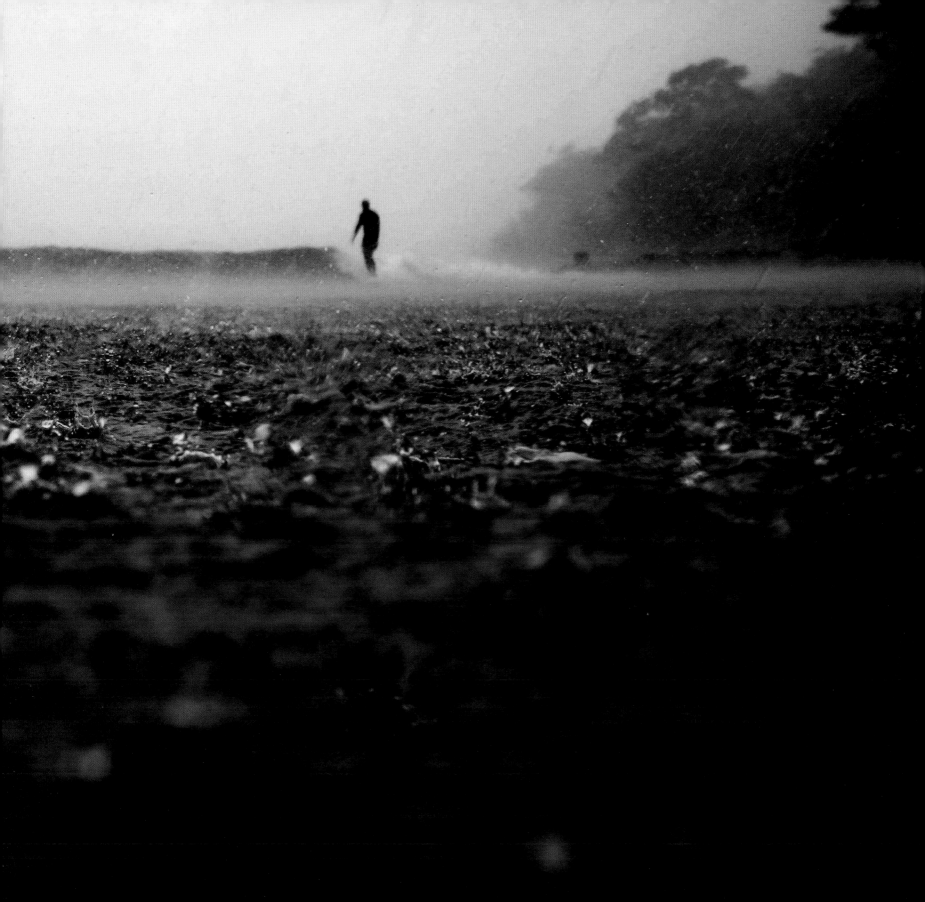

4

Kirra Line Up
PETER JOLI WILSON

A classic Kirra line-up shot during a four-day
run of swell in late August. Conditions at times
were flawless, but judging by the cloud build-up
over Surfers Paradise they might not have stayed
that way for long.

2015

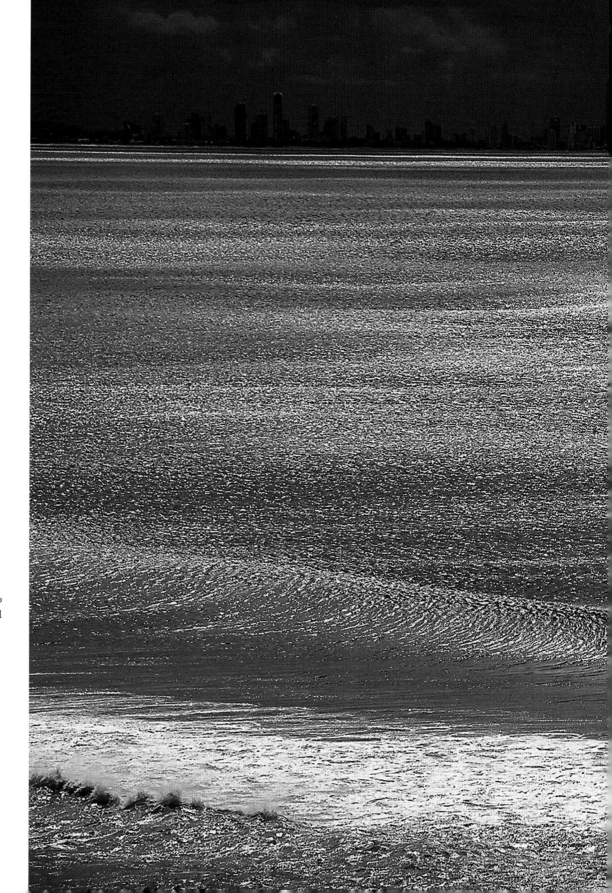

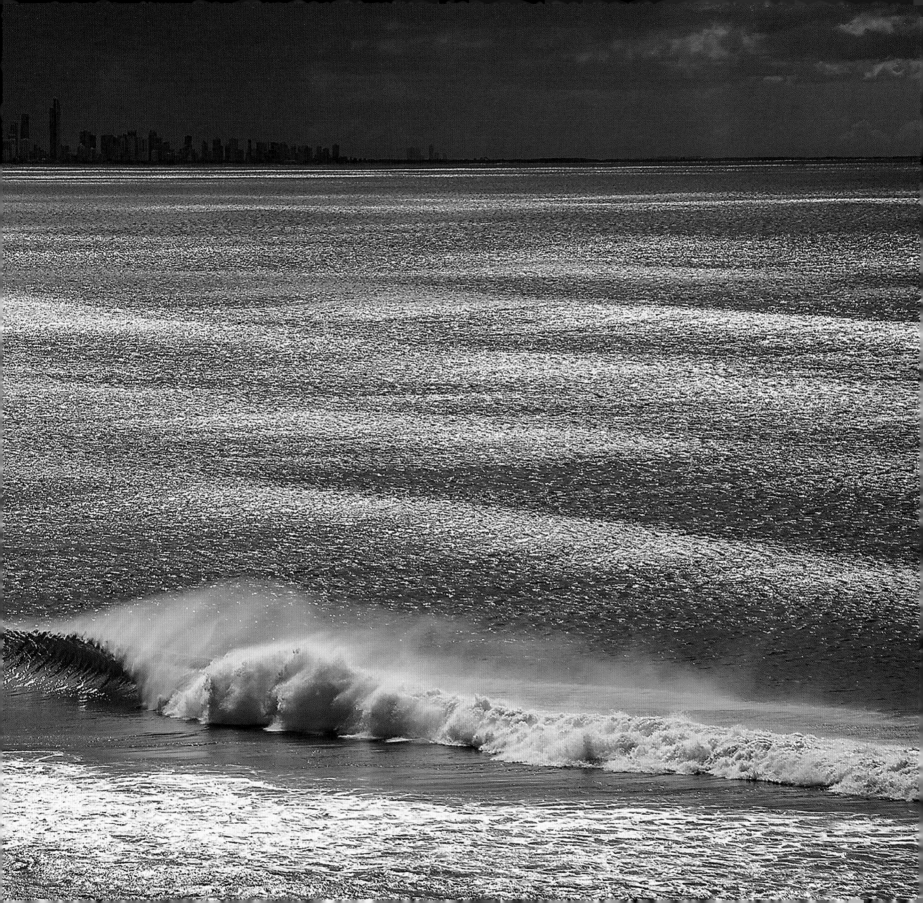

5

Matahi Madness 2
TED GRAMBEAU

Matahi Drollet, at the tender age of 16, is towed
in to one of the most perfect waves of the season
by his brother Manoa, who is one of the most
respected surfers ever at Teahupo'o in Tahiti.

2015

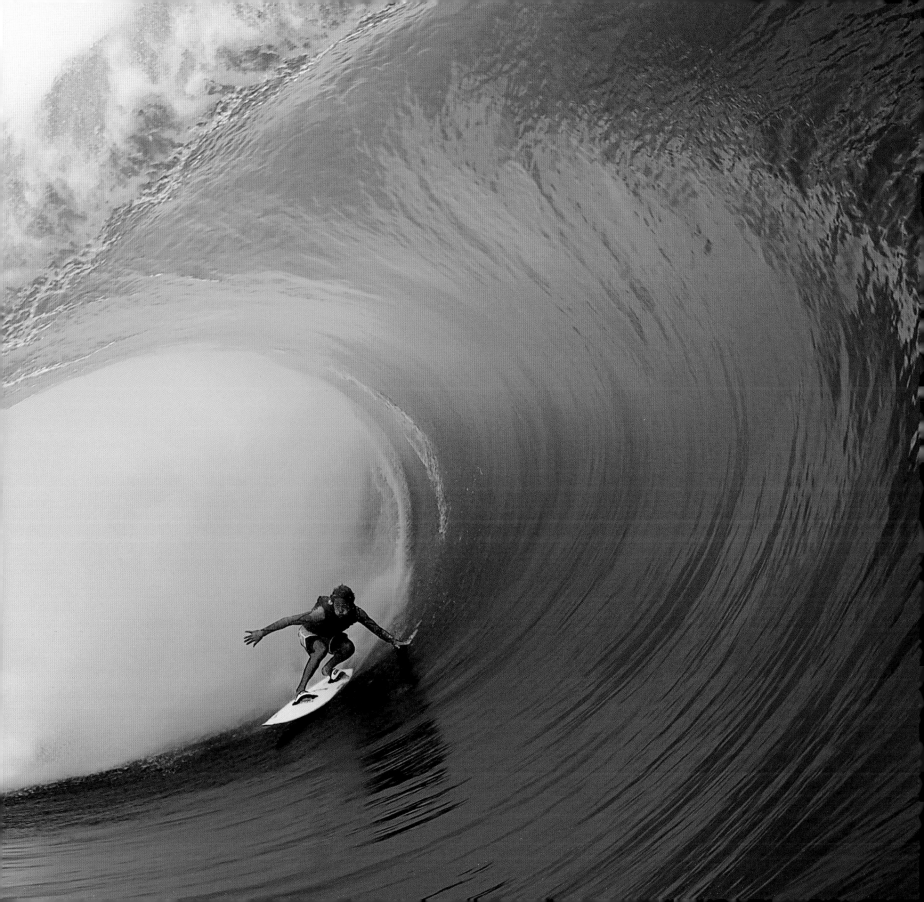

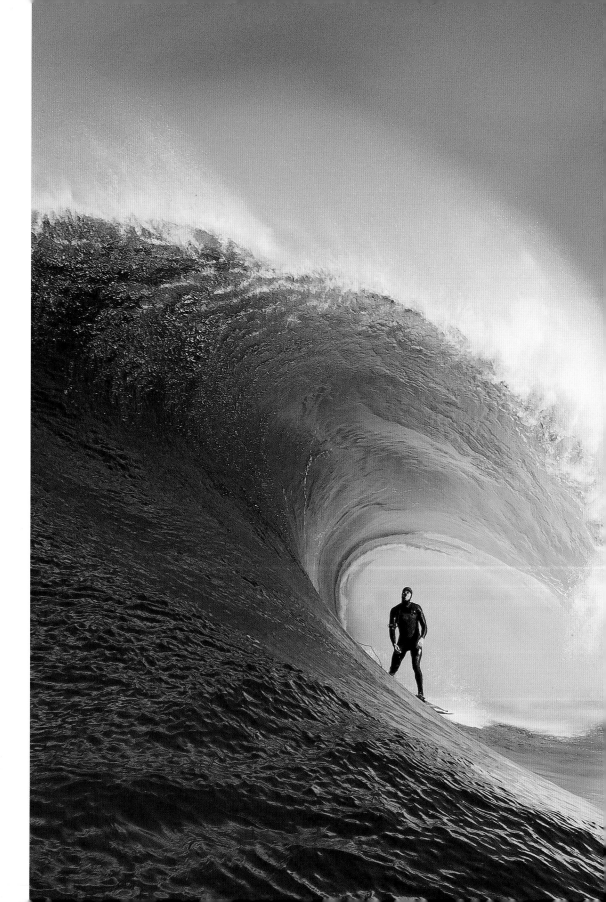

6

Giant Among Giants

ANDREW CHISHOLM

Everything about Shipstern Bluff is big,
from the waves to the cliffs and rocks to the
giant six-foot-five Tyler Hollmer-Cross,
who loves to stand tall in massive barrels.

2015

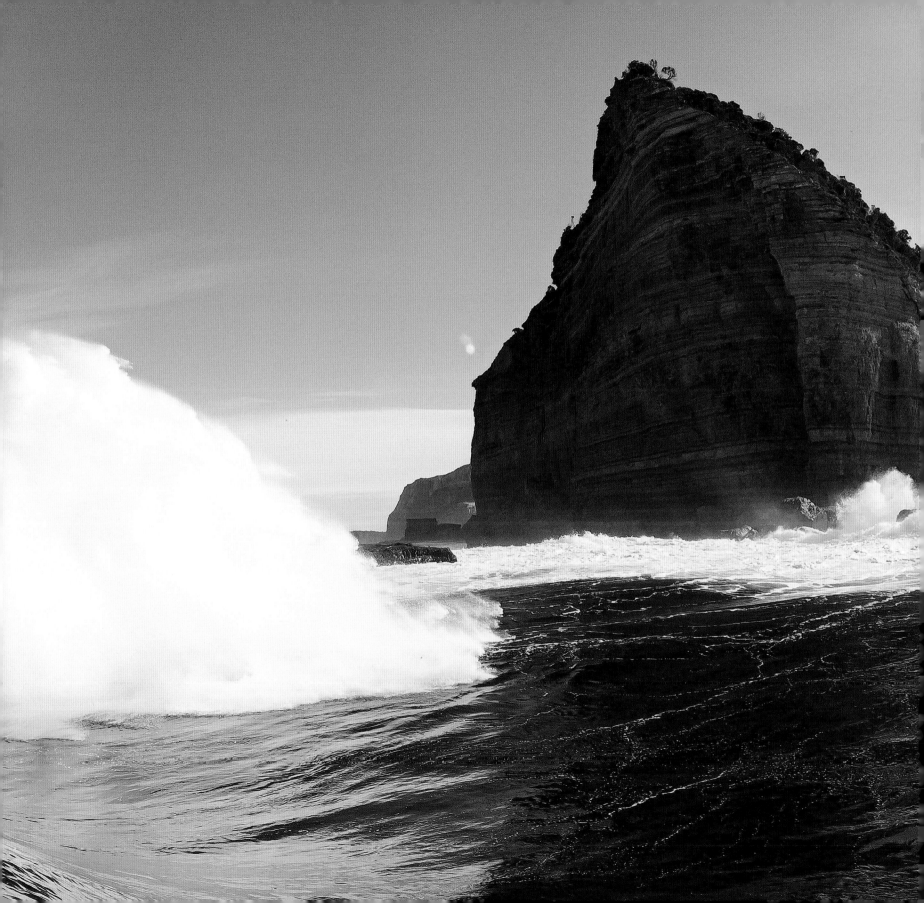

7

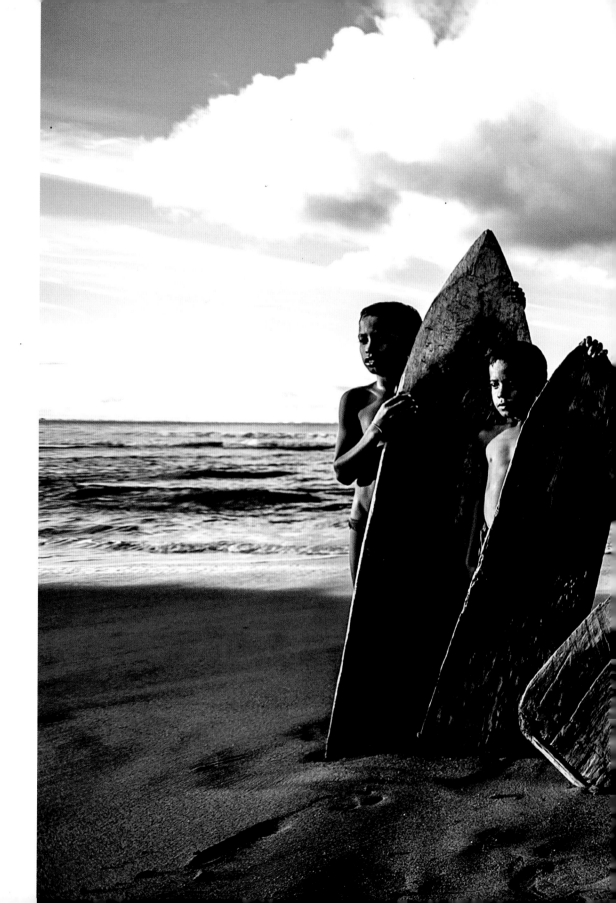

Wooden Boards 01
JASON CHILDS

Kids on a remote island in Indonesia surf
only wooden surfboards. The Pacific Ocean,
somewhere in Indonesia.

2015

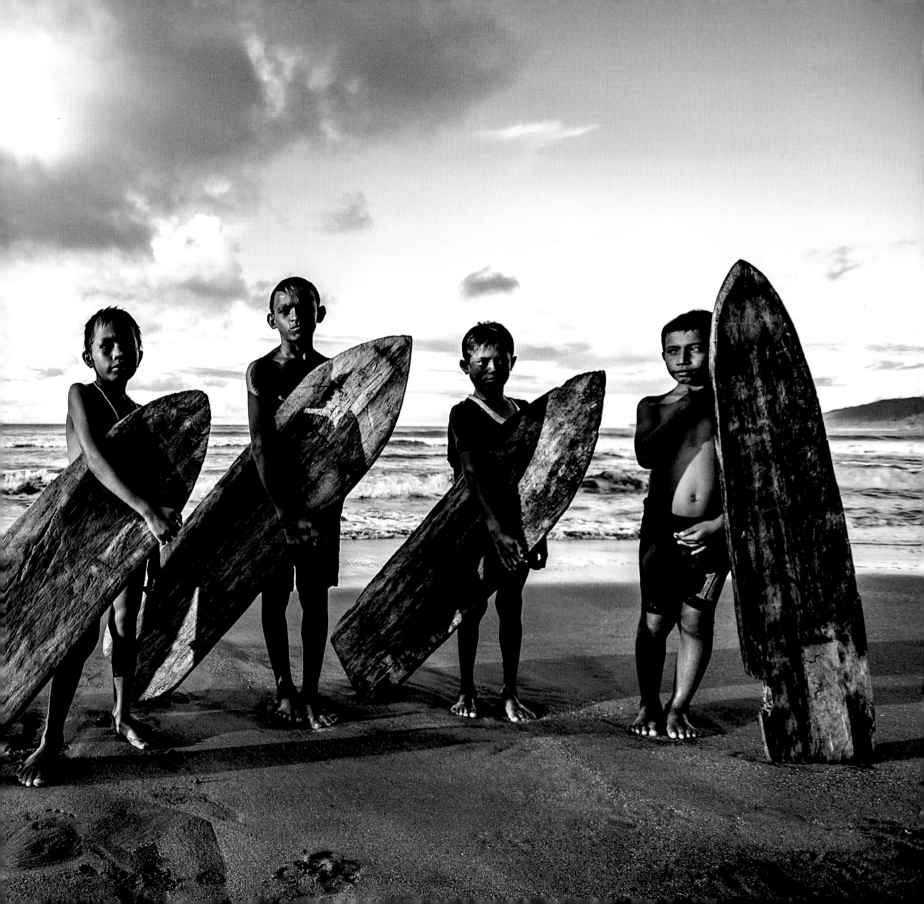

8

Avalanche
RAY COLLINS

Unknown surfer experiencing the fight or
flight moment as a waterfall prepares to land
on his person.

2015

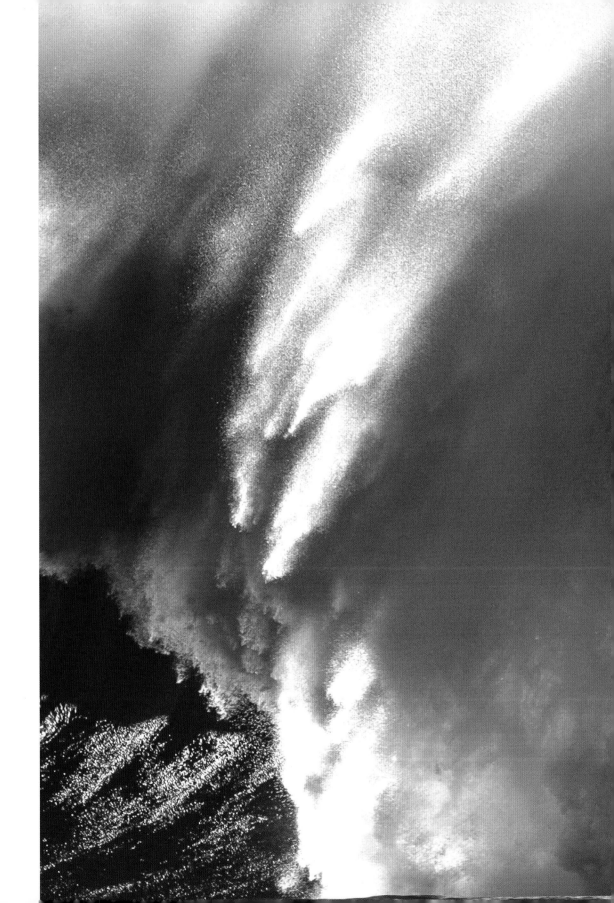

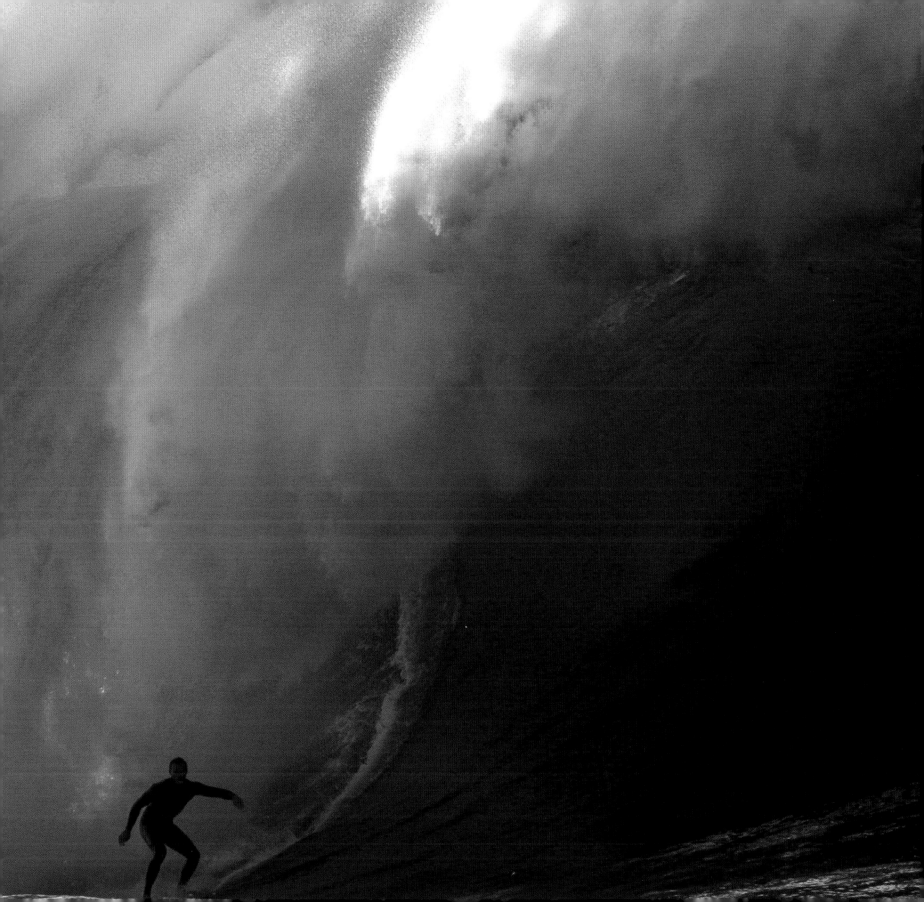

9

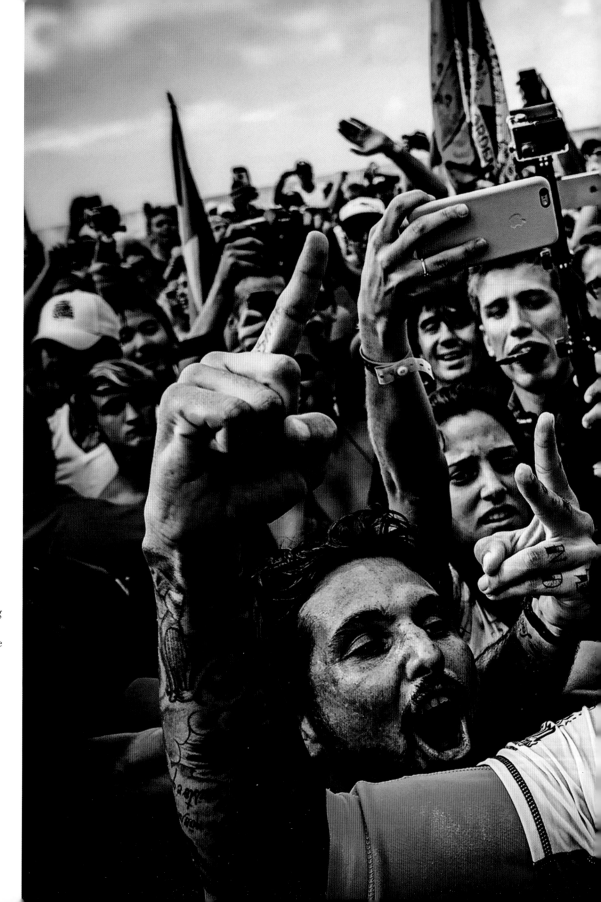

Gabriel Medina
PETER JOLI WILSON

In late December 2014, Gabriel Medina
equalled Kelly Slater's record for the youngest
surfer ever to win the World Professional Surfing
Title. He was also the first Brazilian surfer to do
it and was surrounded by adoring fans as he came
up the beach. The pressure and emotion shows
as Gabriel lets out a primal scream.

2015

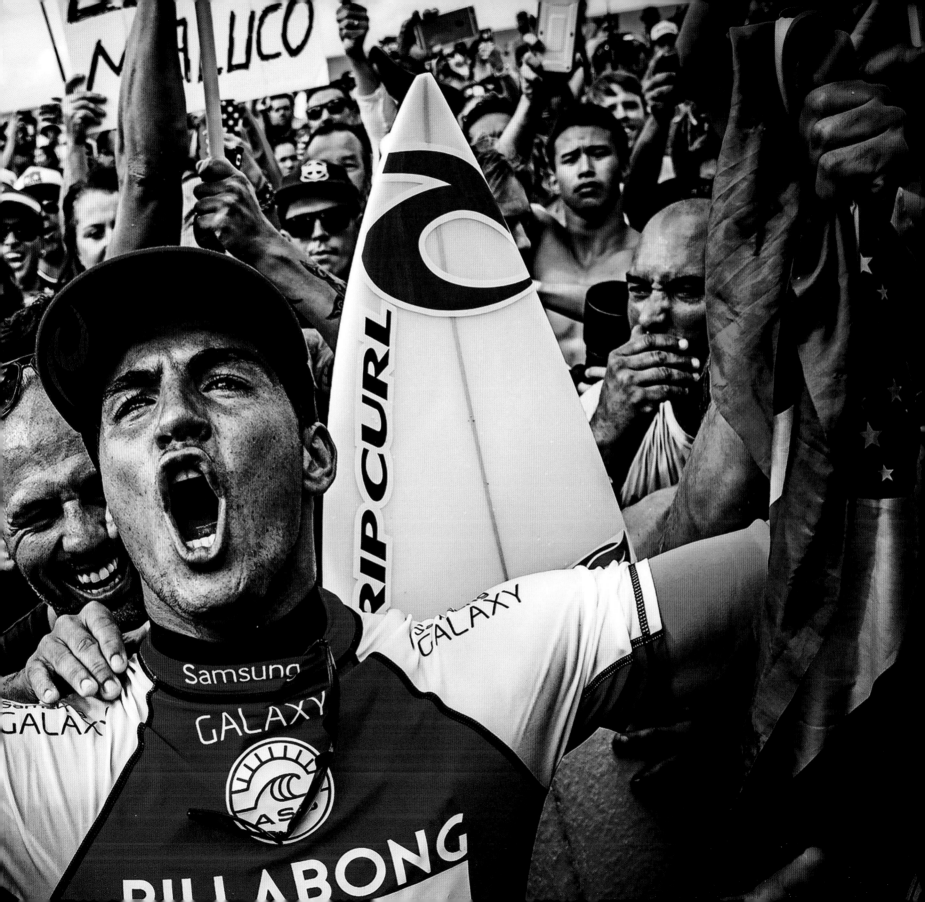

10

Nightmare

STU GIBSON

I'm not good enough with words for such a crazy image, but Mikey Brennan dropped down this monster, which looked 100% unfeasible, then somehow he pulled into a monster barrel, wave of the year at Shipstern Bluff.

2015

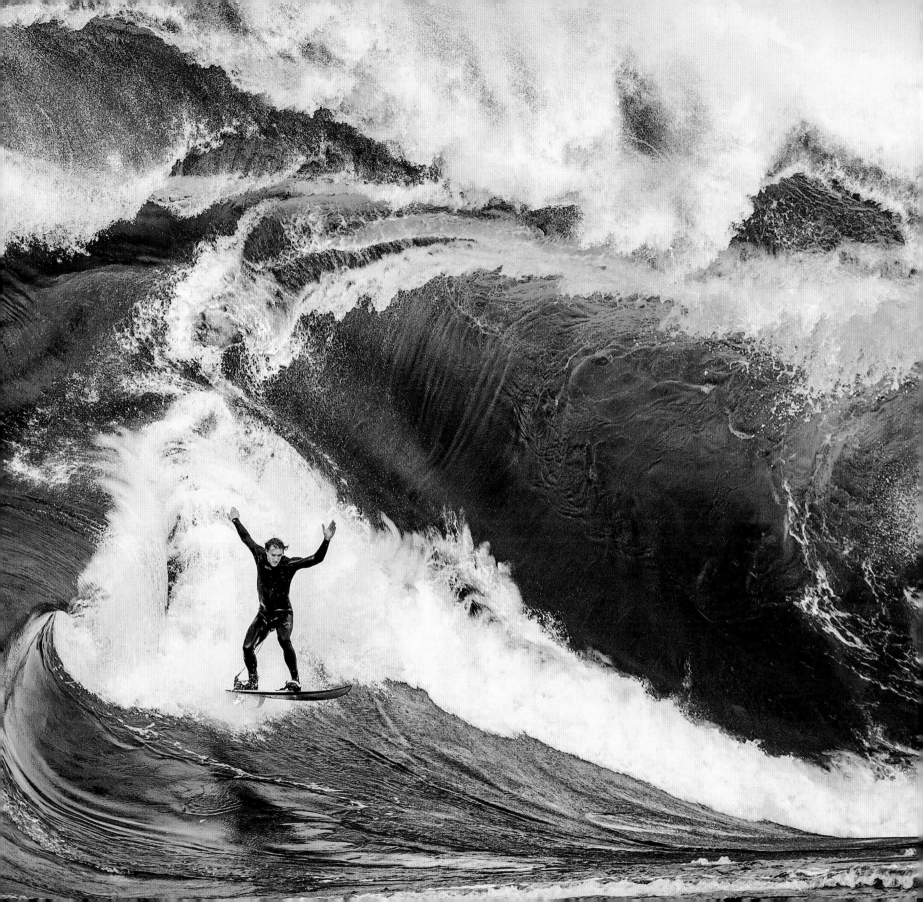

11

Sea Shell
DEB MORRIS

An early-morning shoot with this being my fifth shot of the day, I knew I had captured something special. Two waves colliding, forming this artistic seashell, only lasting for a blink of an eye. Ultimately this wave cost me my sunnies, but well worth the glare!

2015

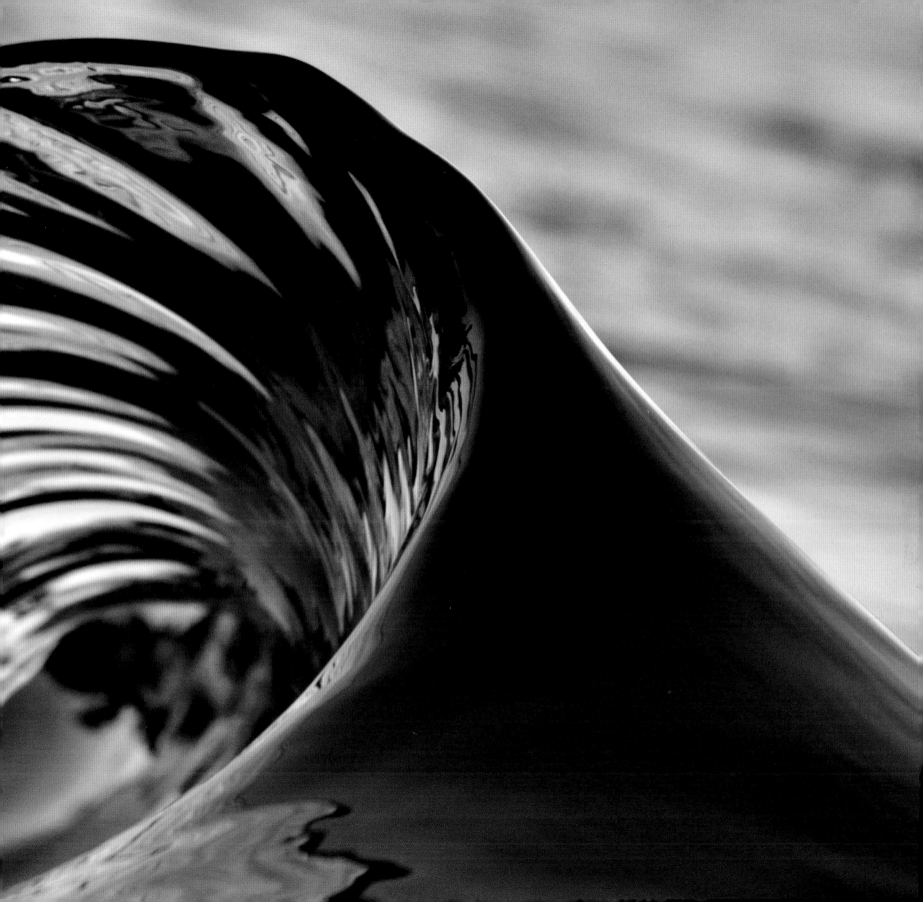

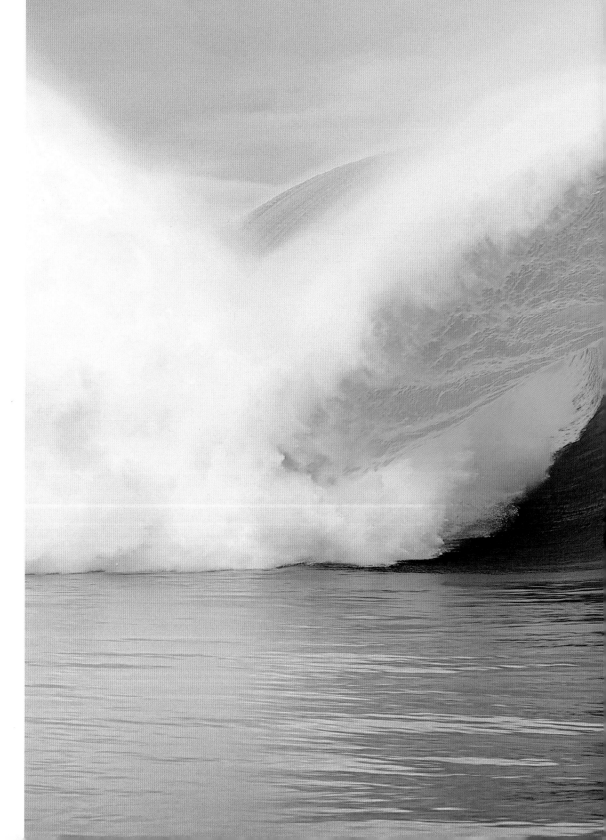

12

Matahi Madness

TED GRAMBEAU

Matahi Drollet, on one of the most
perfect waves of the season.

2015

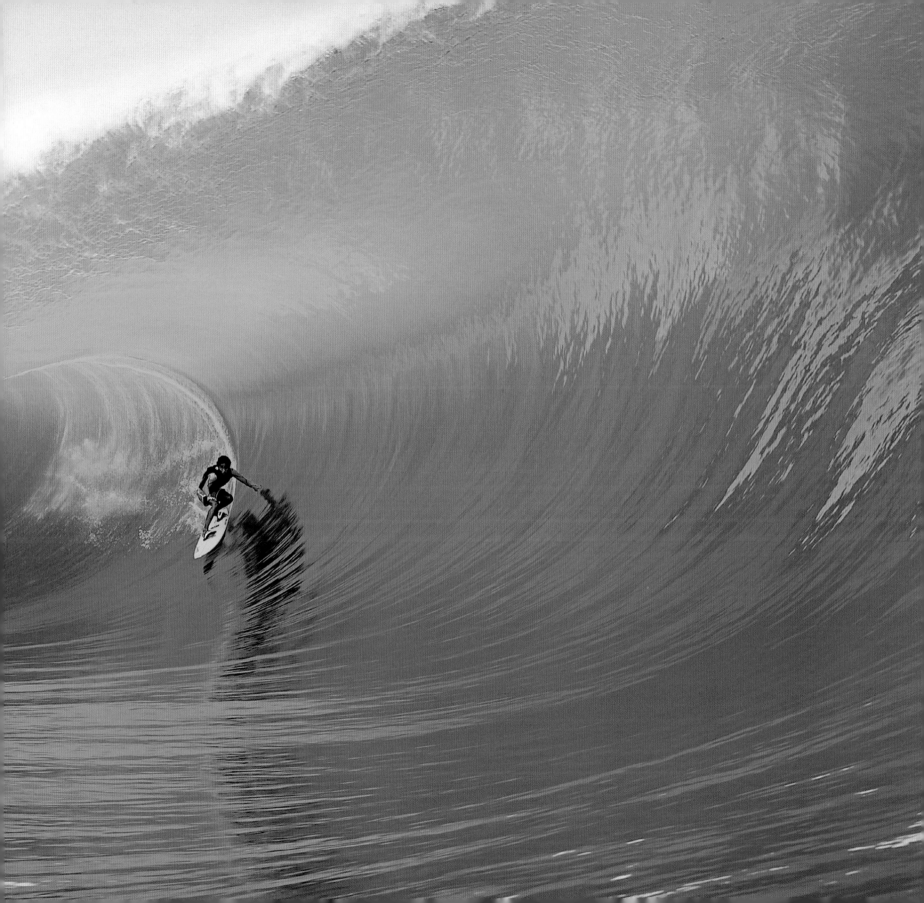

13

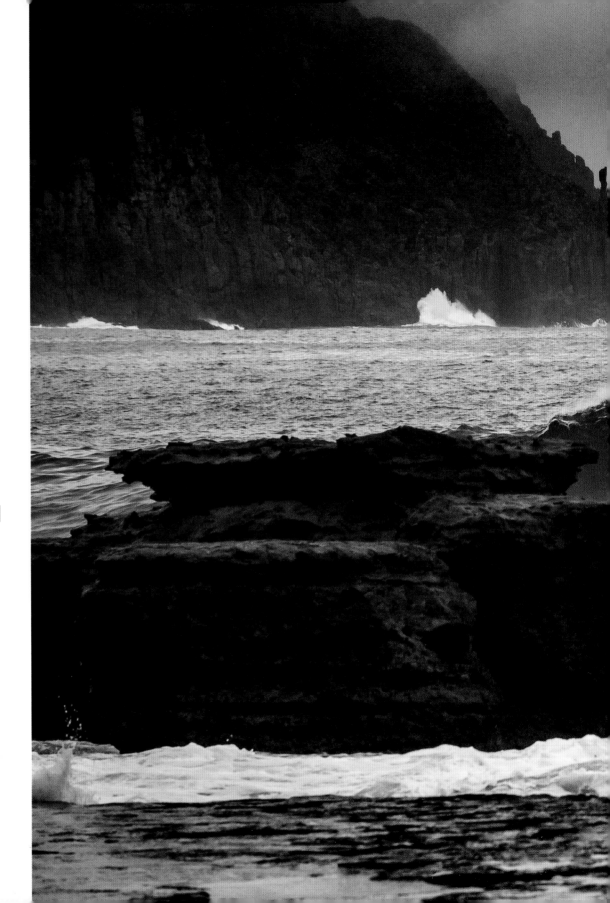

Dancing With the Devil
ANDREW CHISHOLM

He is no fool; Marti Paradisis dances where
angels fear to tread.

2015

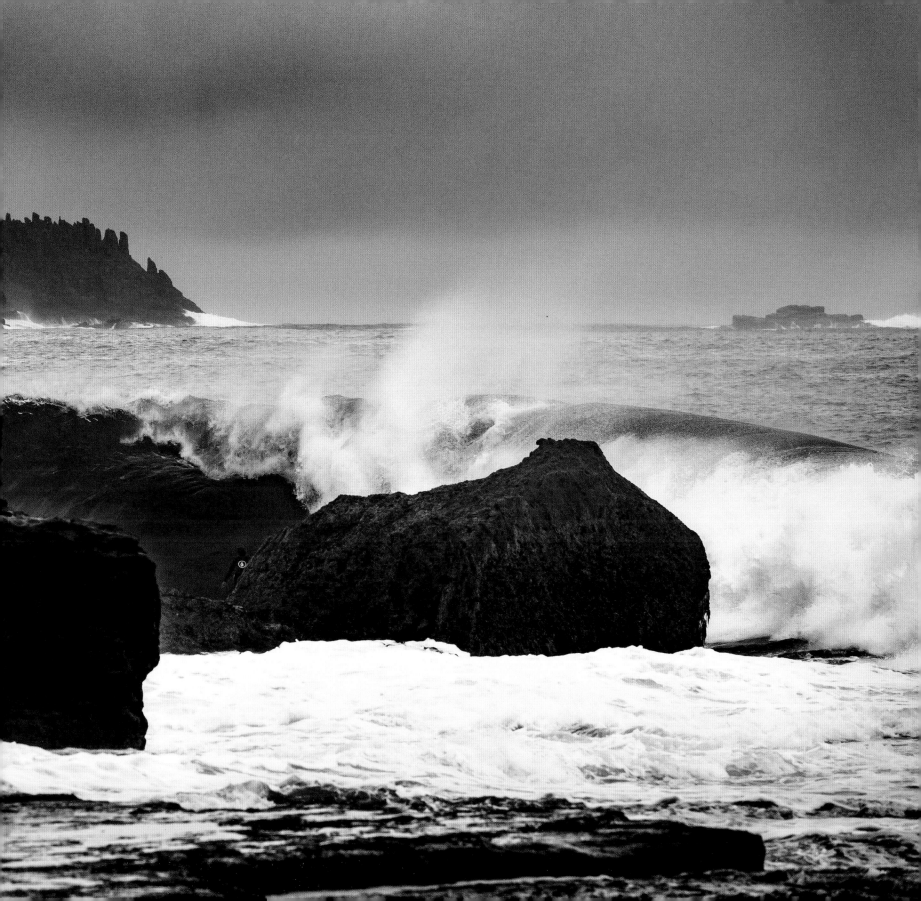

14

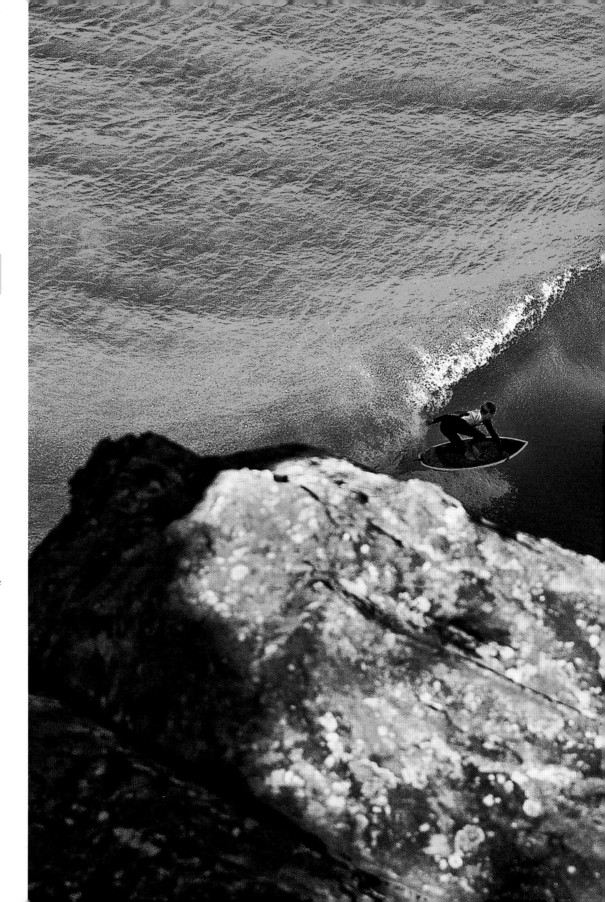

Shadows . . .
MARK ONORATI

... are cast by light. Luke Stedman turns his face towards the sun and they fall behind him.

2015

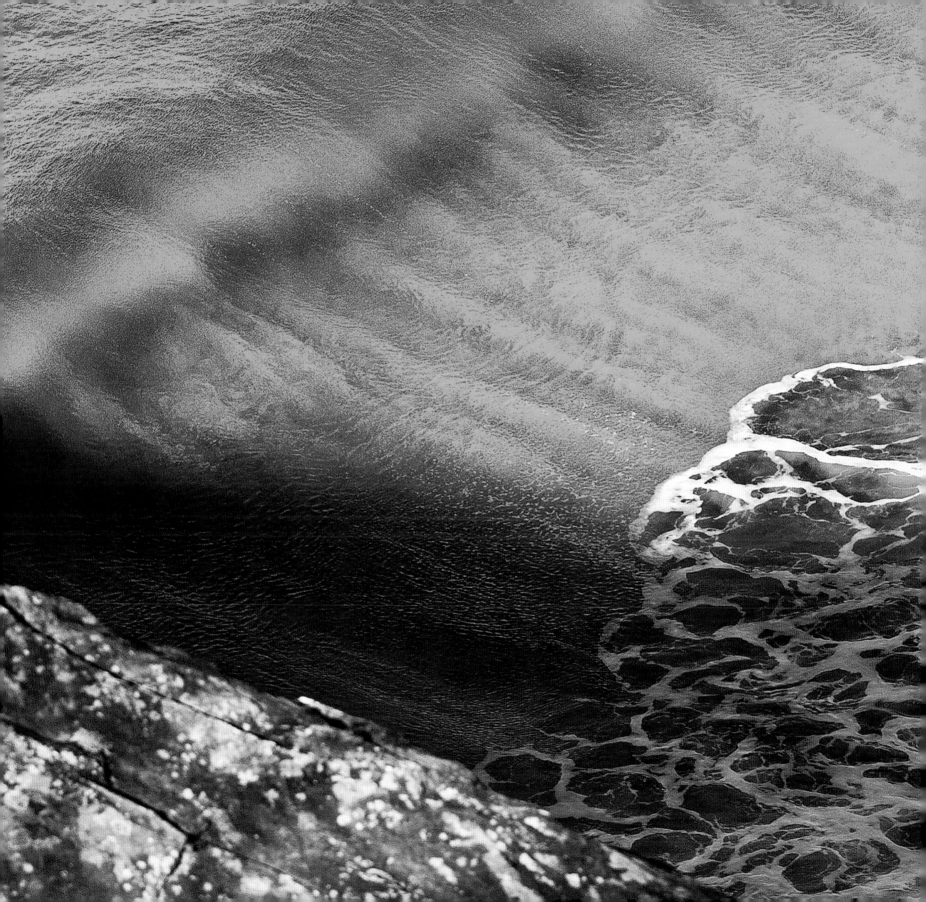

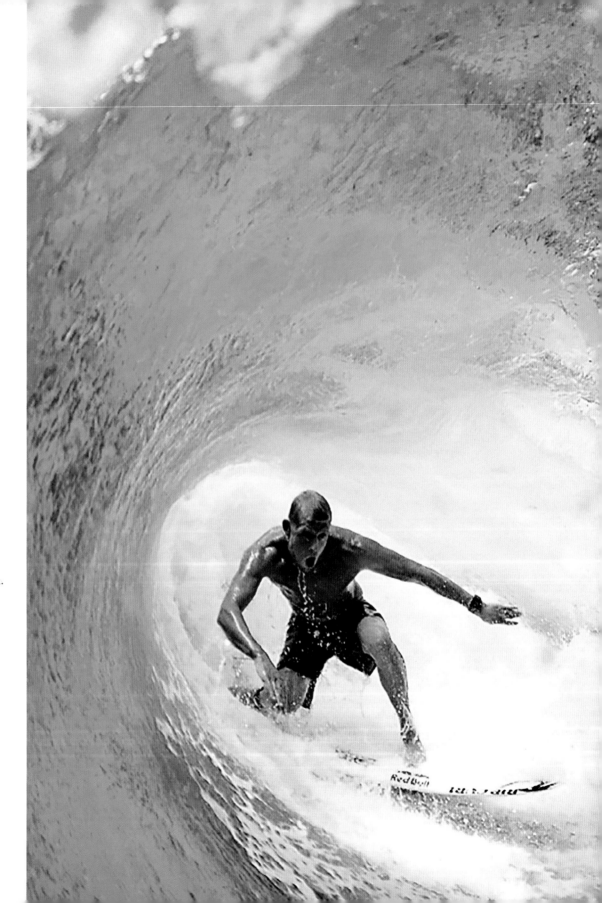

15

Mick Fanning, Oh Yeah
RYAN WILLIAMS

Mick Fanning tucks into a tube at his local break.

2015

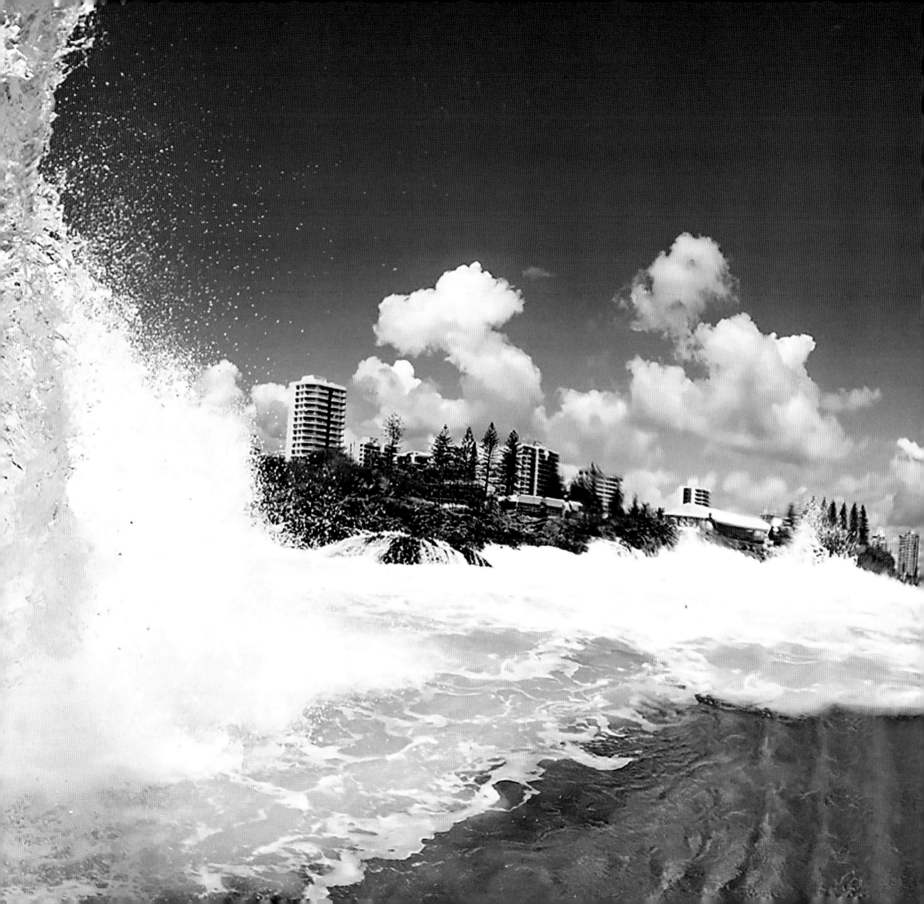

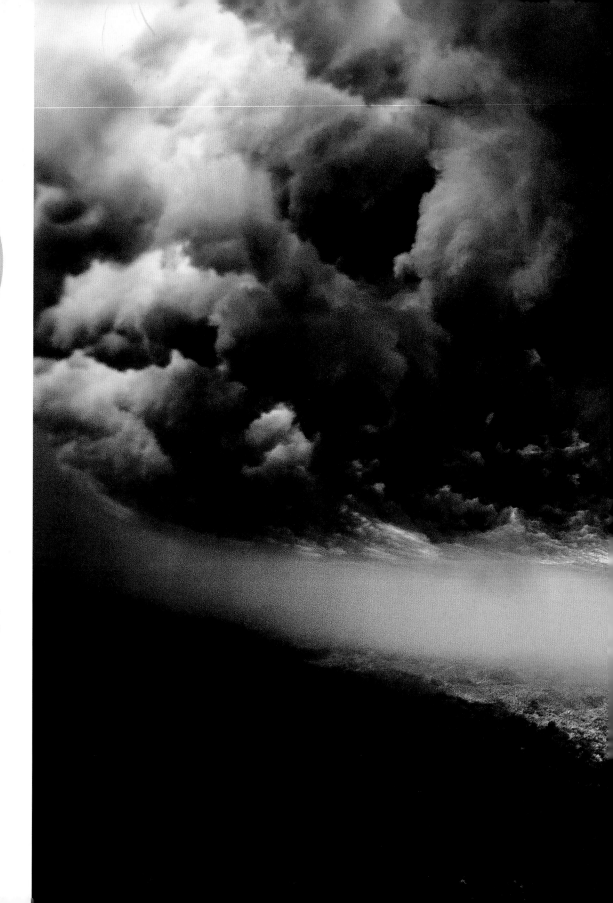

16

Desperate
STU GIBSON

Matt Stevo at a really heavy shallow wave called
Desperations, and right here he's desperate to
get under this bomb that just unloaded on our
heads! I love shooting these underwater images
showing the crazy, storm-like clouds.

2015

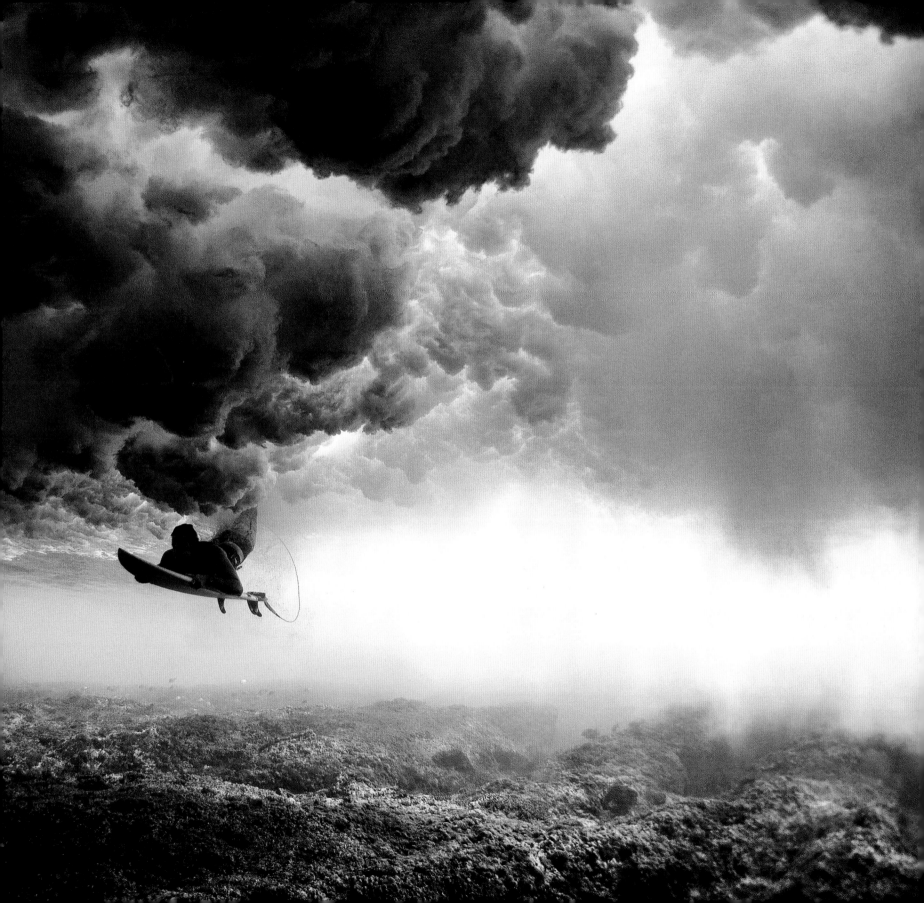

17

Mick Fanning.
Somewhere, Indonesia
TRENT MITCHELL

A forgotten moment of Mick's during
back-to-back days of mindless travel in
search of the perfect warm-water wave.

2015

18

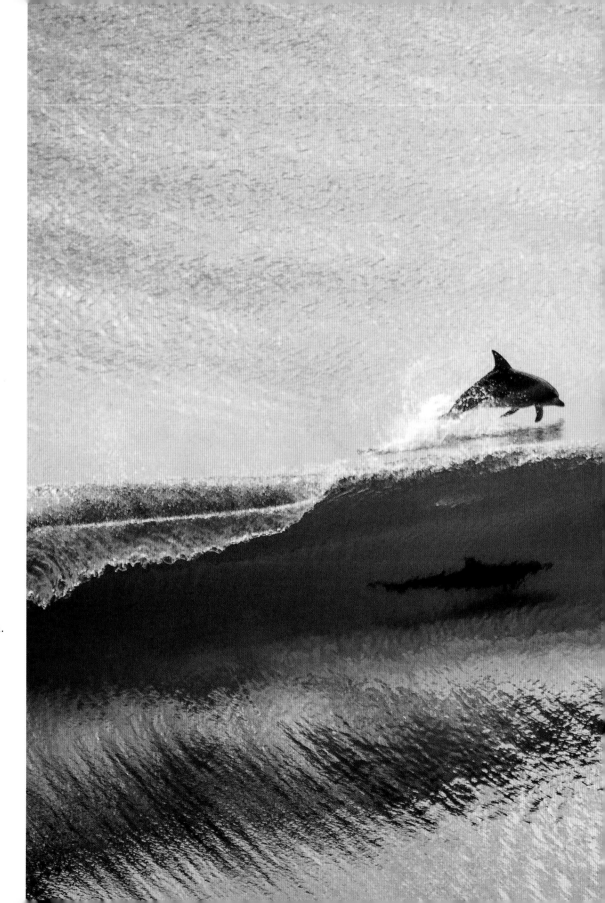

Your Curve
BRODIE McCABE

These two dolphins were playing out in the deeper ocean for some time. As a set of waves came through, they followed the swell towards the shore, racing each other for the key position. As the wave started breaking, one pulled off the back so as not to 'drop in' on the other.

2015

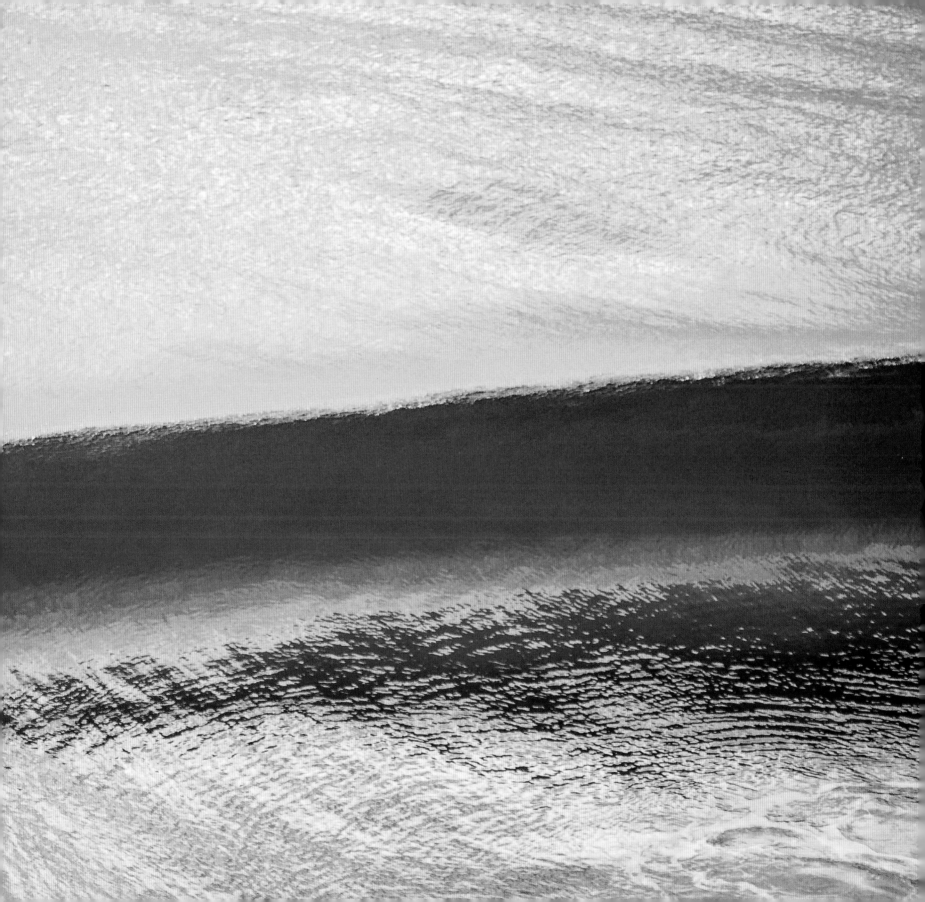

19

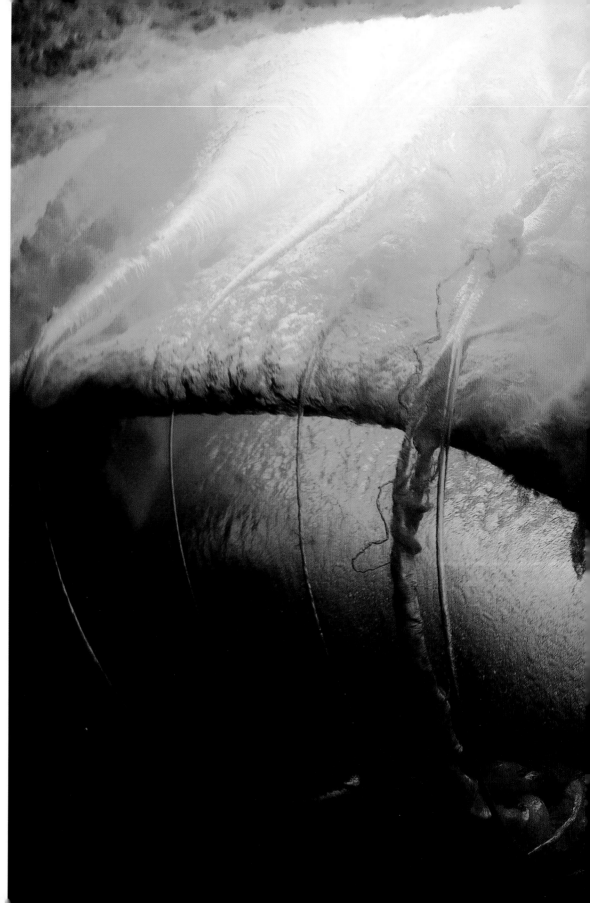

Aqua Helix
ED SLOANE

The beauty of these rings belies their raw power.

2015

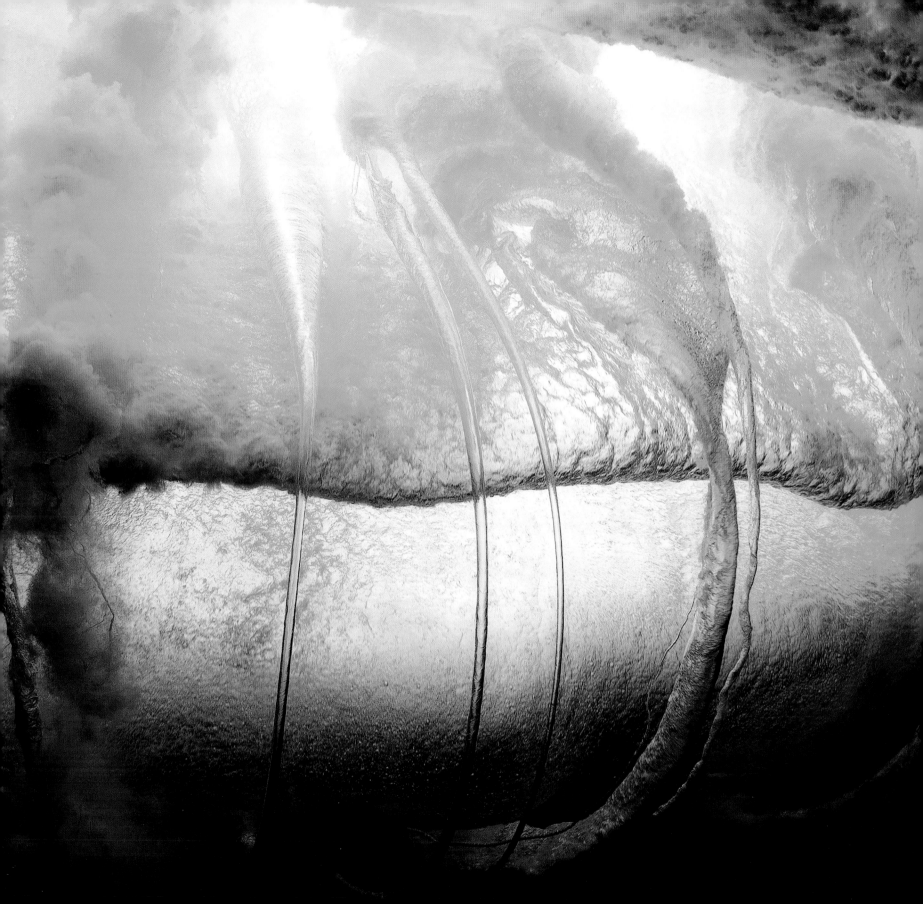

20

Happy Chip

SIMON WILLIAMS

Chippa Wilson in the pit in Indo.

2015

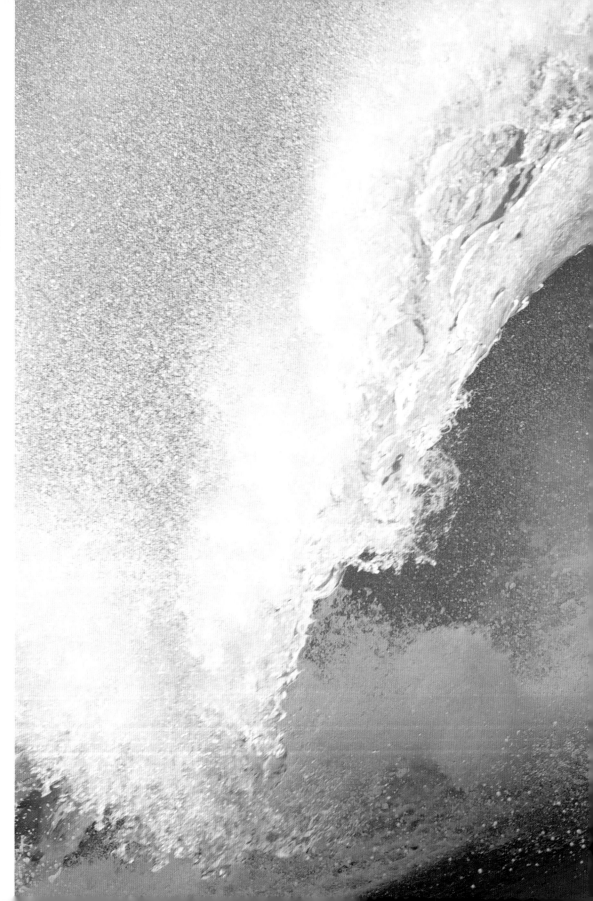

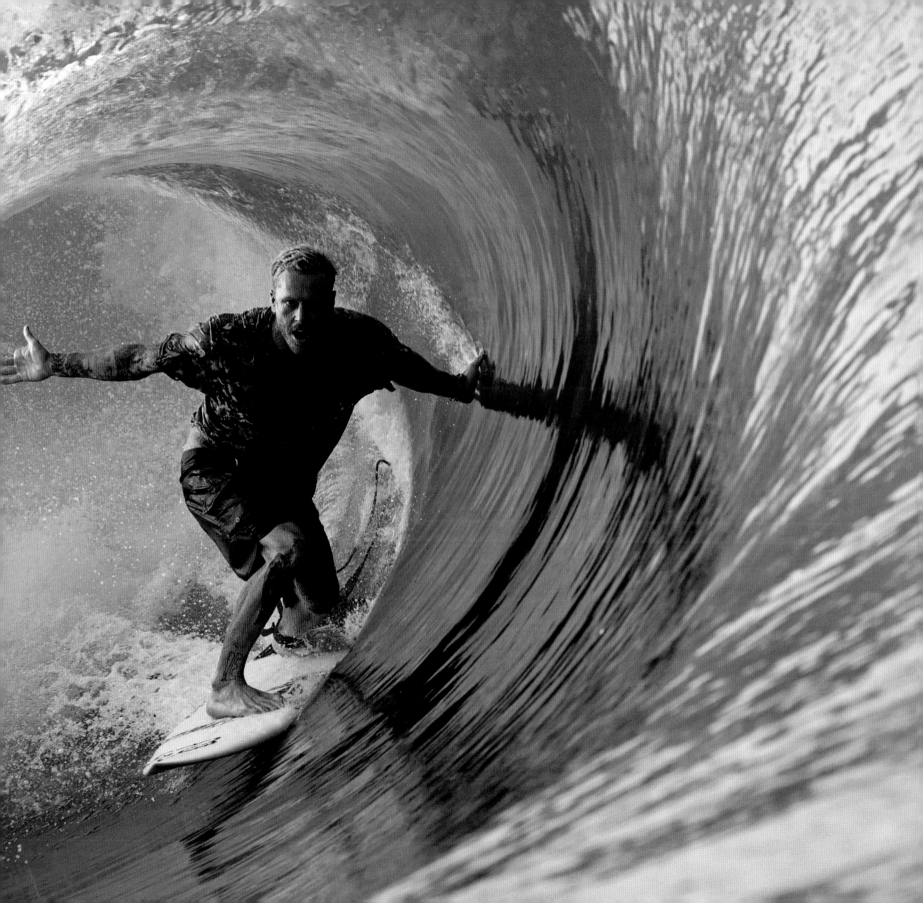

1

Wedge Machine
LUKE SHADBOLT

An explosion erupts as a surfer throws
his arms up in excitement.

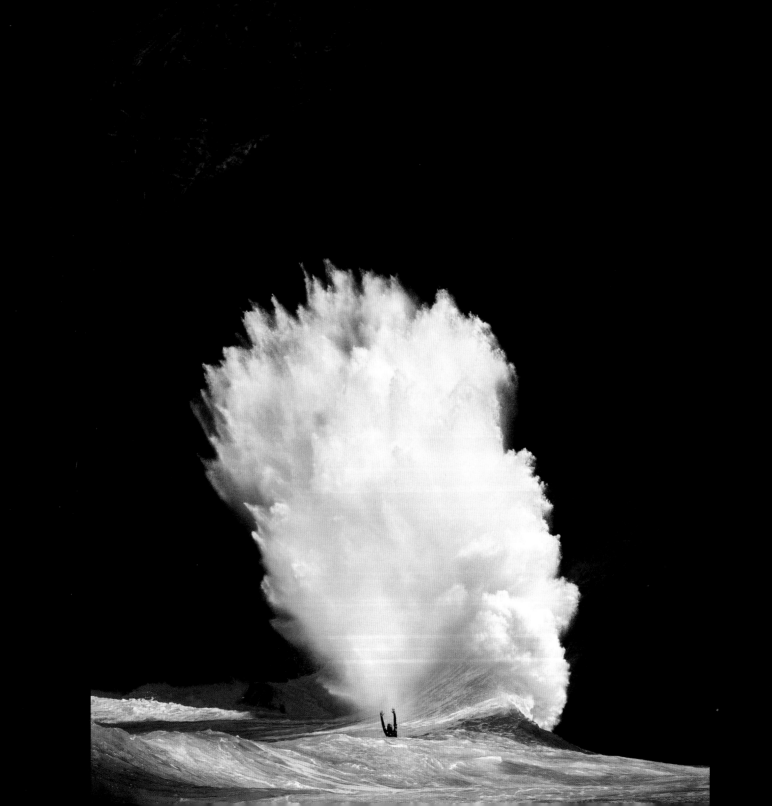

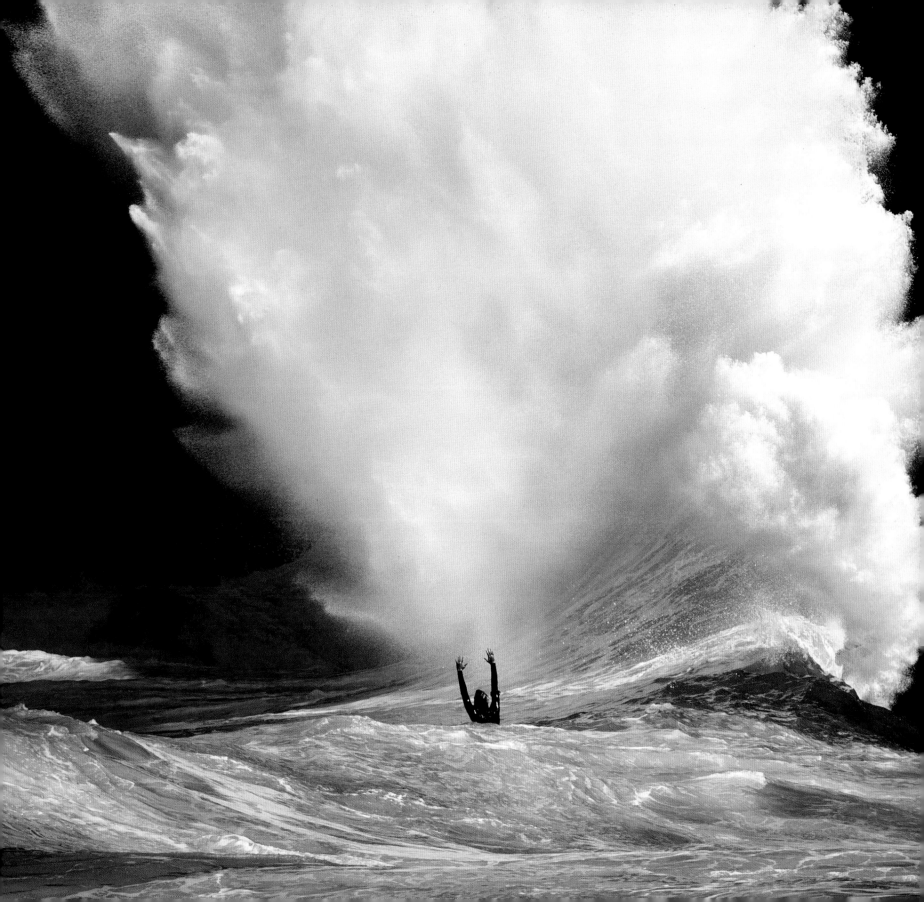

2

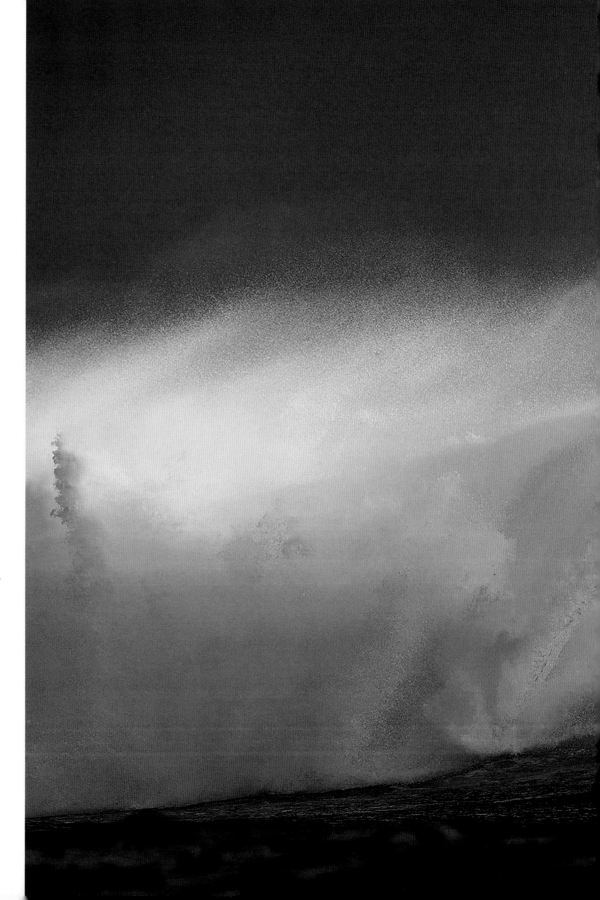

Nat Young
NATE SMITH

Nat Young deserved his 2013 Rookie of the Year
title. Late arvo Cloudbreak show-stealer.

2014

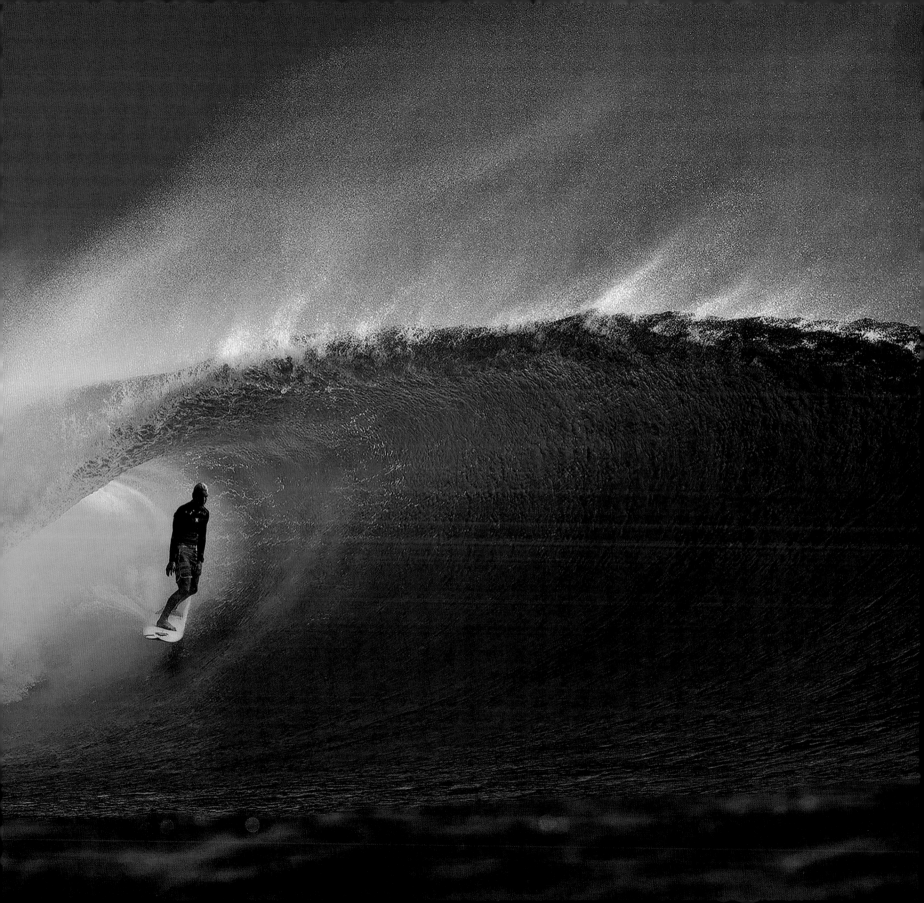

3

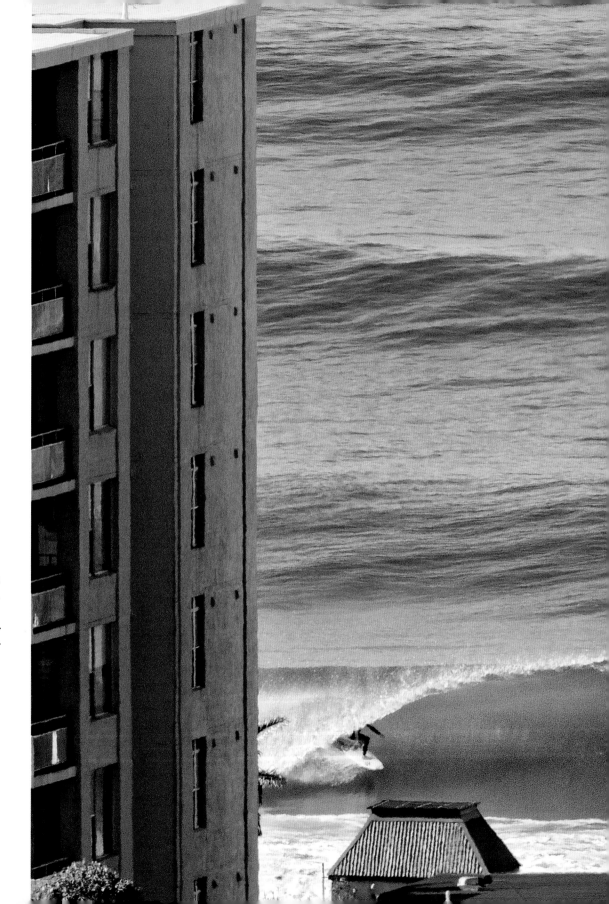

The Marquesas
MARK ONORATI

The Marquesas are the two apartment blocks in the foreground of this image. Their only claim to fame was that, in 1974, they nearly fell into the ocean in one of Sydney's worst-ever storms. World tour number 7, Kai Otton, is the surfer.

2014

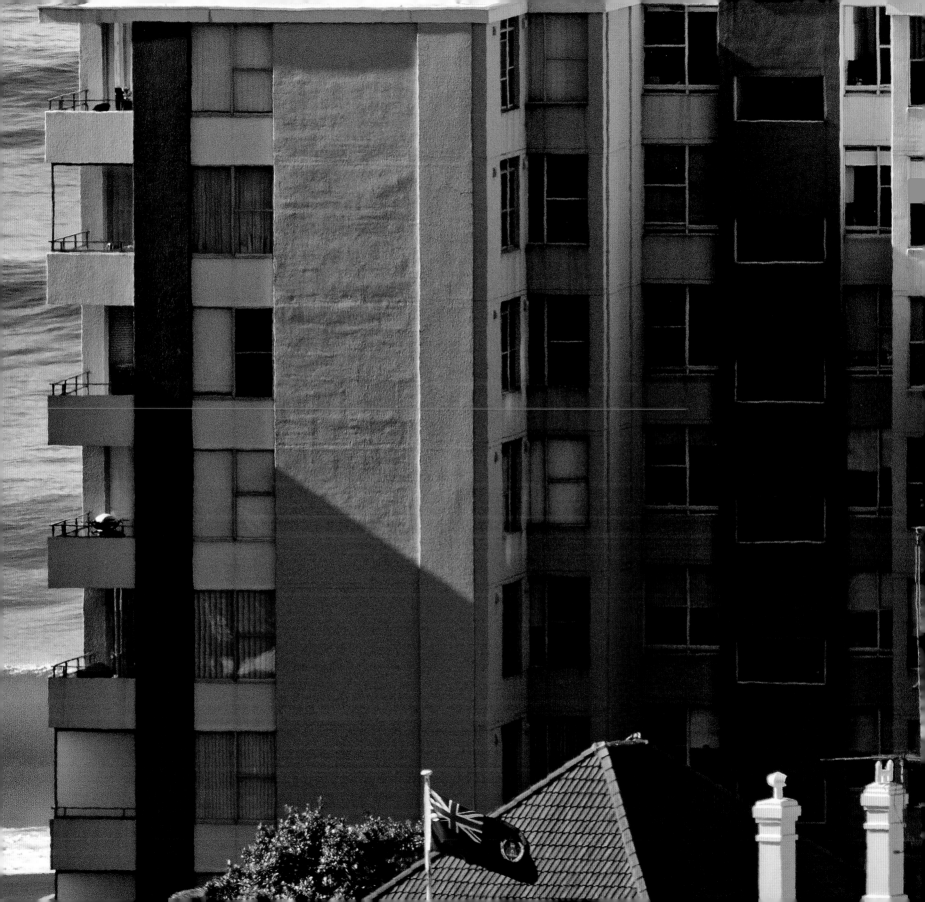

4

Watch Your Fins

STU GIBSON

Mich Hoult on what we all thought was
unrideable! And he does it on his backhand.
Mikey Brennan broke his back here the year
before. Mich makes the pit and gets clipped on
the next section to tweak his ankle. He was out
of the water for four months.

2014

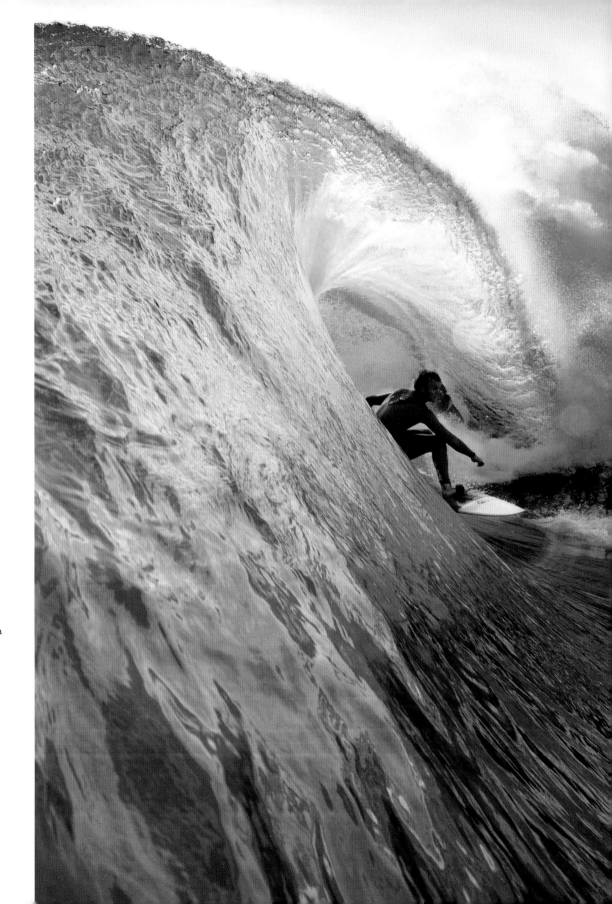

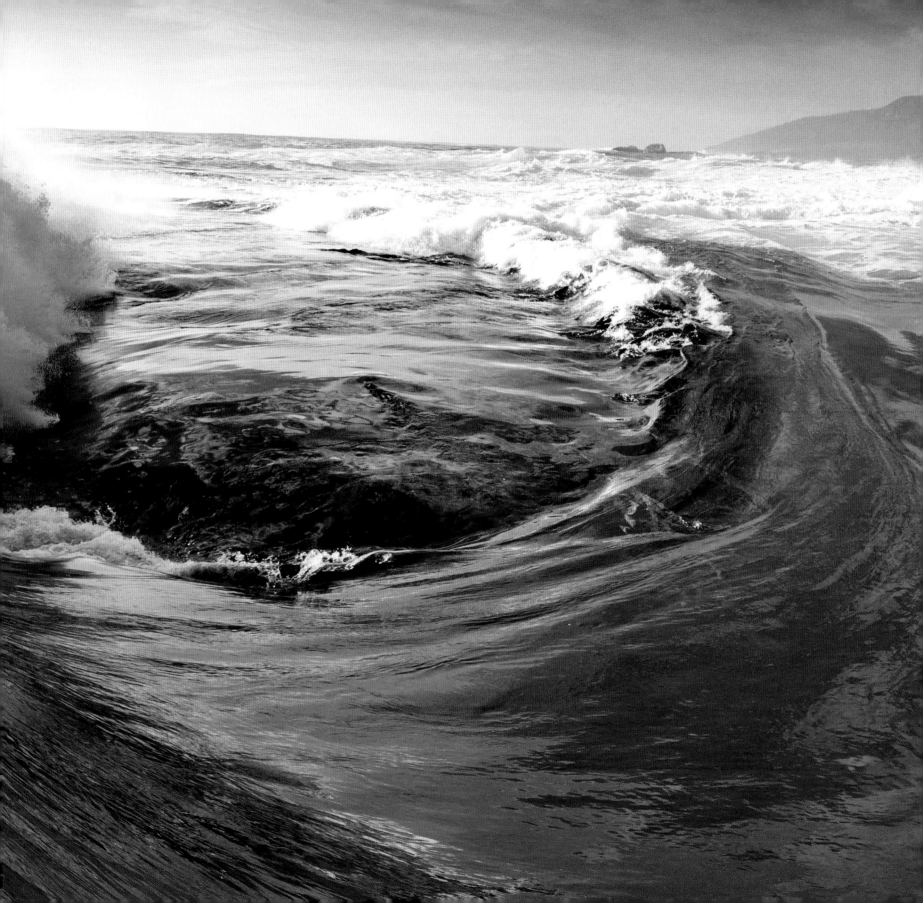

5

Pedra Branca
Nightmare
STU GIBSON

Tyler Hollmer-Cross, you plan a mission for five years, you make it 50 kms out to sea twice in this time, finally on a rogue swell the wave you have envisioned arrives and you're on the back of the rope! You're in, this is it! The ONE!! Skipping down the face, hang on a minute, what is this wave doing, what is that section lifting? No Do Not Close Out, this cannot be happening! You don't wake up, it's not a nightmare . . . yes, this is the biggest close-out ever on your head.

2014

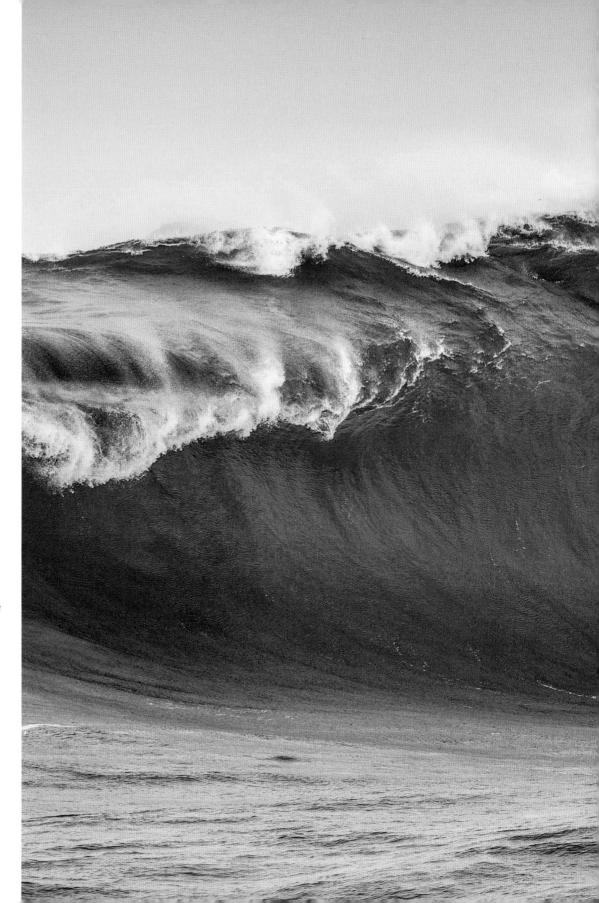

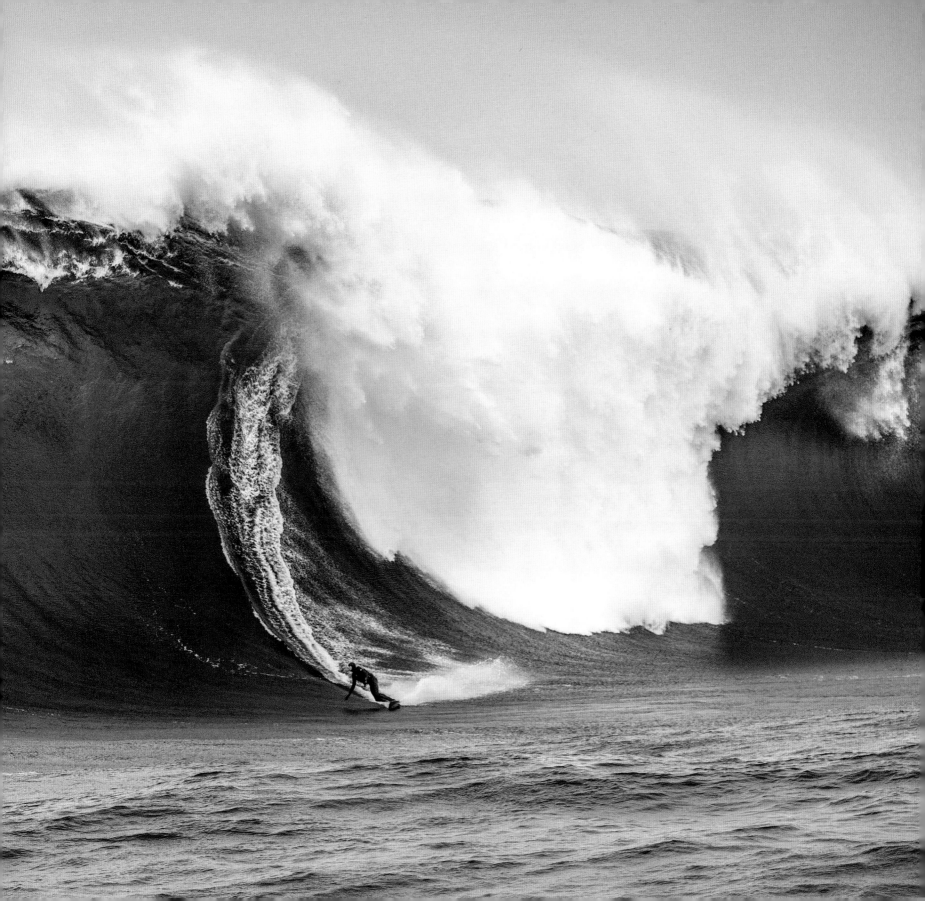

6

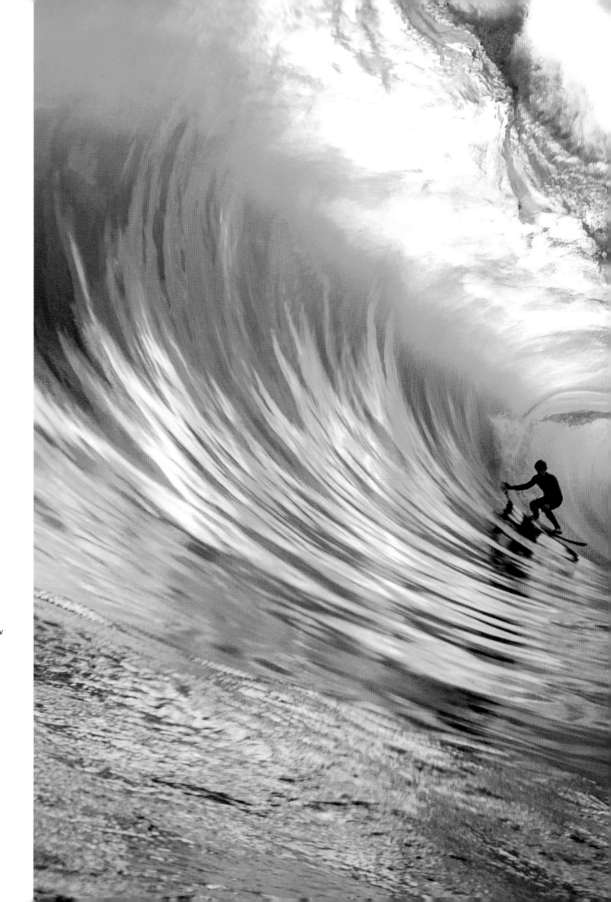

Fine Line

ANDREW CHISHOLM

Just below Kyron Rathbone lies a barnacle-encrusted reef. At one of Australia's heaviest waves, Kyron holds on for a view of a lifetime and also a chance to cheat death on this shallow rock slab. The wave breaks onto an exposed granite slab, which you can see in the bottom right corner of the photo.

2014

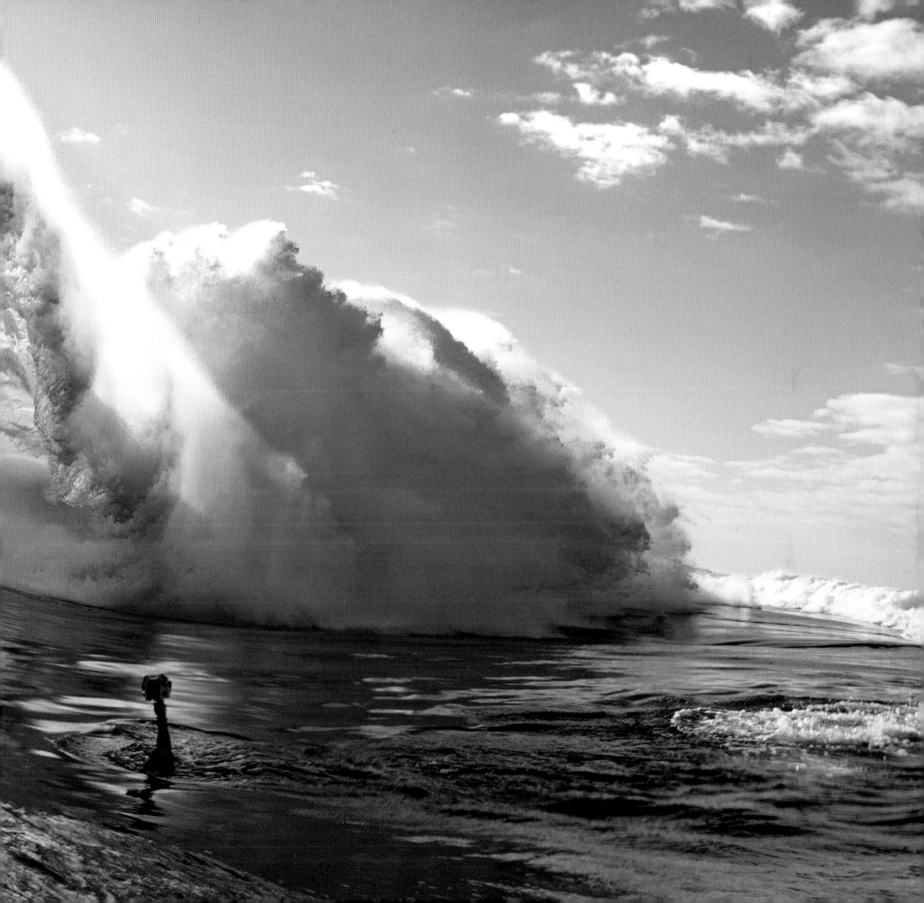

7

Kelly Slater.
Cloudbreak, Fiji
PETER JOLI WILSON

Kelly Slater standing tall with his arms out-
stretched during the final of the Volcom Fiji Pro
against Mick Fanning. Slater won the event but
Mick Fanning won the 2013 World Title.

2014

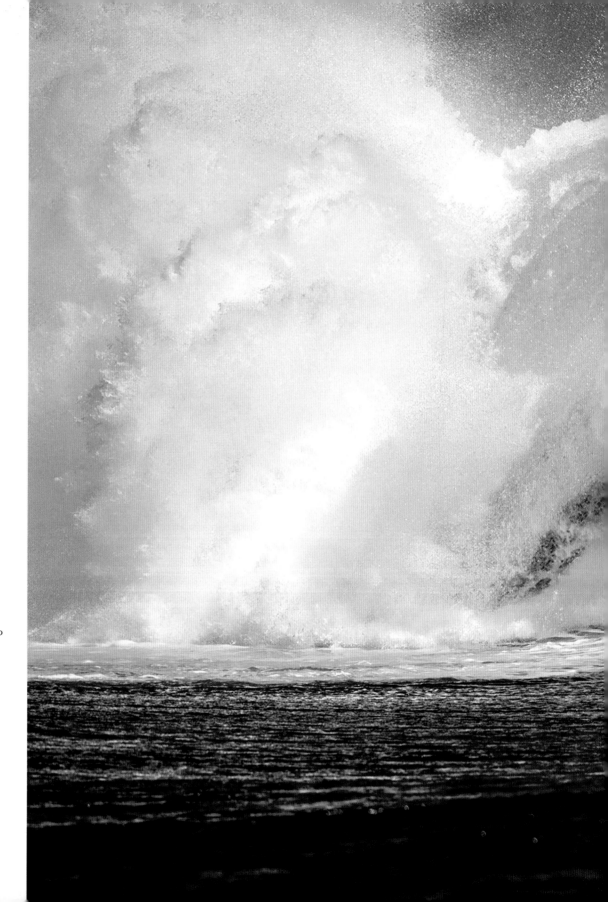

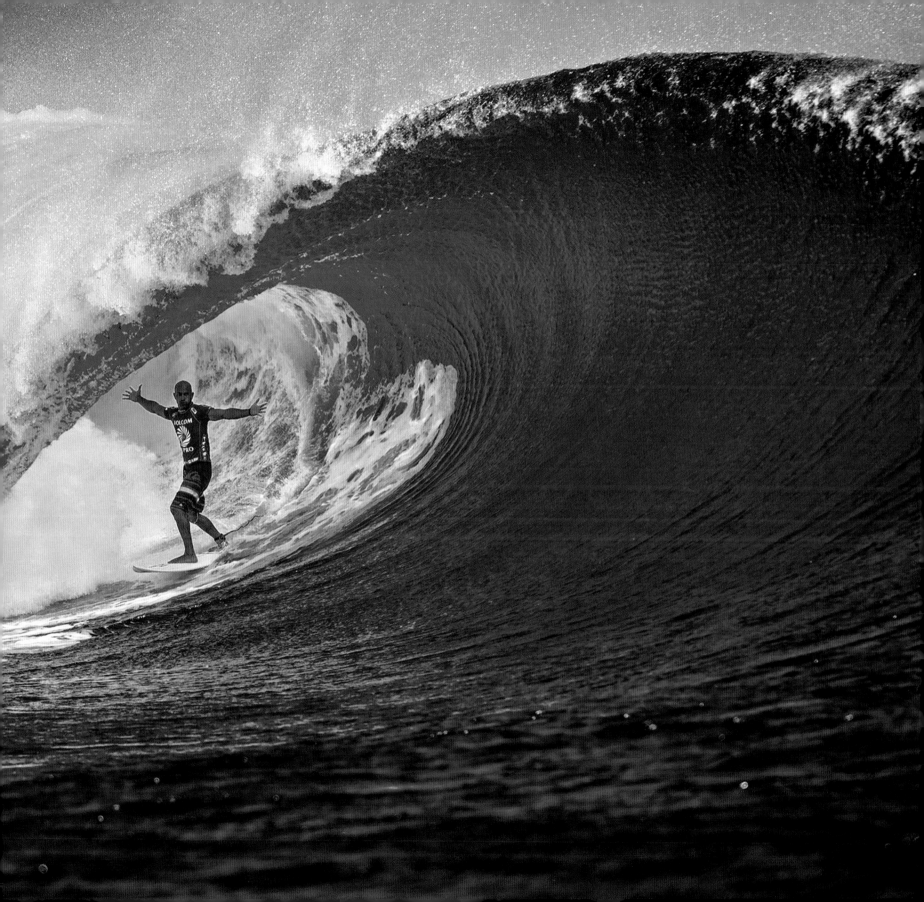

8

Golden Wall

DEB MORRIS

Floodwaters bleed through the ocean, leaving
it tainted with this golden colour. Kneeling on
the foreshore without waterhousing, this 15cm
miniature wave rolled through, revealing all
its beauty.

2014

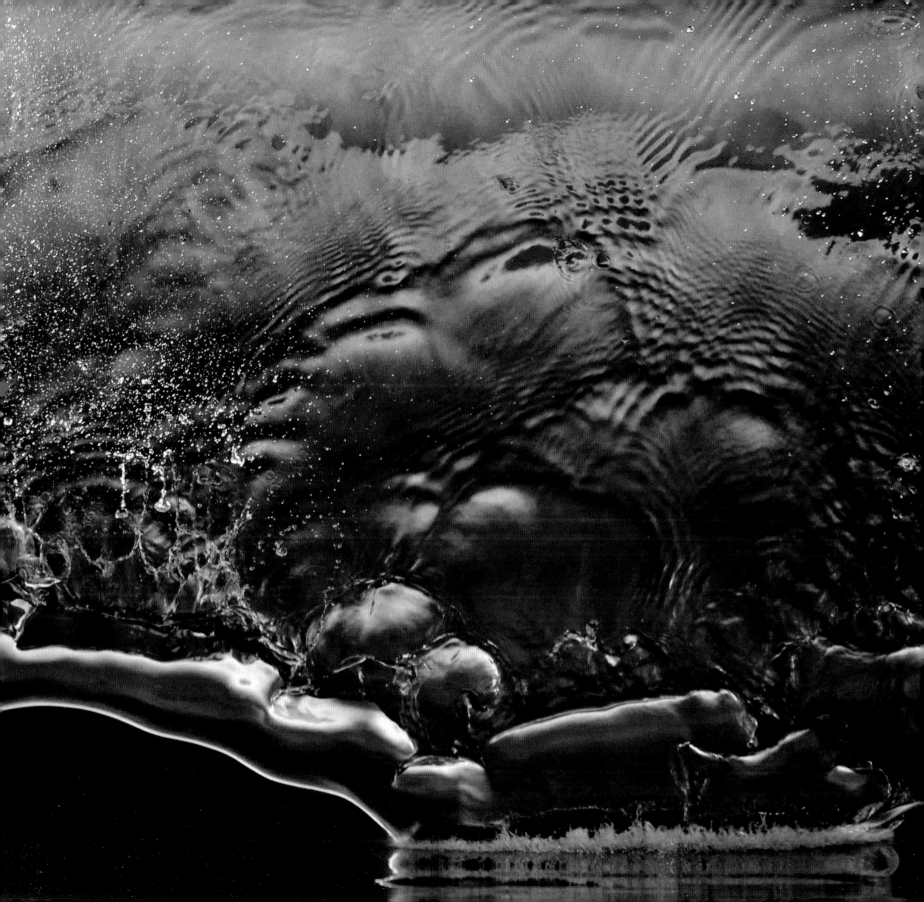

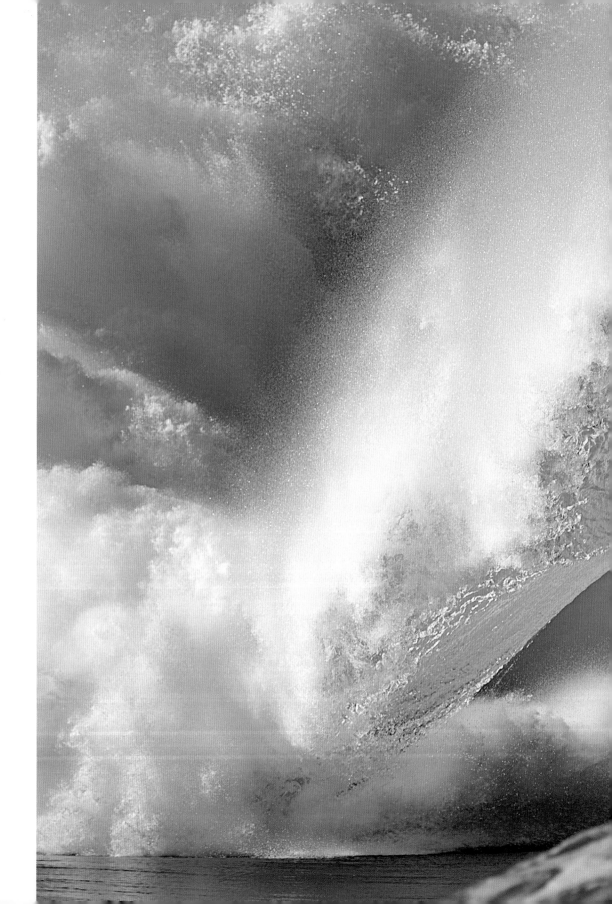

9

Into the Abyss
TED GRAMBEAU

Mark Mathews deep in the vortex of a
Teahupo'o barrel.

2014

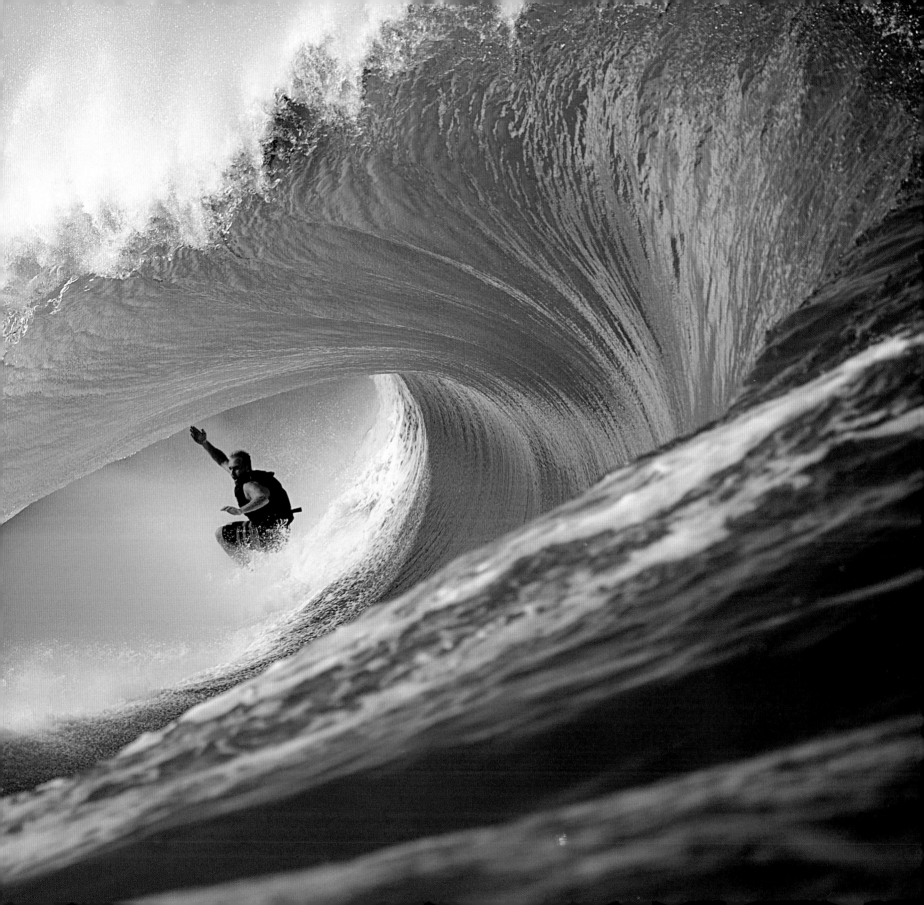

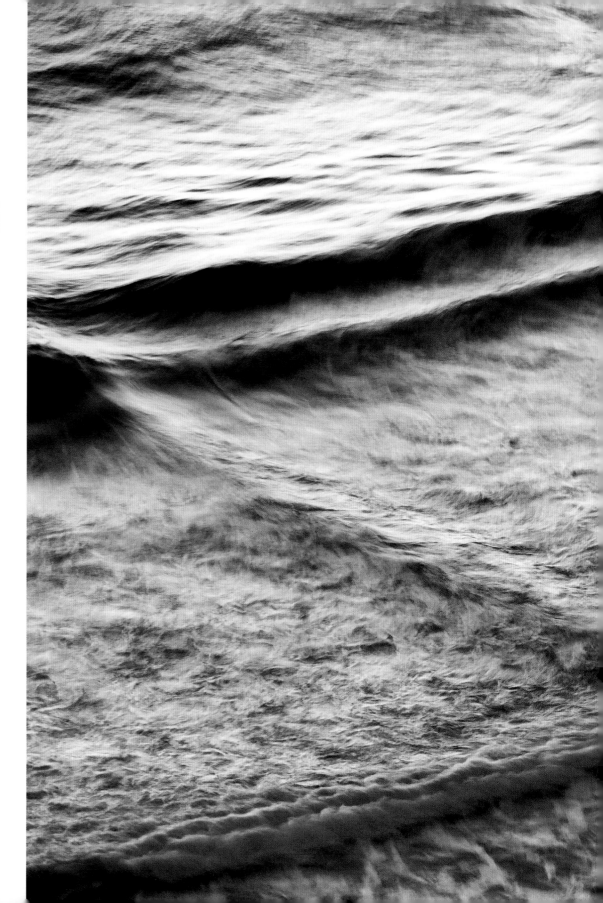

10

Tessellated Seas
TRENT MITCHELL

An image from my book series titled
Above/Below.

2014

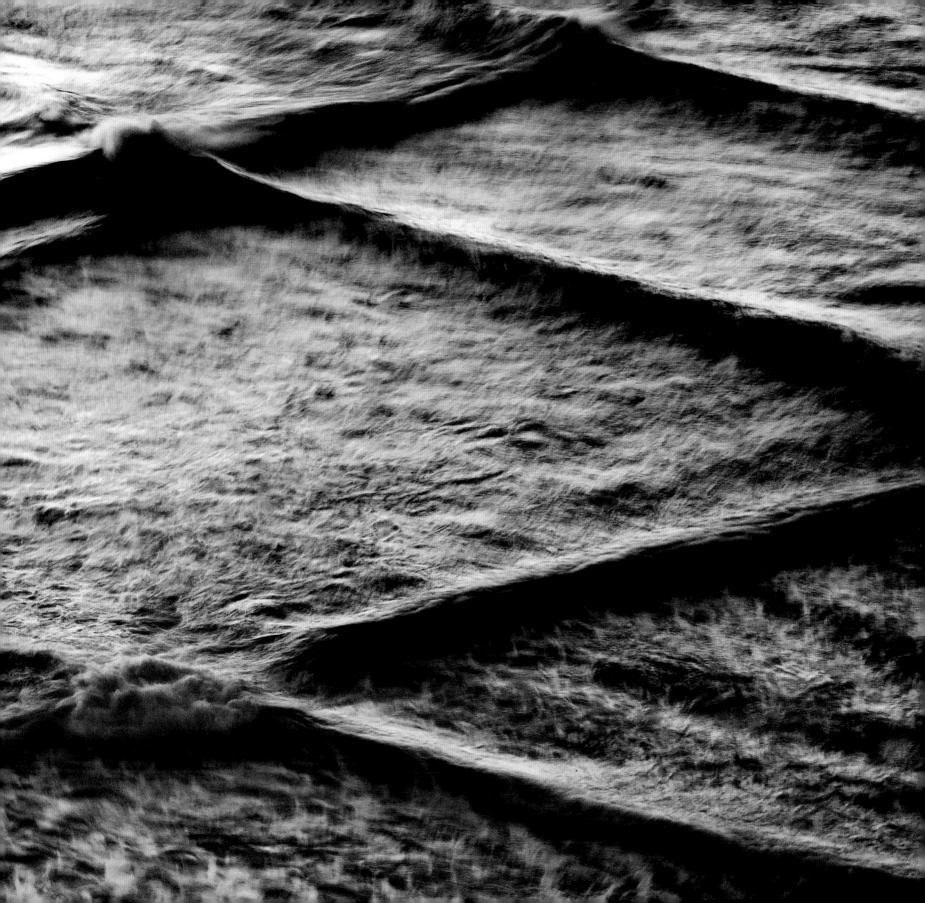

11

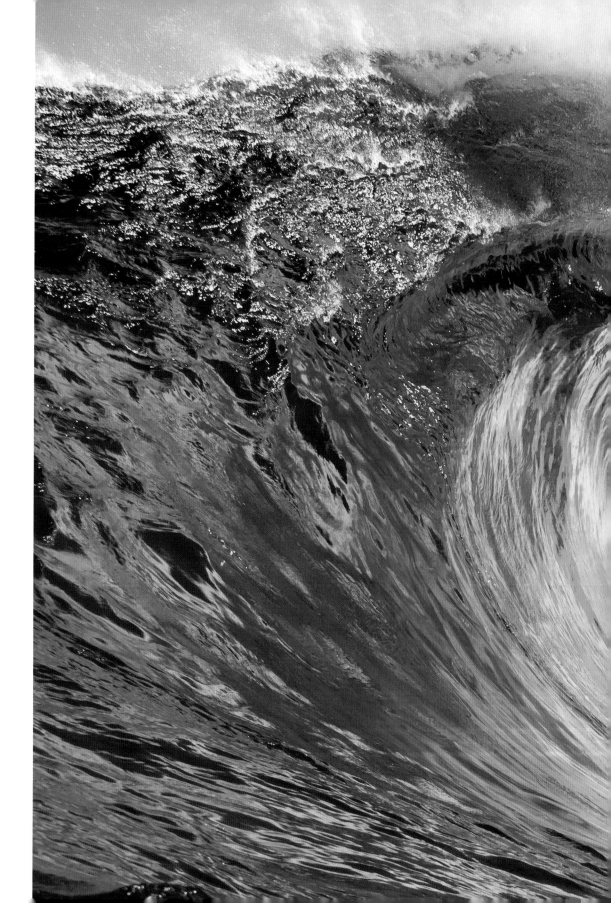

Open

ANDREW CHISHOLM

A tube big enough to do a full bottom turn inside the pit? This is exactly what Laurie Towner did to make this monster at Shipstern Bluff in Tasmania.

2014

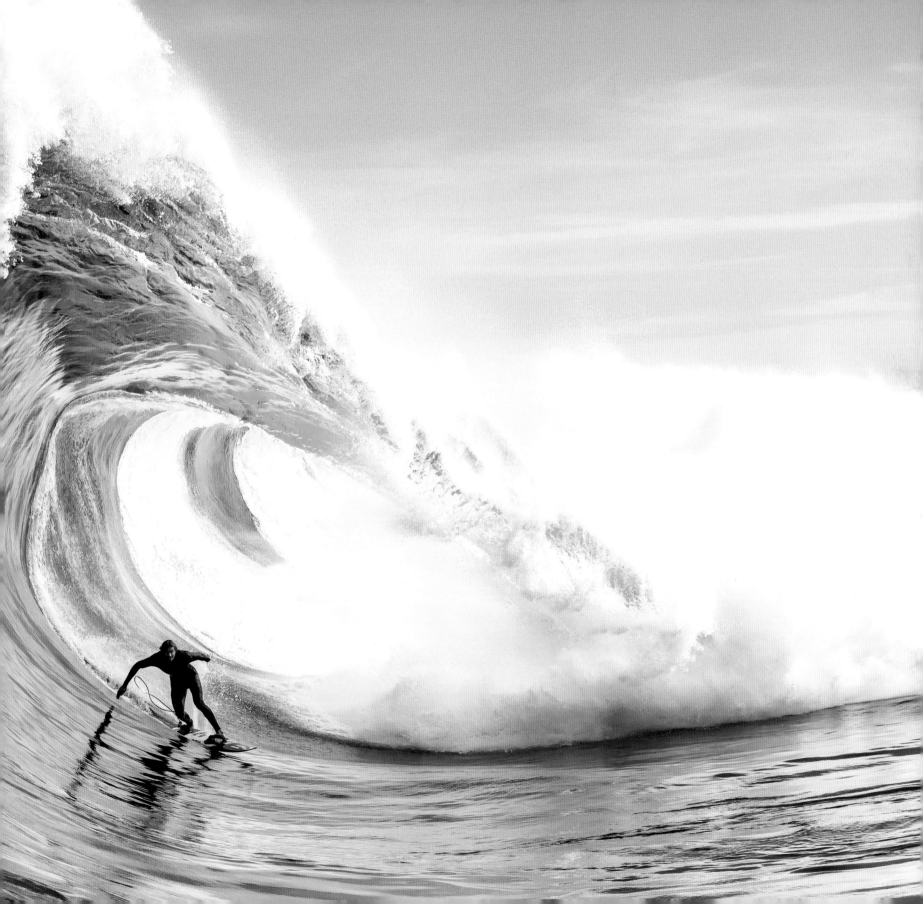

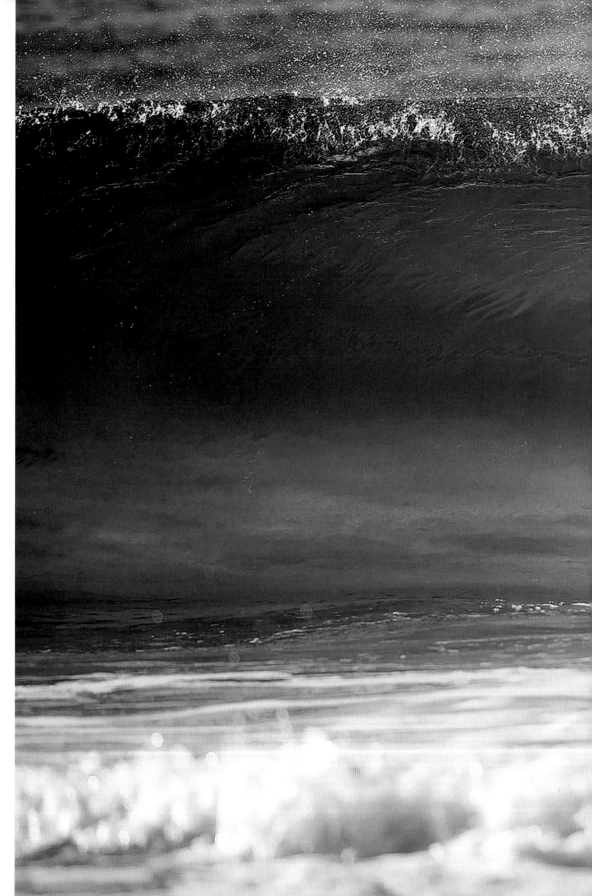

12

Fun

NATE SMITH

Noa Deane having a day most would kill for.

2014

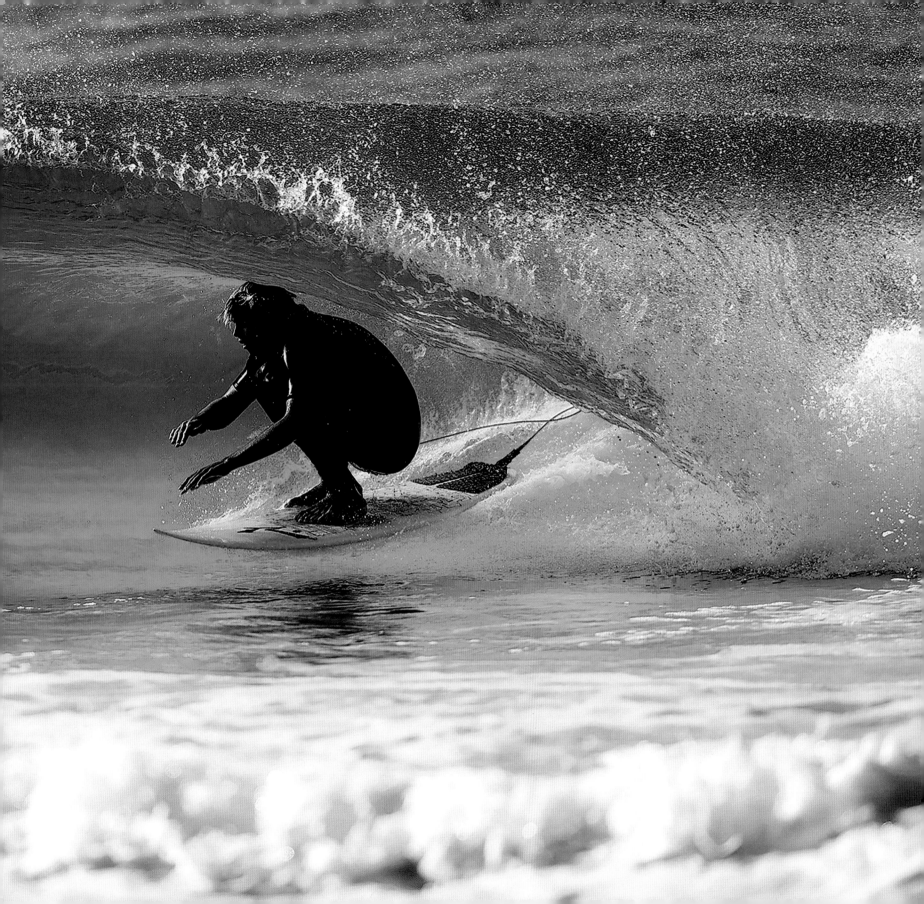

13

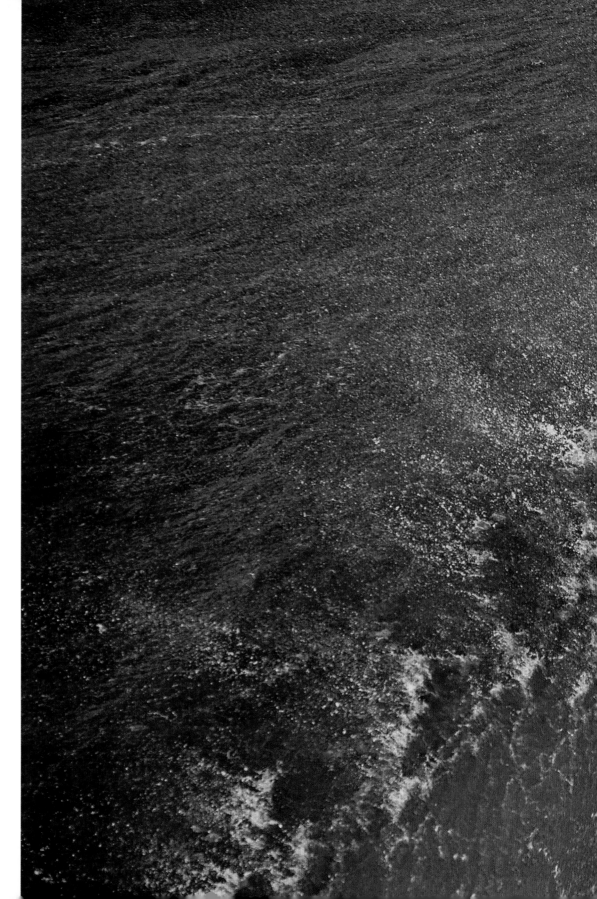

Kelly Slater, Kirra, 2013
TRENT MITCHELL

A moment taken during the best Kirra freesurfing of 2013. Kelly Slater post-event win contentment. This image graced the cover of *Surfing World* magazine.

2014

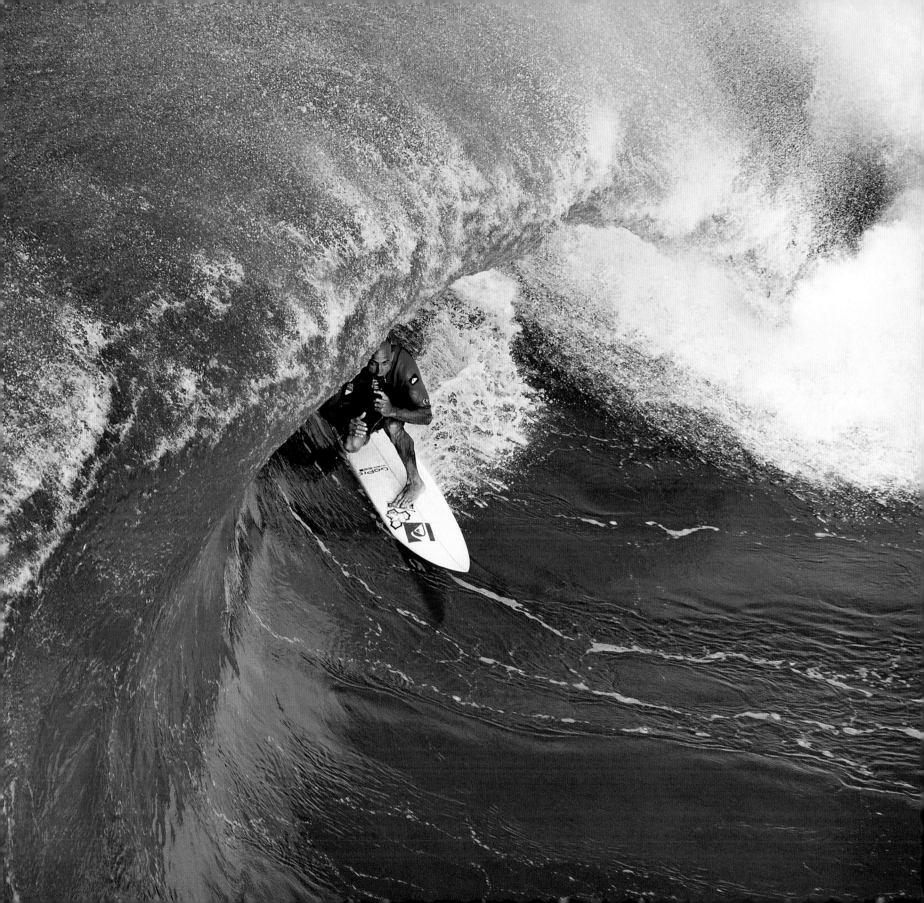

14

Let It Go
TRENT MITCHELL

Mick Fanning lets a long runner slip by during the best day at Kirra in 2013.

2014

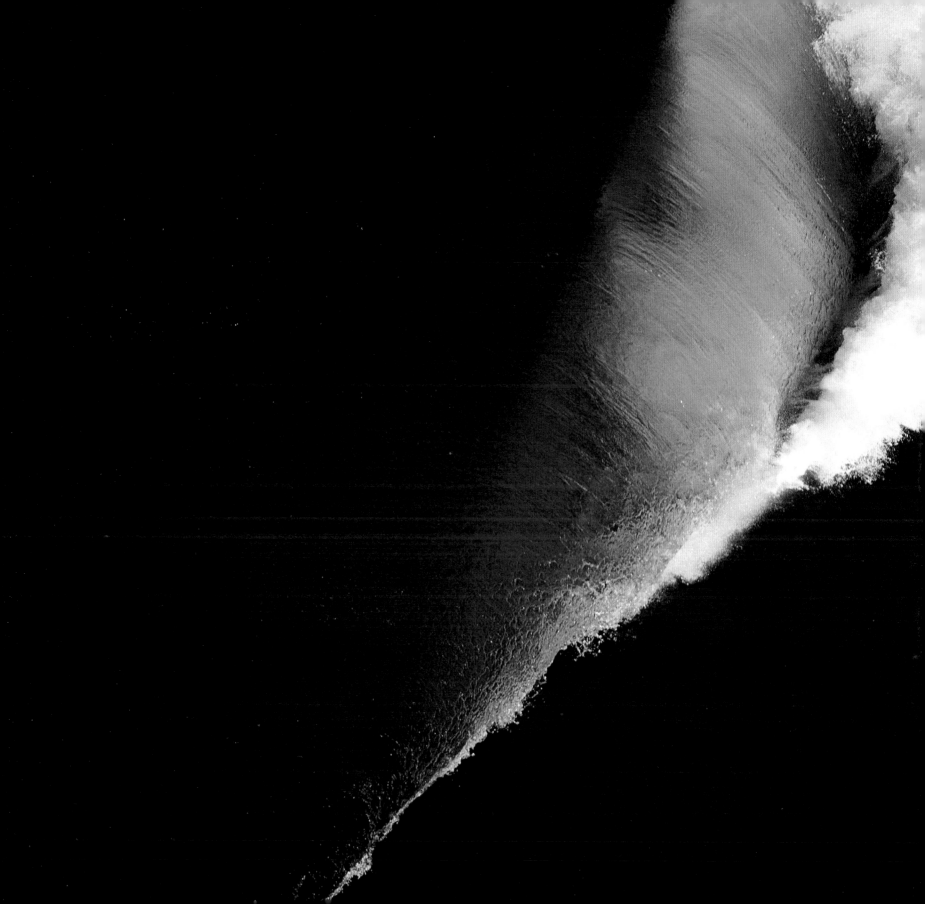

15

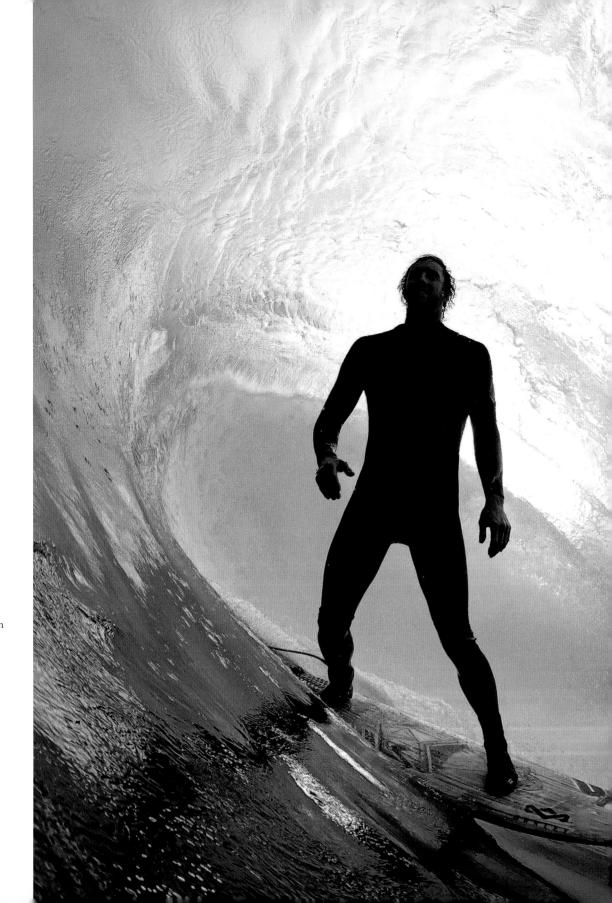

Mikey Brennan,
Shipstern Bluff
STU GIBSON

This was a super-rare bluebird arvo. Mikey
Brennan came down to show the Rip Curl team
how it's done at Shippies and he did just that,
wave after wave, stand-up paddle bombs!

2014

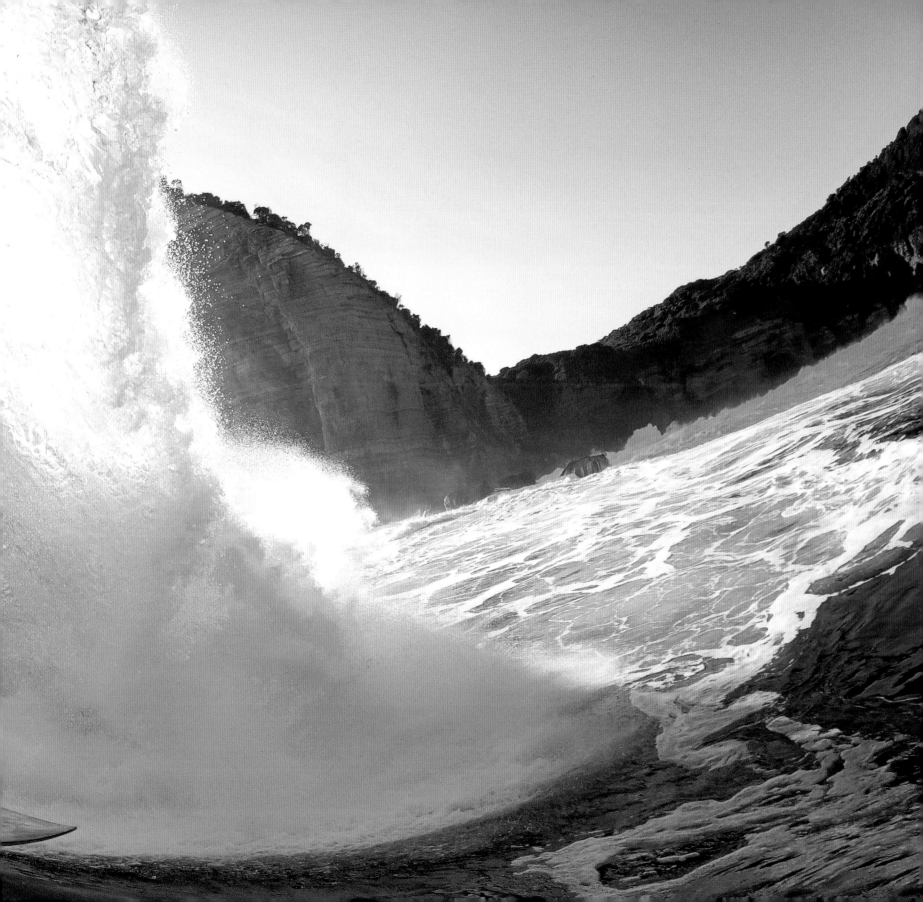

16

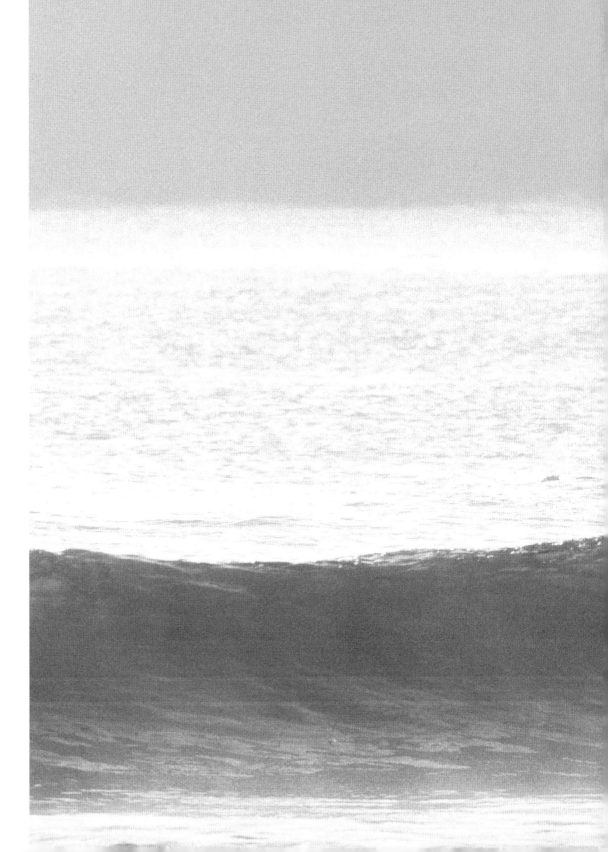

Enticing
DANE PETERSON

Matt Cuddihy making a more than average day at Noosa Main Beach look quite enticing.

2014

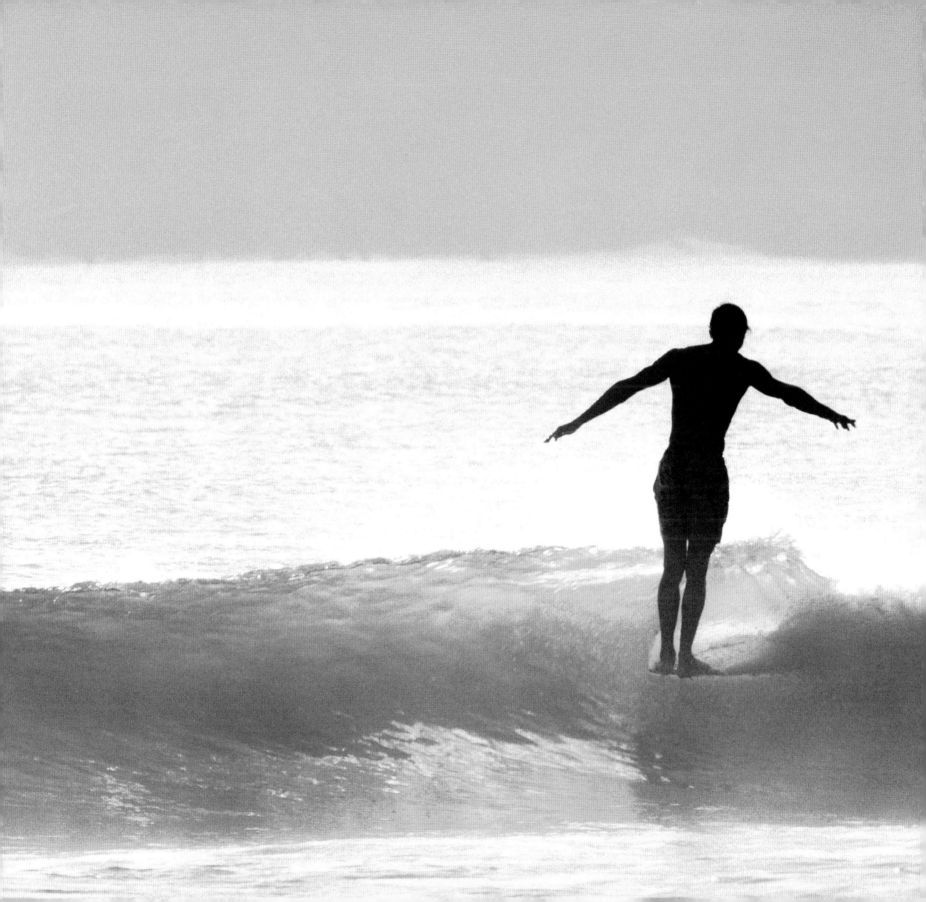

17

Flying High
PETER JOLI WILSON

Ace Buchan flying high after winning the
Billabong Pro Tahiti.

2014

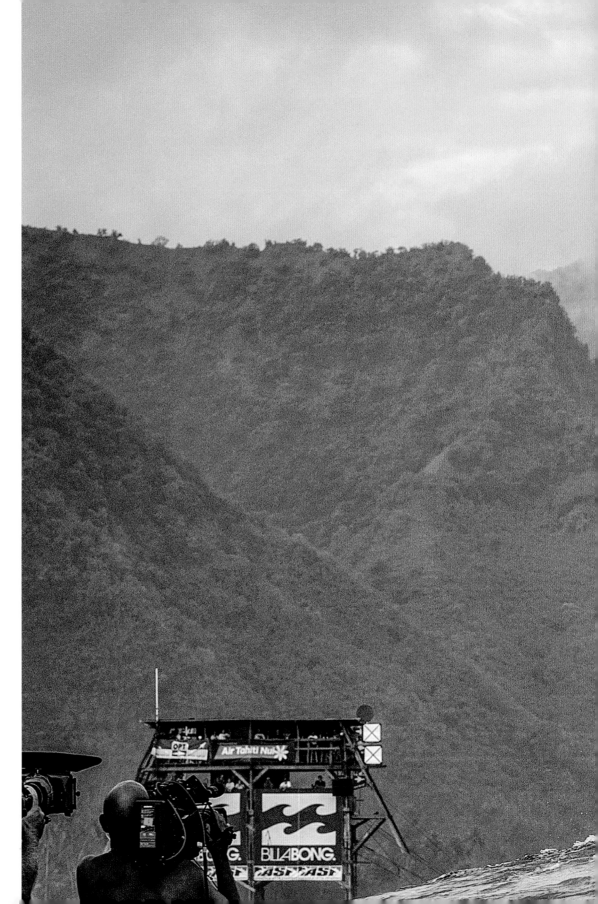

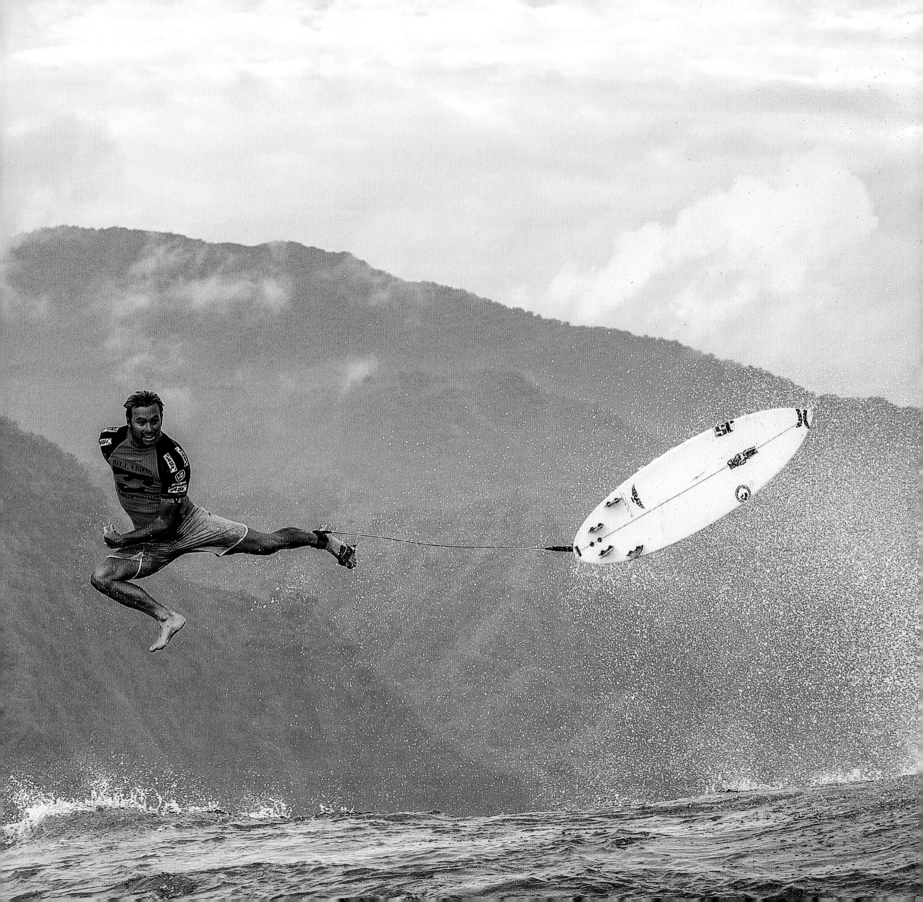

18

Peter Drouyn versus Westerly Windina
NATE SMITH

The awesome Westerly Windina in
intimate reflection.

2014

19

Cyclops

RUSSELL ORD

Chris Ross deep in the Southern Ocean
over a very sketchy piece of reef.

2014

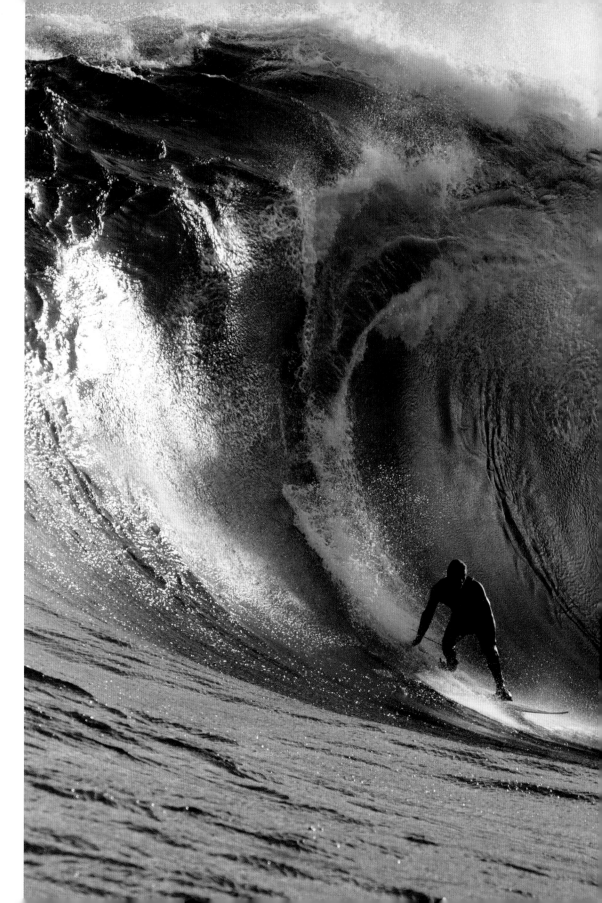

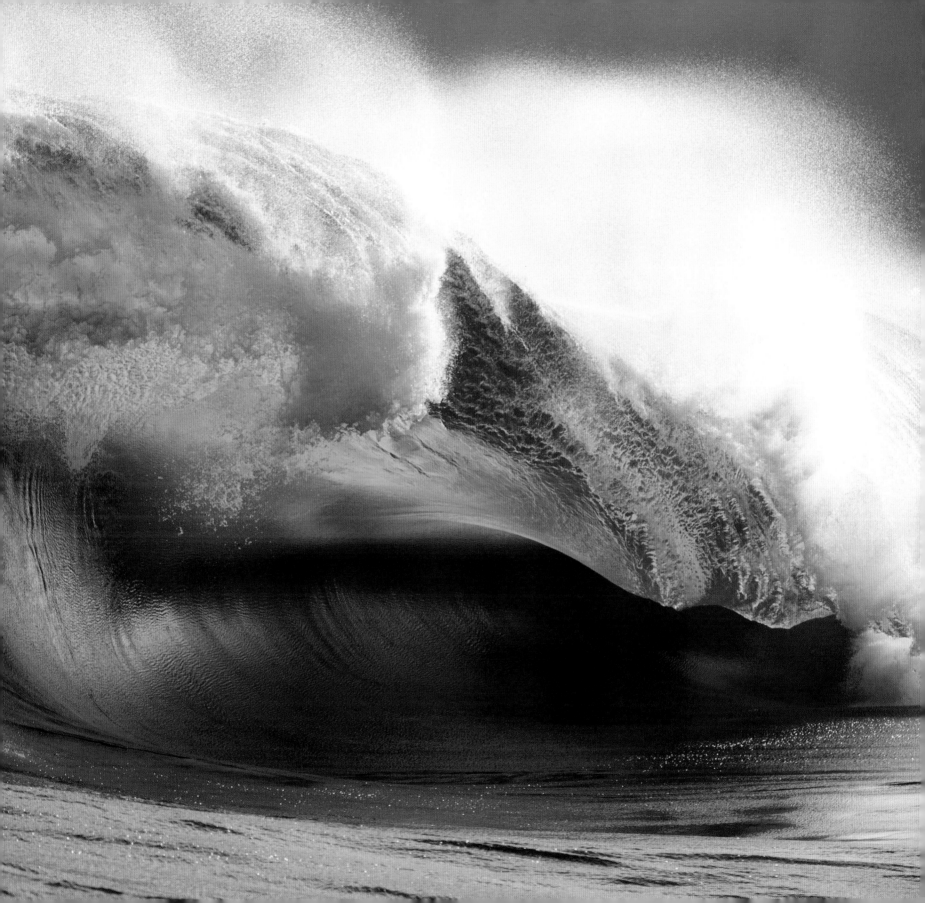

20

Surfers' Shadows
CRAIG DAVID PARRY

I captured this image on the shore of Byron Bay with my UAV. Before photographing the surfing, I noticed through the video downlink that their shadows were almost symmetrical. One of my most beautiful surf lifestyle images.

2014

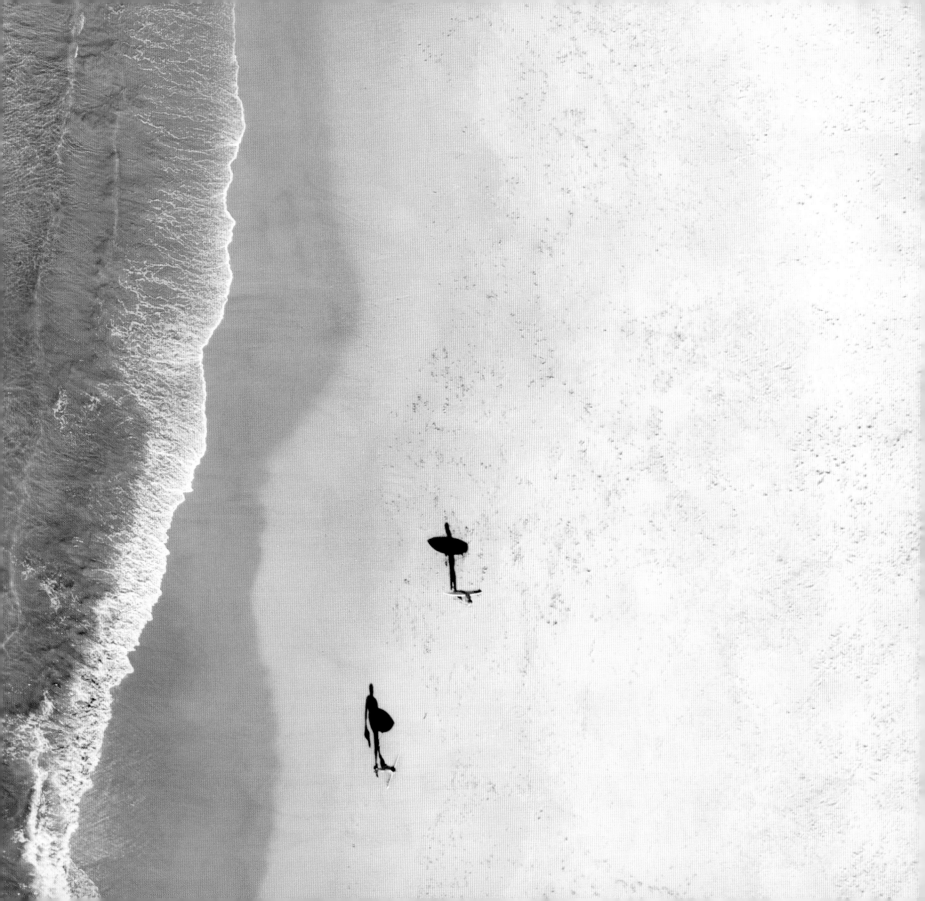

1

Cloudbreak
PETER JOLI WILSON

Big wave surfer Mark Healey has undone his leg-rope and is trying to penetrate the face of the wave as a huge wave rolls through Cloudbreak.

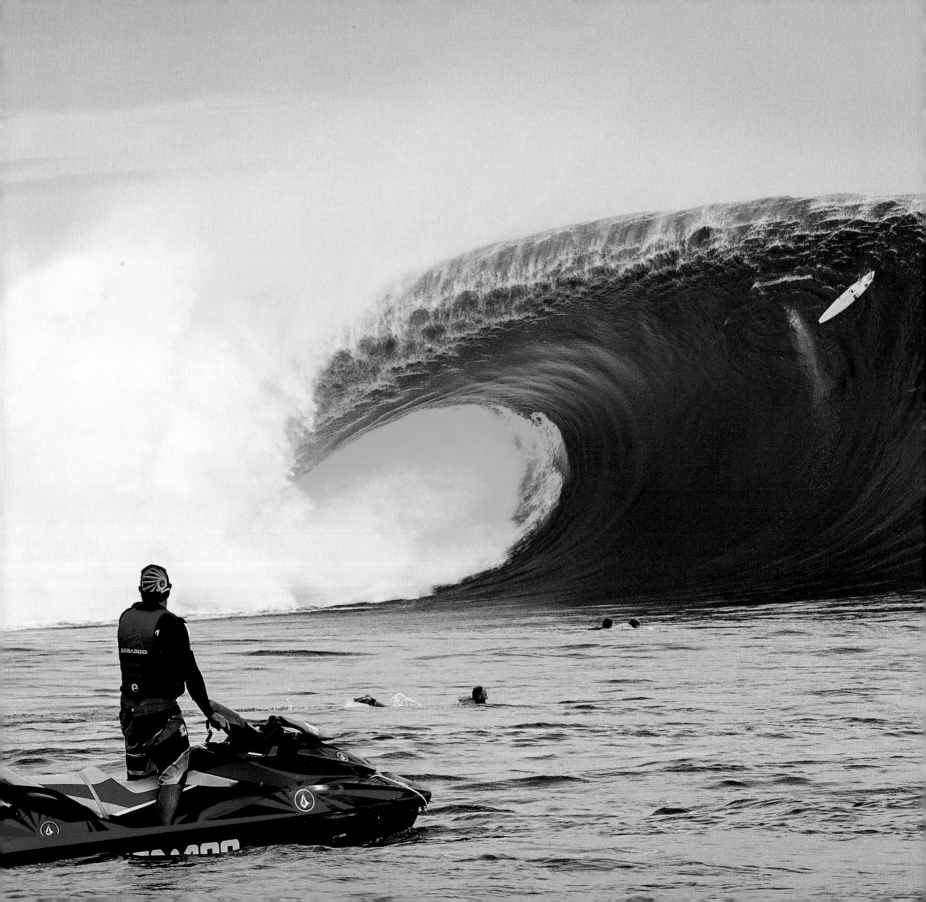

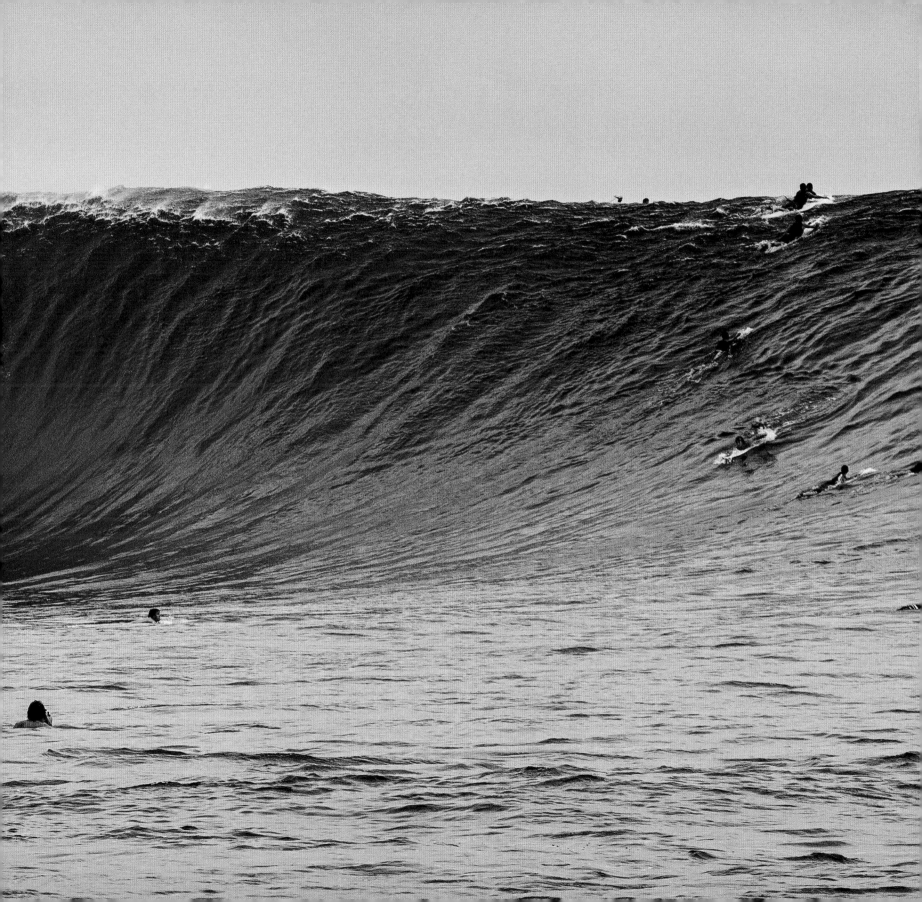

2

Flying Free

ANDREW CHISHOLM

Unknown surfer Alex Zawadzki throws himself
off the ledge at Shipstern Bluff. The wave was
one of the biggest ever ridden and the wipeout is
horrendous, ending in an air evacuation.

2013

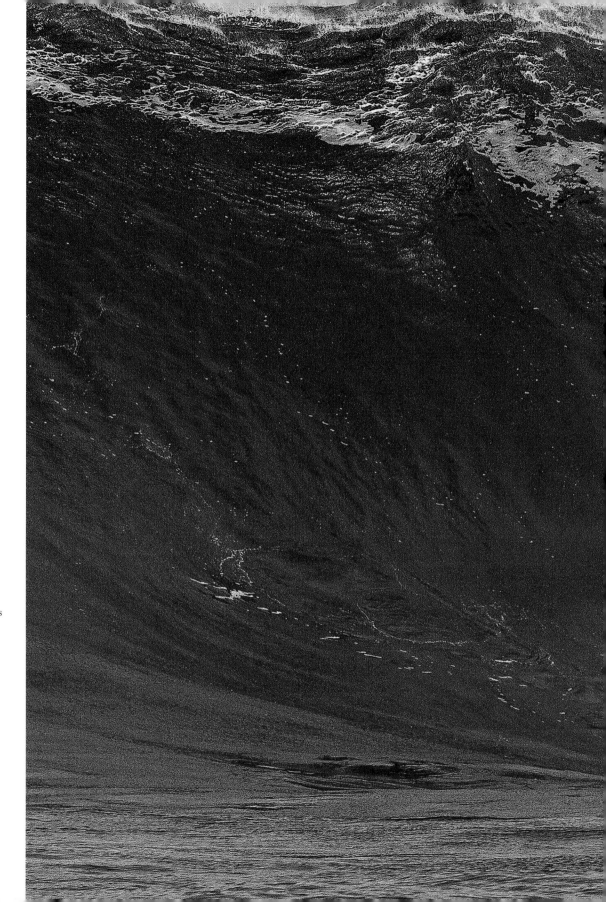

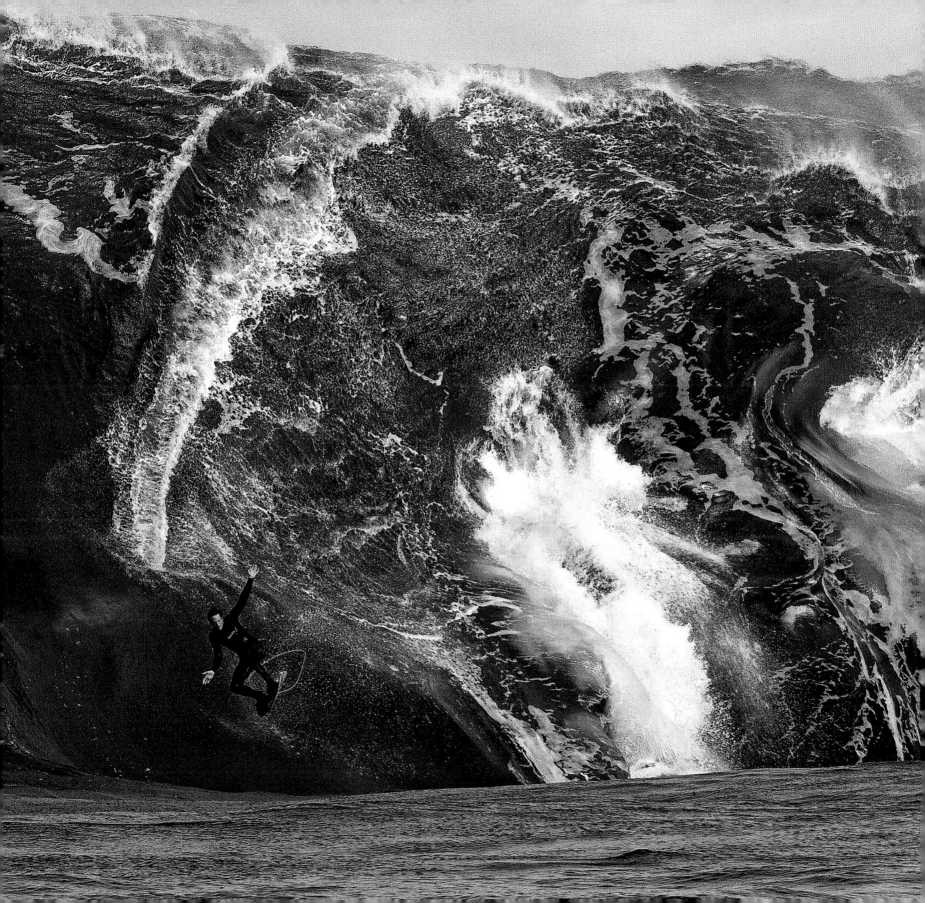

3

Big Turn Blur
MARK ONORATI

Big turn blur.

2013

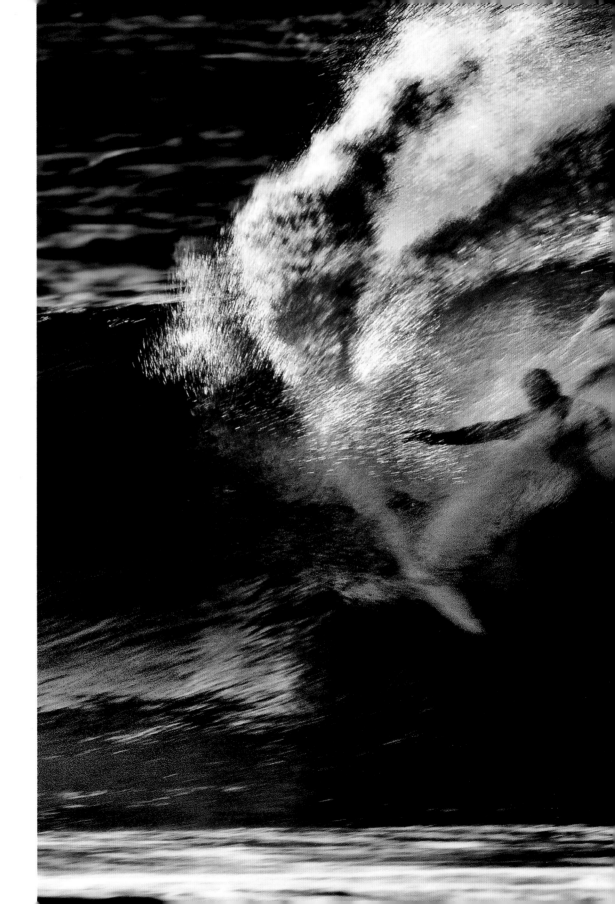

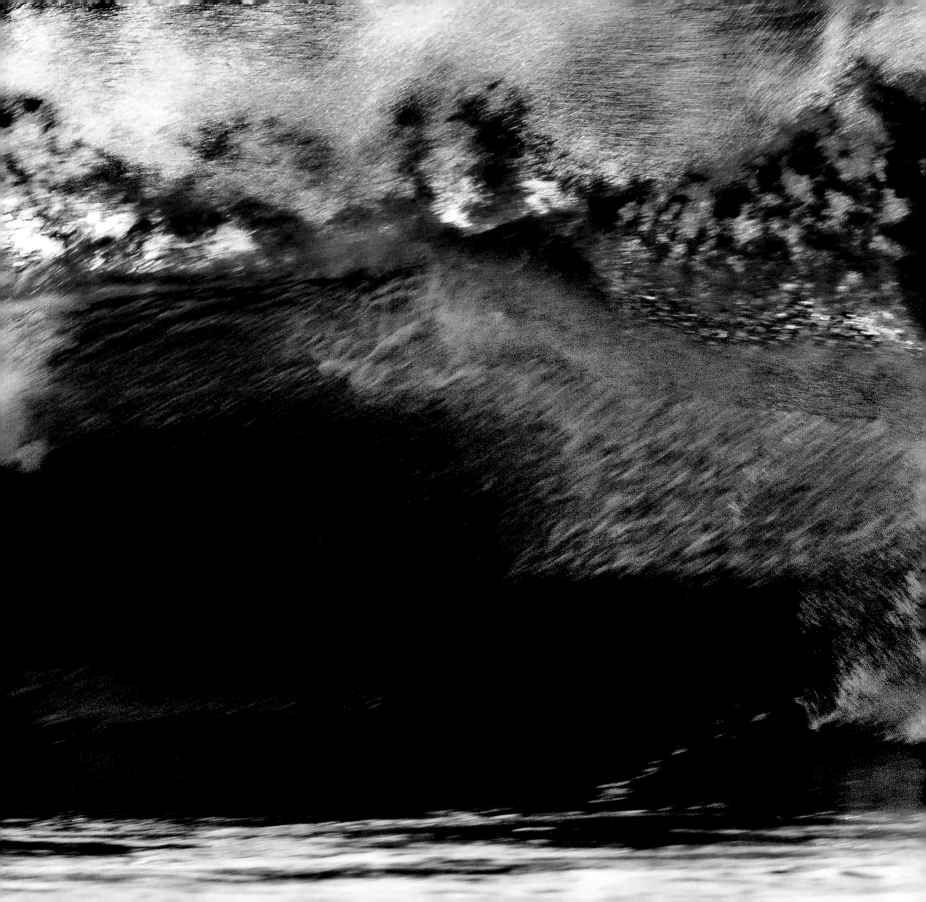

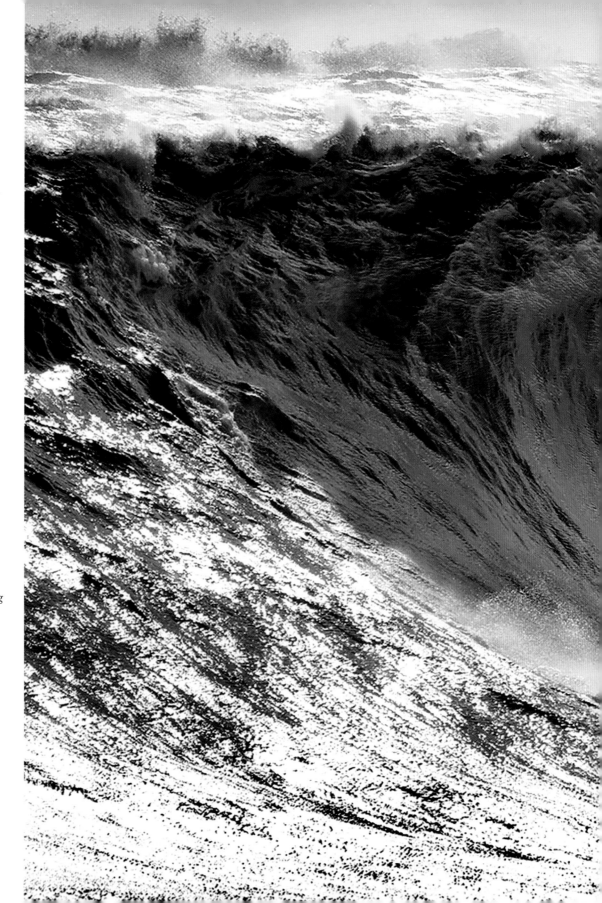

4

Miracle Wave

ANDREW CHISHOLM

The guinea pig for the first part of a remarkable
session, Marti Paradisis moments before copping
a beating of a lifetime.

2013

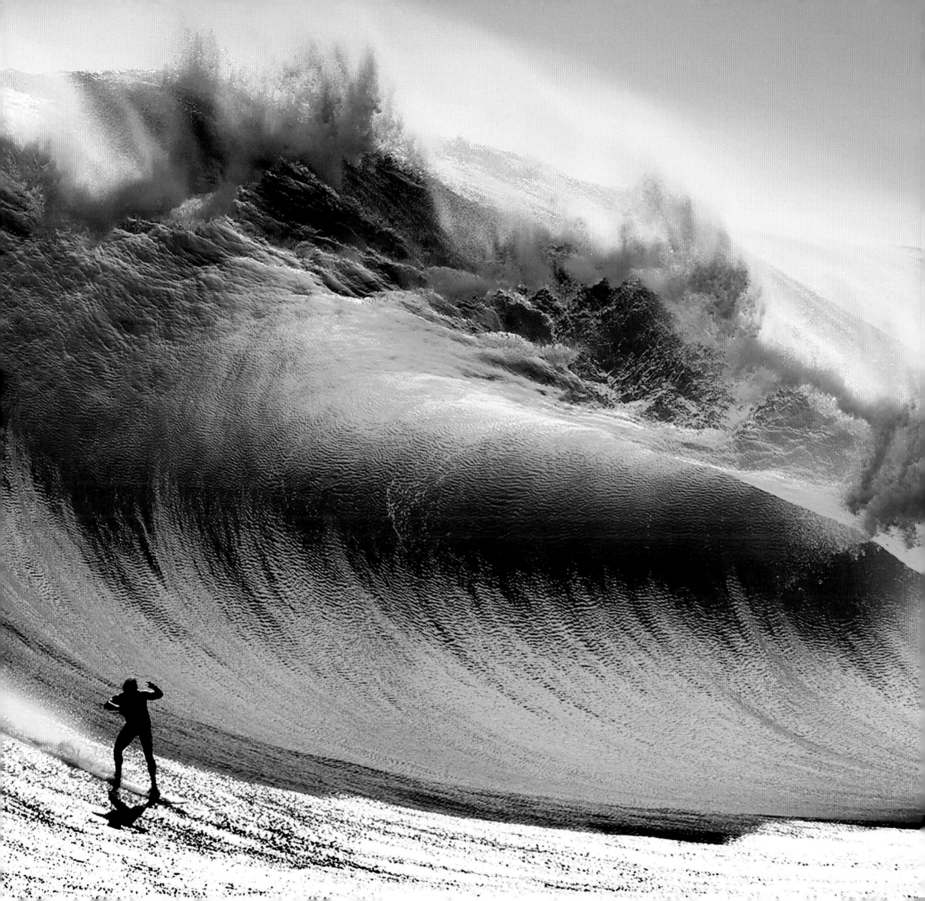

5

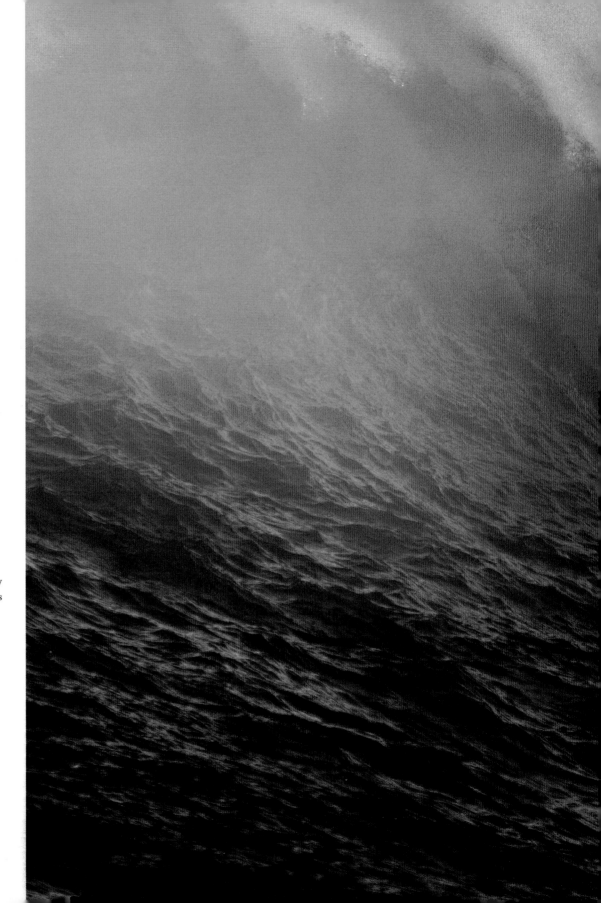

Southern Blaze
BILLY MORRIS

Ryan Hipwood, a kilometre from land and many miles from home, paddling outer reef bomboras just before dusk in the Great Southern Ocean.

2013

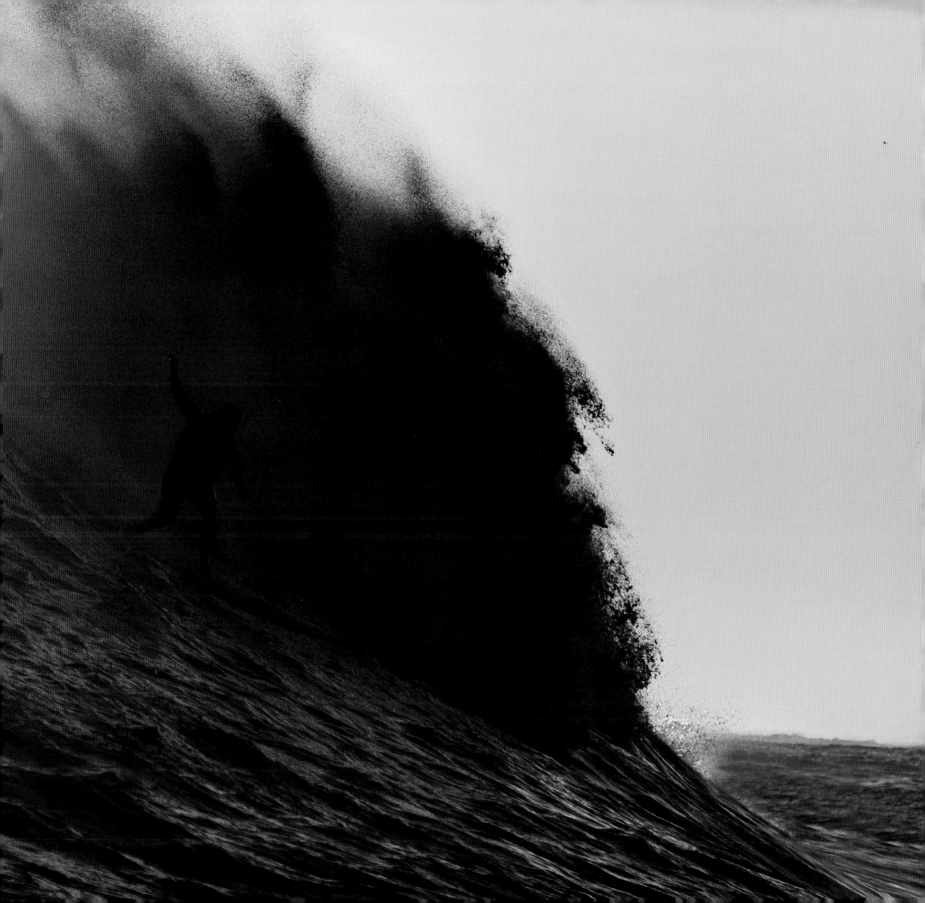

6

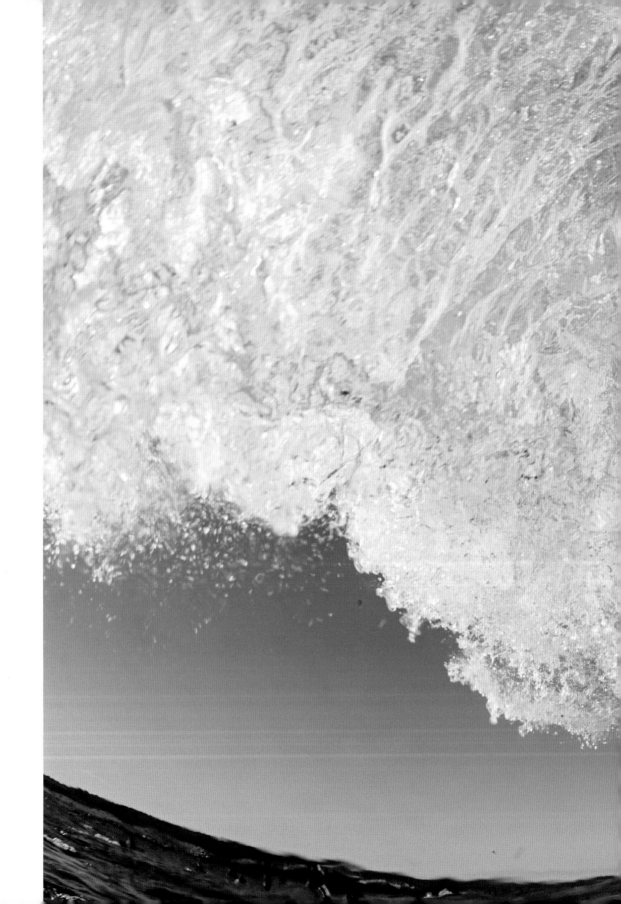

Jack Robinson –
The Box
RUSSELL ORD

The view behind the surfer at an extremely
heavy wave in West Oz, by far the best shot
I have ever taken there.

2013

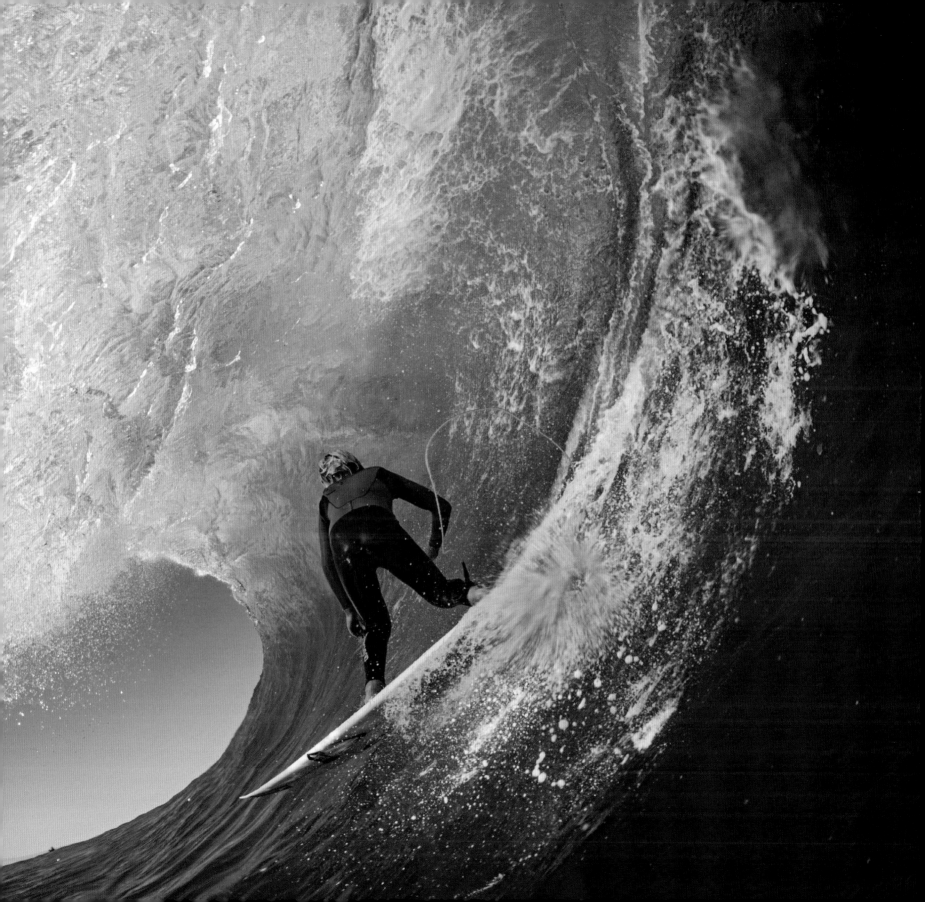

7

Chris Shanahan –
Secret Slab

RUSSELL ORD

Just a perfect barrel at his home break with a touch of size.

2013

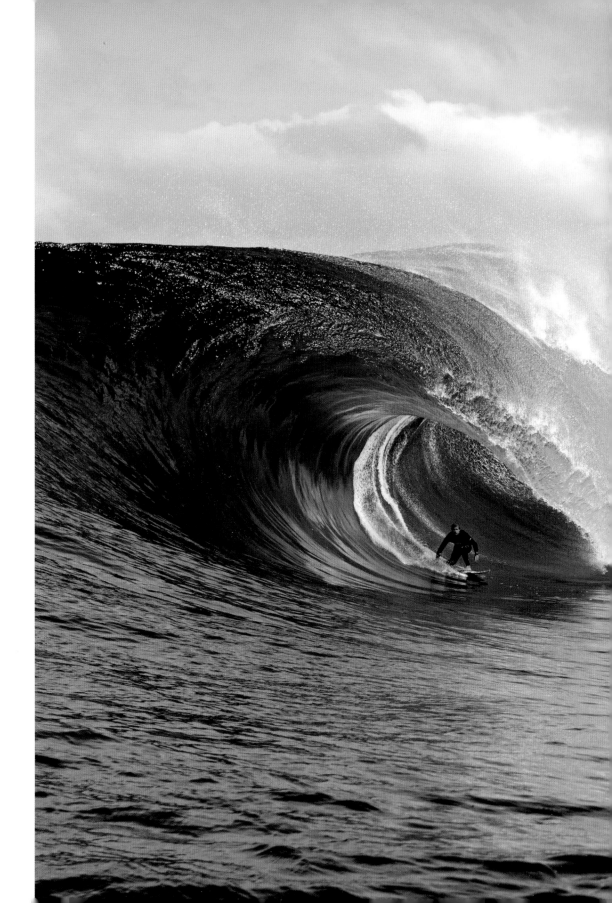

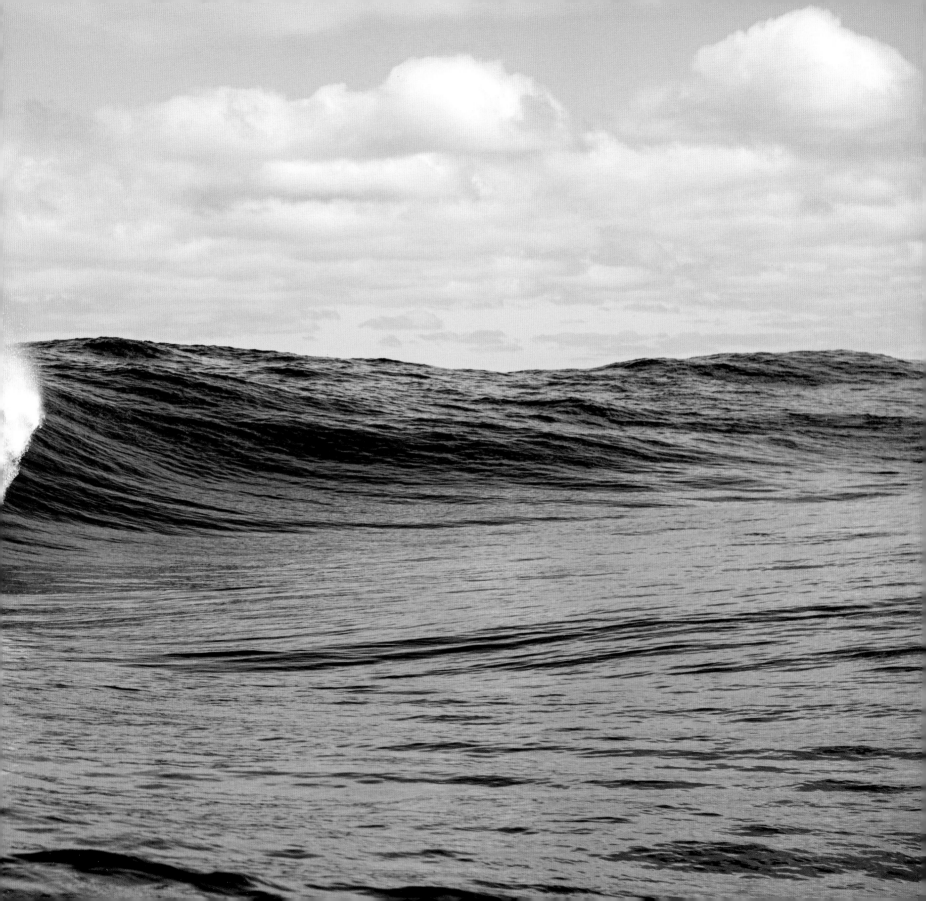

8

Paul Paterson – Spot X
RUSSELL ORD

Paul Paterson three seconds before a one-minute
hold down, including three waves and blown ear
drums – glad you're still with us.

2013

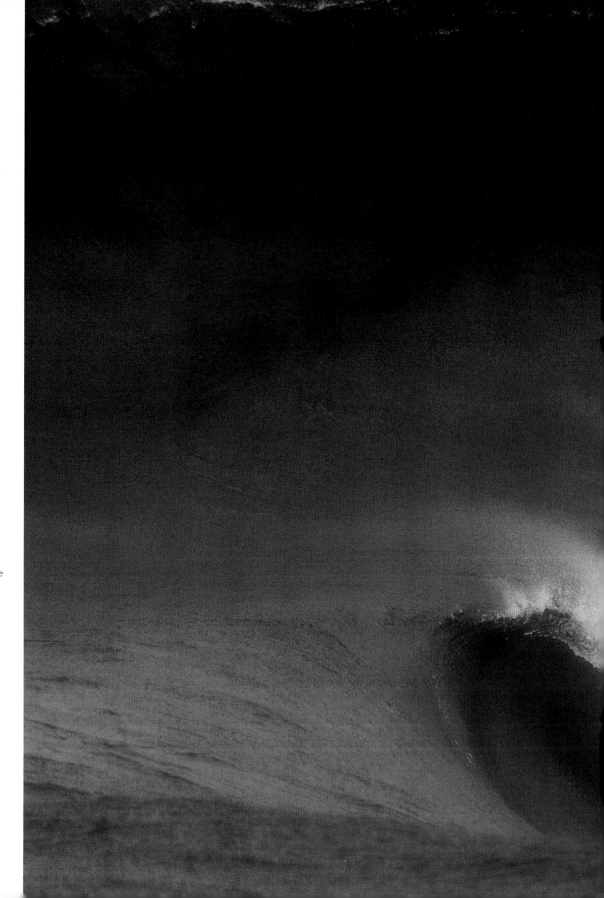

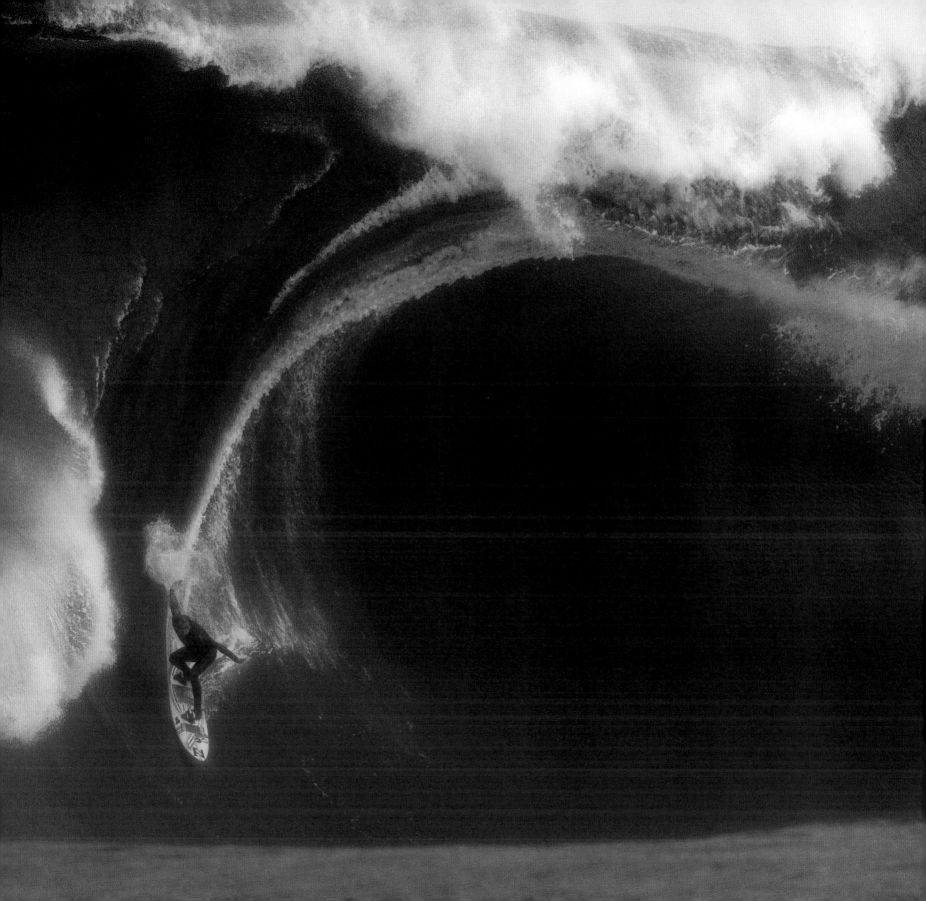

9

Kirra III

TED GRAMBEAU

Shot from a helicopter, a surfer finds himself in
a zone that could be described as either 'Heaven'
or 'Hell': the possibility of attempting a late
take-off and riding one of the world's most
perfect waves, or alternatively, get caught inside
and punished by the powerful, shallow-breaking
sandbar wave that is Kirra.

2013

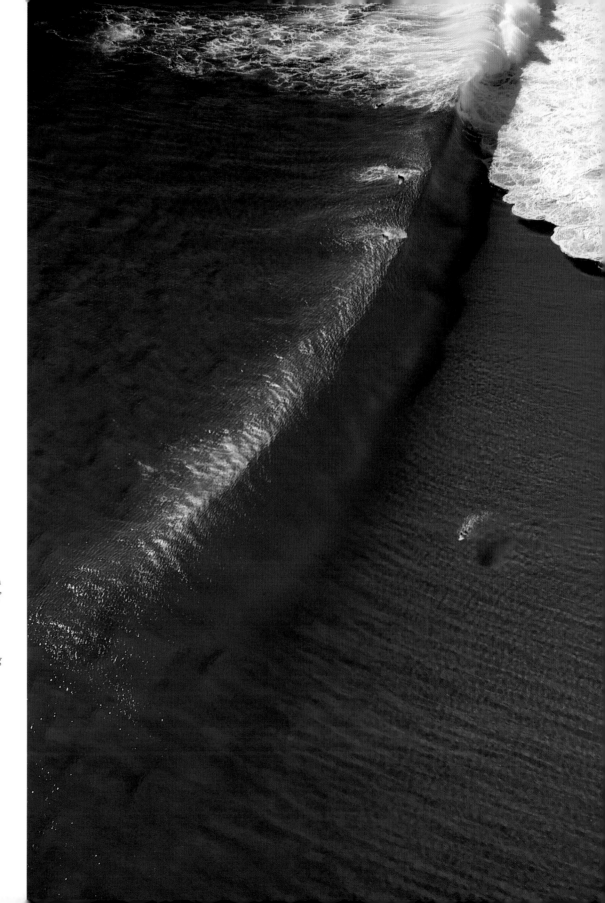

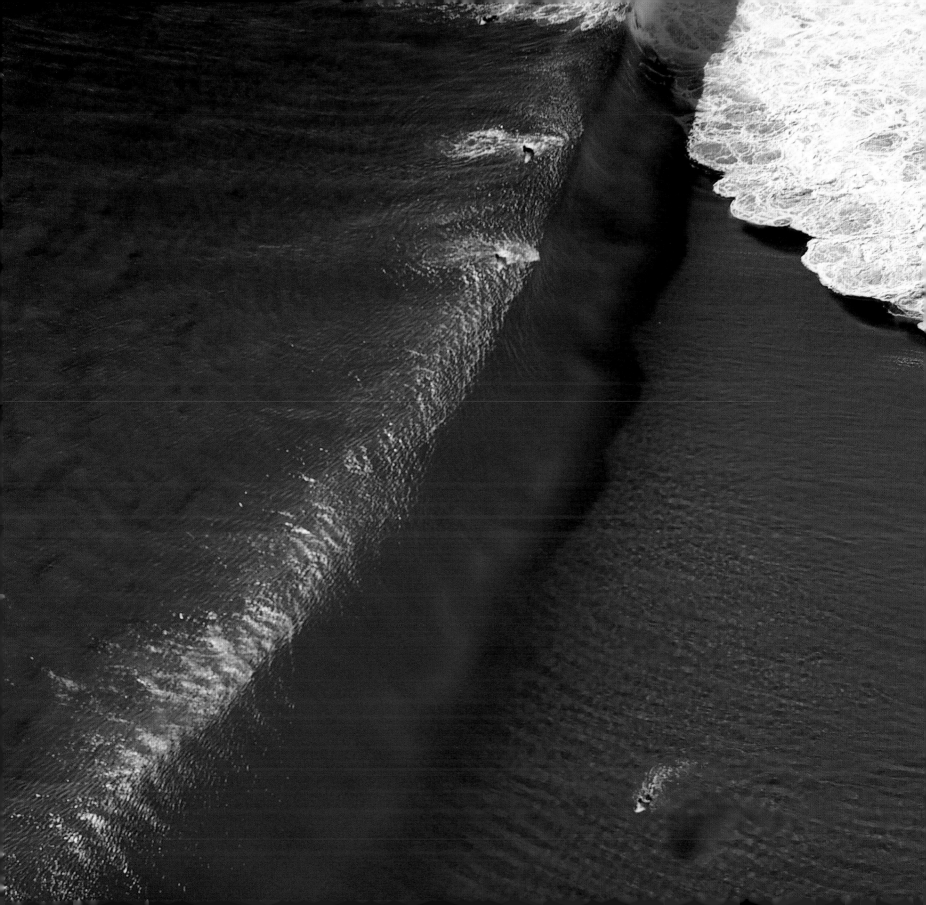

10

Indicators
LUKE SHADBOLT

Torrential rain and the first swell in a year and
a half to break properly at this wave combine to
create my favourite shot from home this year.

2013

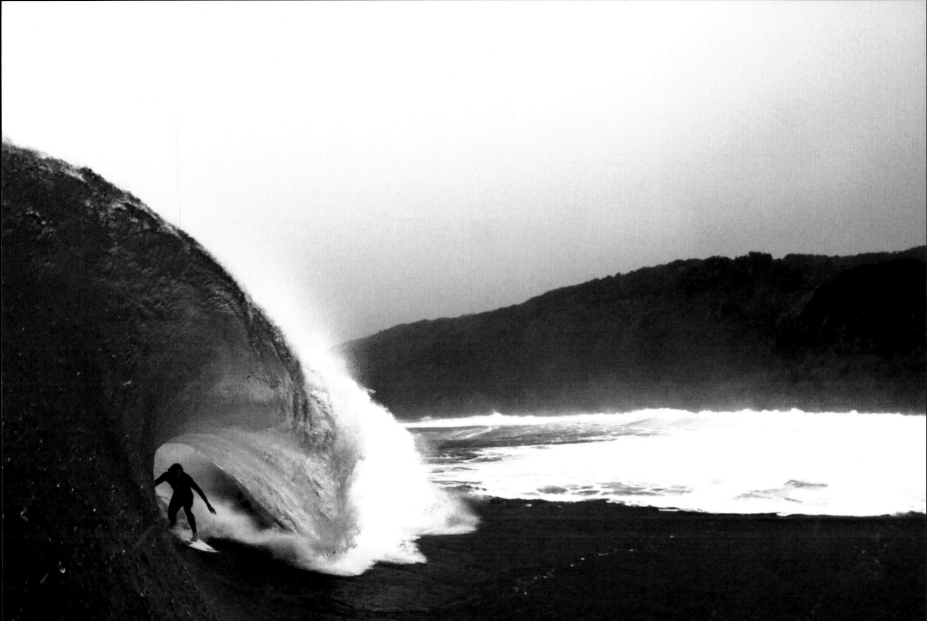

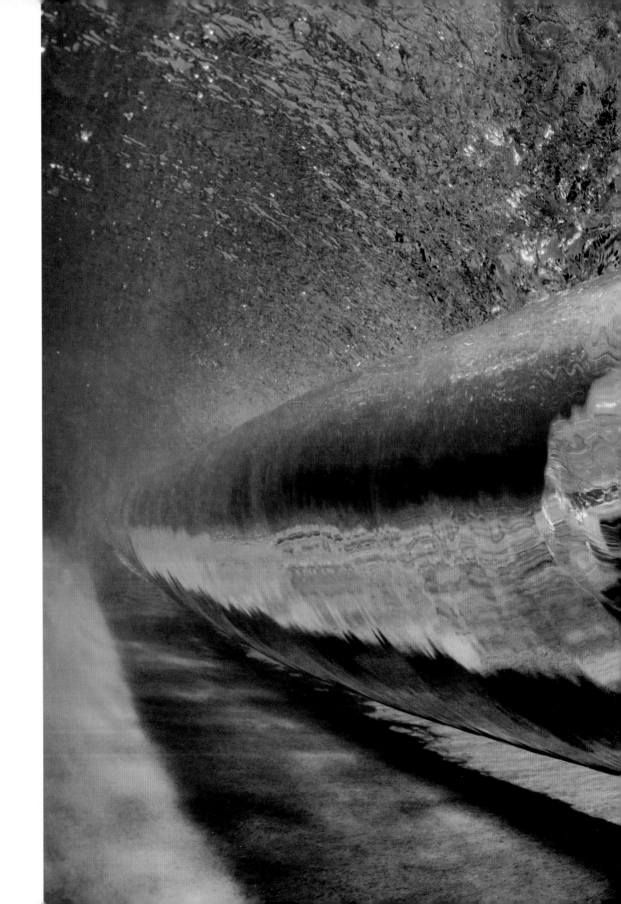

11

Clarity
RAY COLLINS

Underwater clarity bubble.

2013

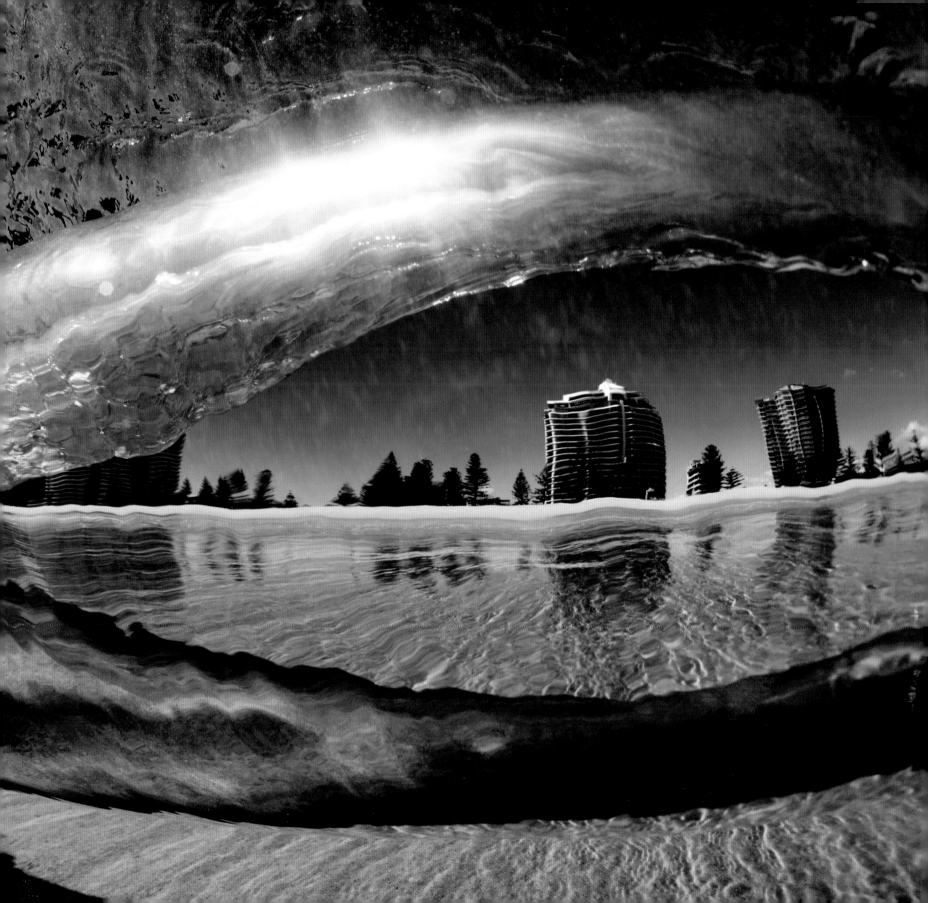

12

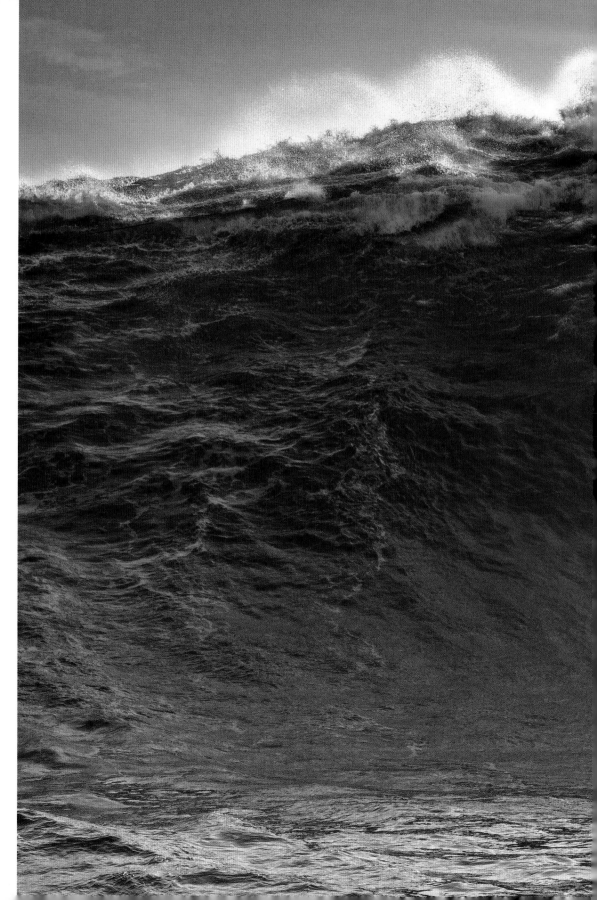

Afternoon Peak
ANDREW CHISHOLM

Lone goofy footer Danny Griffiths shoots down
the face of a monster at Eddystone Rock.

2013

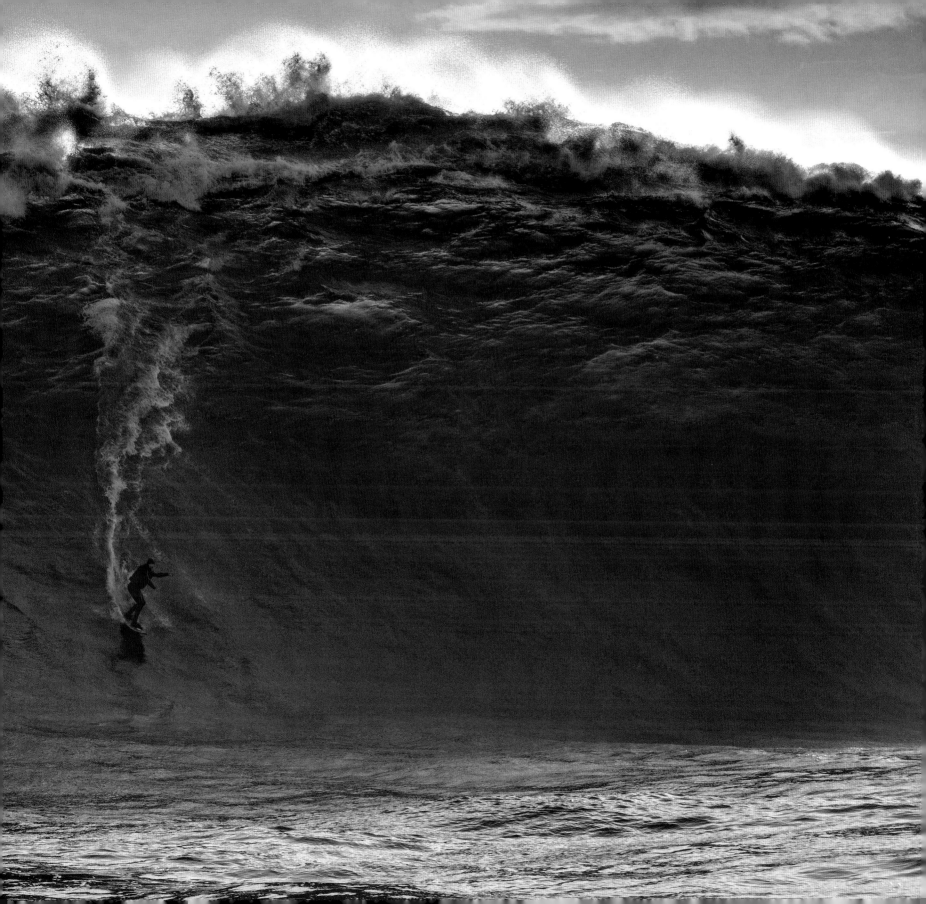

13

Bent Knost

DANE PETERSON

Hot and glassy days in Southern California are what dreams are of made of. Here's Alex Knost defying gravity at San Onofre on one such day.

2013

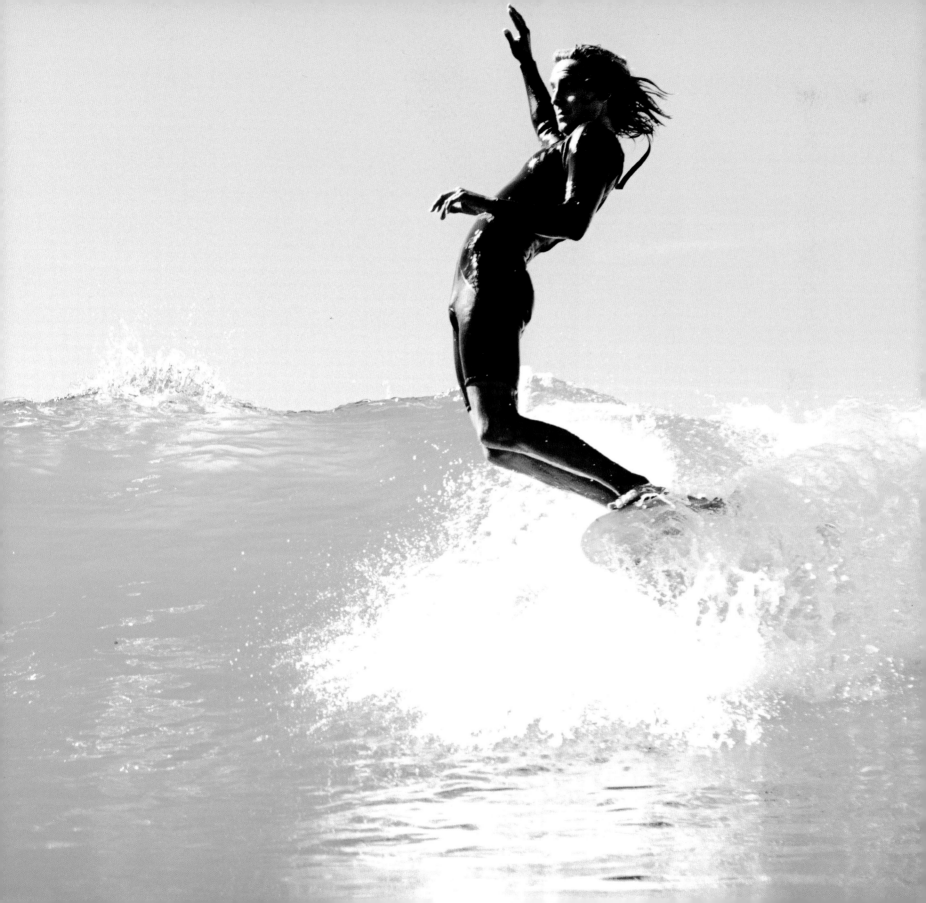

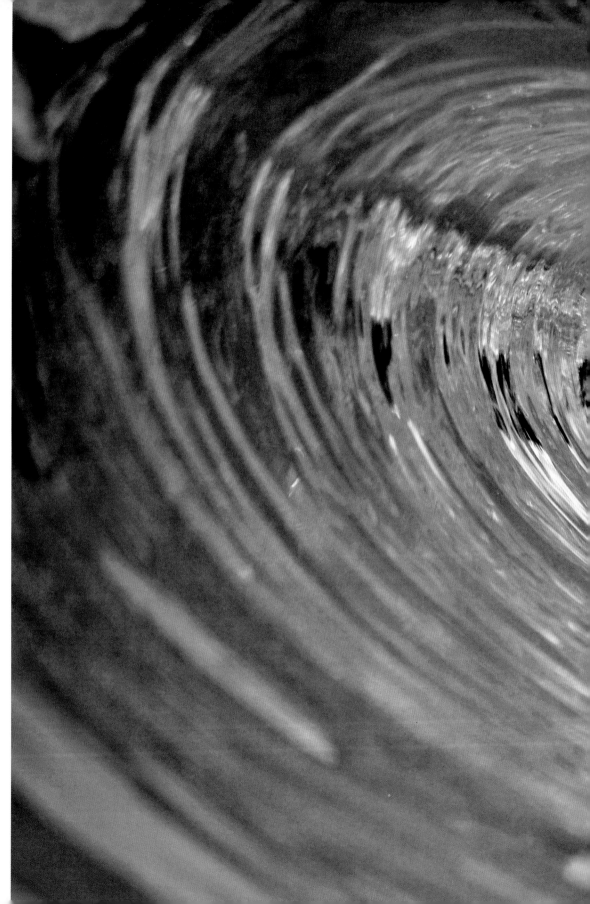

14

Bejewelled

DEB MORRIS

This jewel-encrusted barrel is just 20cm in height.

2013

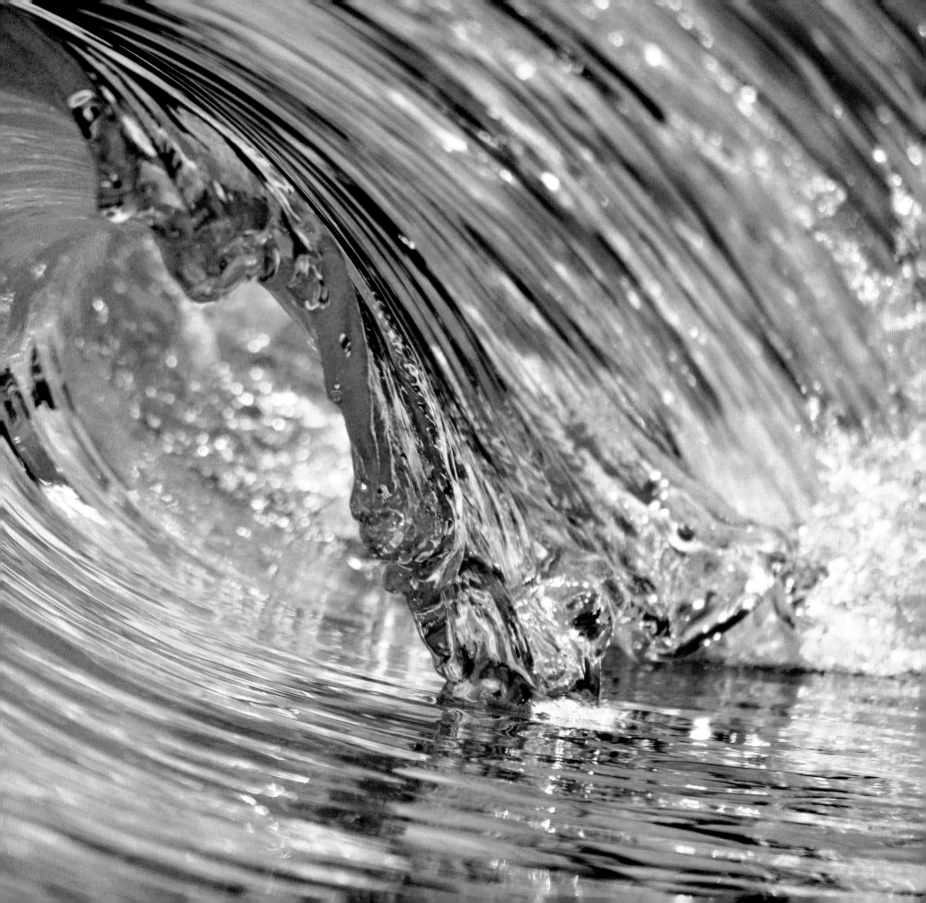

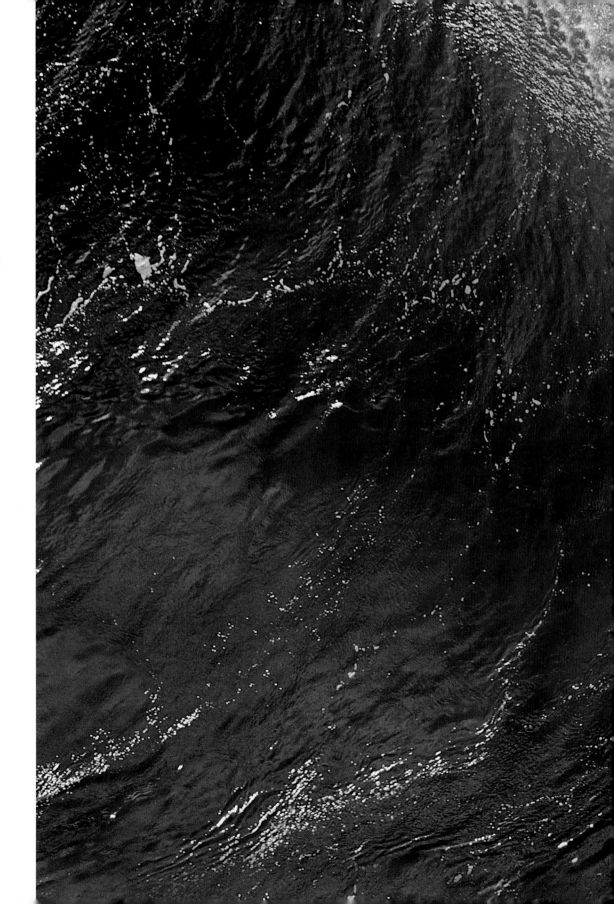

15

Above Kirra
TED GRAMBEAU

Shooting out of a chopper high above Kirra,
I capture Bede Durbidge about to pull into a
perfect Kirra barrel.

2013

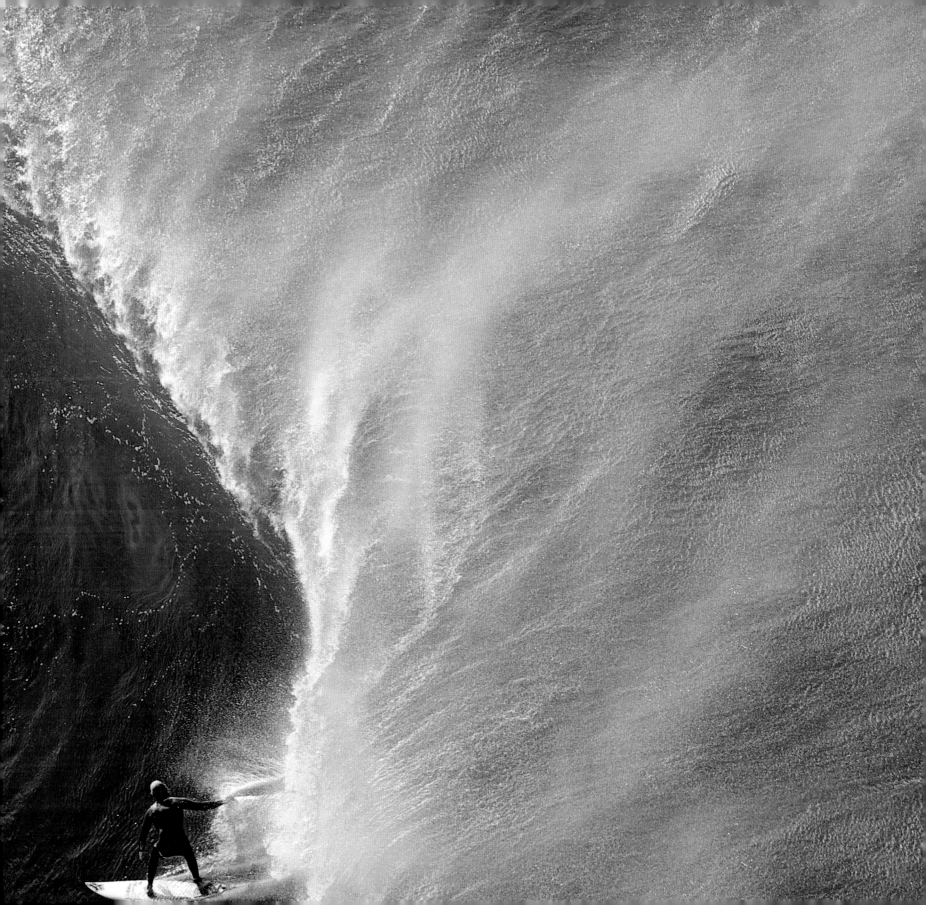

16

Teewah Smoke

DANE PETERSON

The dense smoke from a bushfire in the Great
Sandy National Park created a surreal frame
for me to capture this young lady slider at First
Point, Noosa.

2013

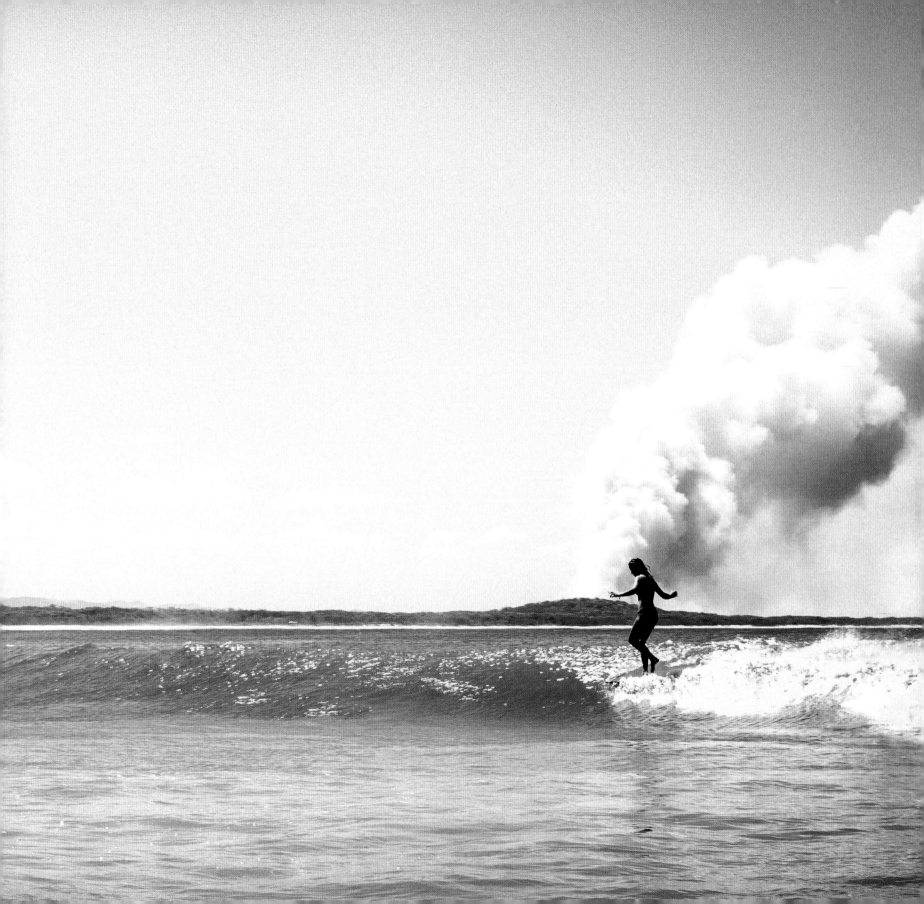

17

Kelly Slater
PETER JOLI WILSON

Kelly Slater rinses off post-heat during his march to the final of the Quiksilver Pro France. This was his first contest win at Hossegor in 20 years and his first Quiksilver Pro France win.

2013

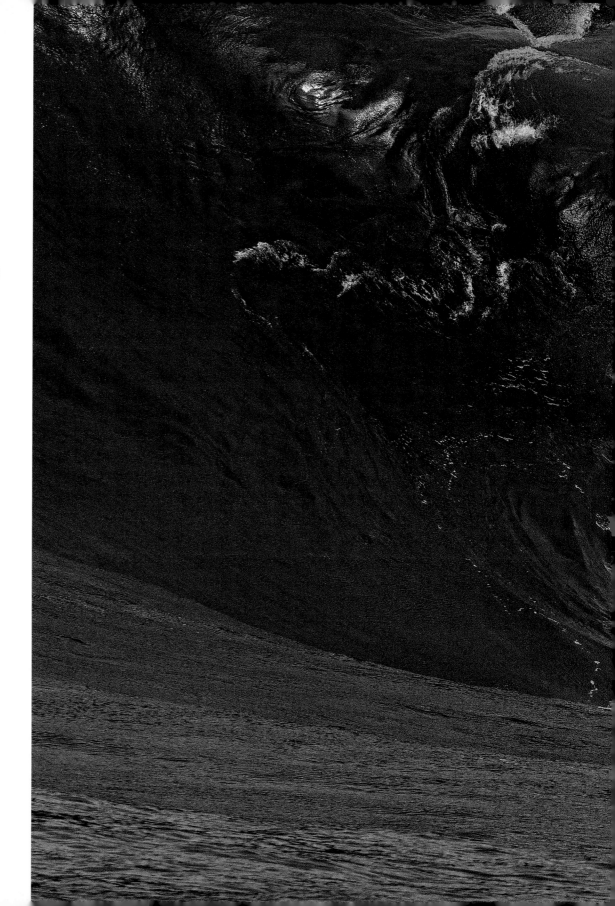

18

Leg Splits

ANDREW CHISHOLM

The wipeout of Alex Zawadzki. He ended up
being air evacuated out with a damaged leg.

2013

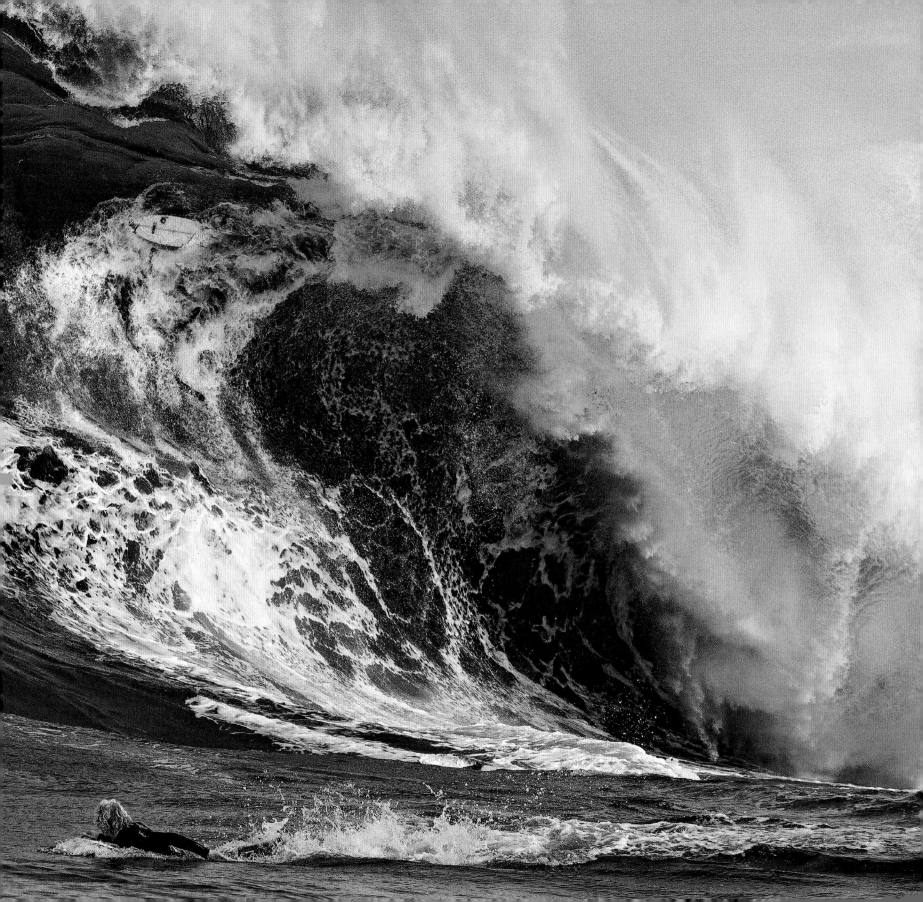

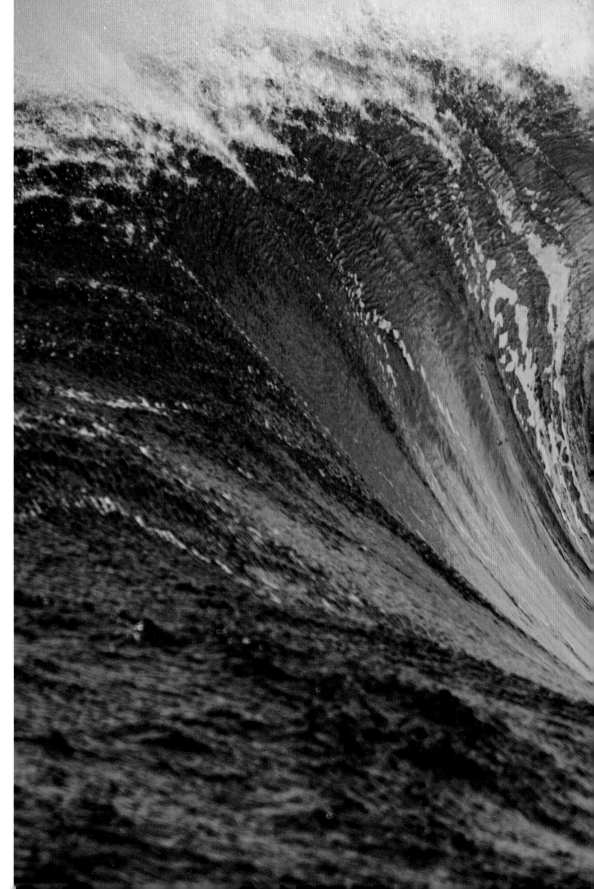

19

**Cale Grigson –
Secret Slab**

RUSSELL ORD

Straight through the eye of the beast.

2013

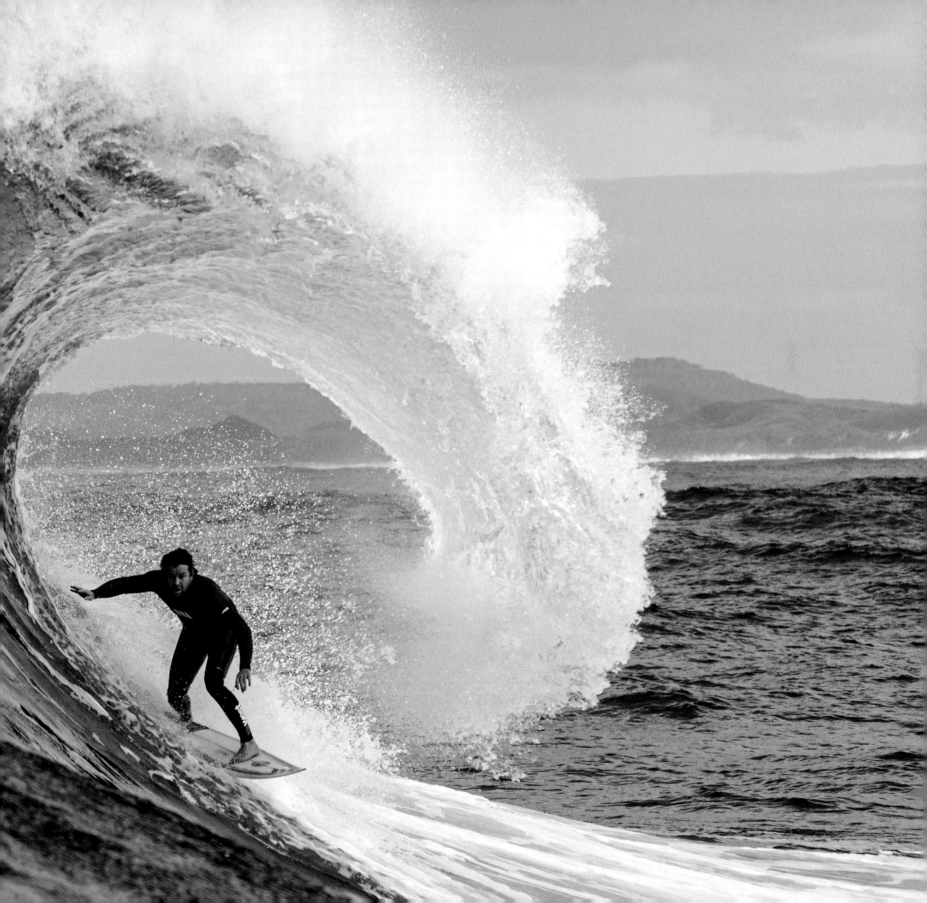

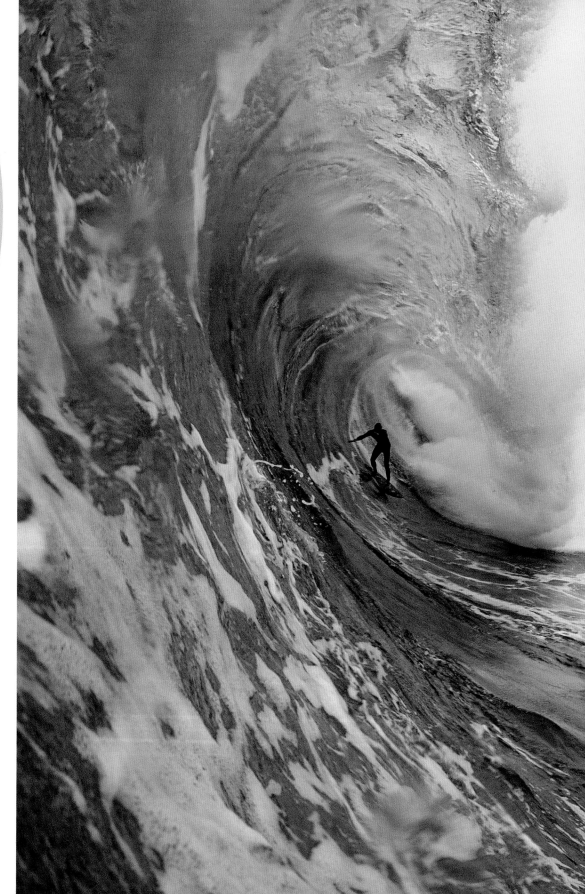

20

Chris Ross – The Right
RUSSELL ORD

Absolute bomb at The Right – fisheye plus an
absolute beating for the both of us.

2013

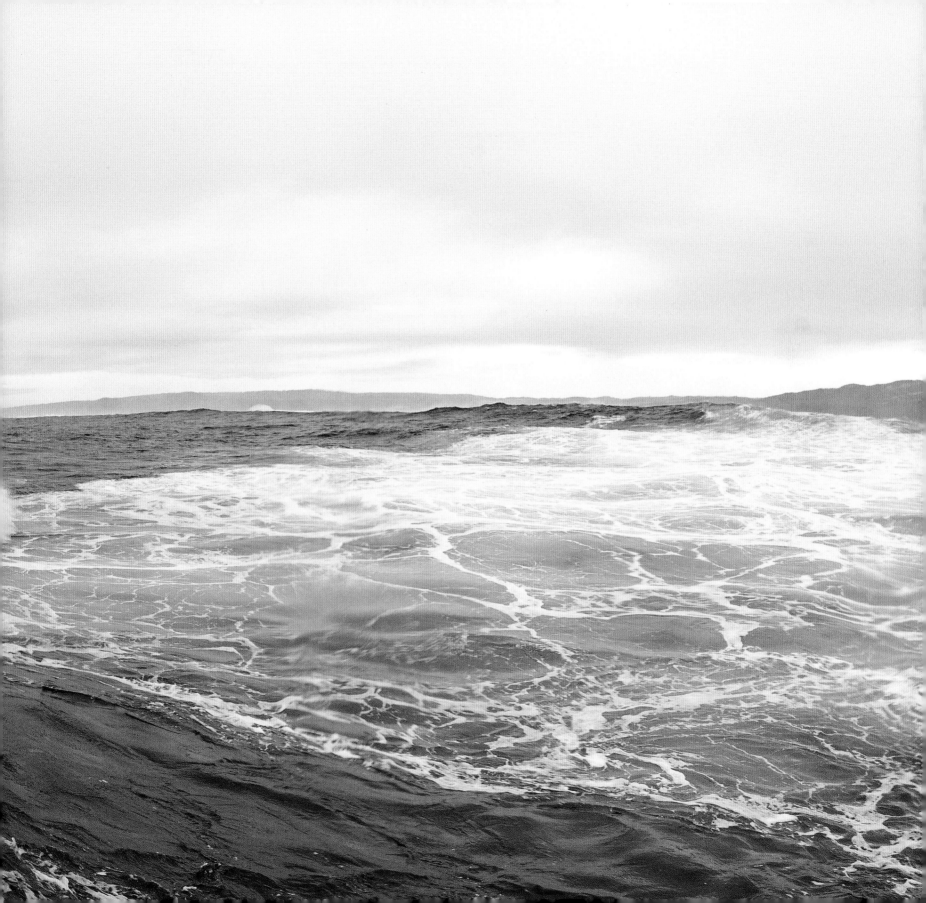

PHOTOGRAPHERS

Leroy Bellet

Jason Childs

Andrew Chisholm

Ray Collins

Jack Dekort

Stu Gibson

Woody Gooch

Ted Grambeau

Chris Gurney

Brodie McCabe

Trent Mitchell

Bill Morris

Deb Morris

Mark Onorati

Russell Ord

Christopher Peel

Craig David Parry

Dane Peterson

Rich

Luke Shadbolt

Ed Sloane

Nate Smith

Philip Thurston

Ryan Williams

Simon Williams

Peter Joli Wilson

LEROY BELLET

'Hi, I'm Leroy Bellet. At 18 years old, I'm lucky enough to live on the South Coast of New South Wales, Australia. Not knowing whether I will roll out of bed and into a regular high school day or some of the most raw, dangerous and beautiful situations Mother Nature has to offer is what keeps me on my toes. I think drowning in paperwork would be the worst way to go.'

leroybelletphoto.com

JASON CHILDS

'My photography has taught me to see the
beauty of the world around us.'

Jason Childs has been a professional photographer and photojournalist
for more than 30 years. 'My signature style and talent is capturing the
definitive moment; balanced with my knowledge of light, my images have
the sense of the intimate, majestic and the bold. My success derives from
my patient, single-minded pursuit of capturing the definitive moment.'

Jason's lifelong fascination with the ocean has played an important
part in keeping his photography in balance. An avid surfer and jet ski
expert, Jason has also established himself as one of the most valued and
prolifically published surf photographers in the sport. Since 1985, his
surfing and beach lifestyle photography has stood firmly among the best in
the world and has graced the covers of every major surf and beach lifestyle
magazine around the globe, including the prestigious USA publication,
Surfer Magazine, where, after decades of covers and features, he still serves as
senior staff photographer.

'The ocean is where I feel at peace and free; it is where I feel most
connected to the natural beauty of this planet. Photographing the waves
and the ocean's moods is a unique challenge. Whether swimming and
shooting in the surf or climbing a cliff to get an angle … it is all about
bringing the viewer into another world.'

Jason's photography continues to evolve on many levels, and now with
a family of his own, he feels a deep connection to portraiture and
capturing the intimacies, love and honesty within family groups. Jason is
experienced and professional, relaxed and unobtrusive, but persuasive.
His favourite studio is the outdoors so shooting is always relaxed and
natural. Jason remains a photojournalist at heart, a passionate artist who
continues to dedicate his life's work to the capturing of the moments,
times and places of our lives.

childsphotos.com

ANDREW CHISHOLM

Andrew Chisholm was born in Tasmania, the place he proudly calls home to this day, relishing in the spectacular coastline and pristine wilderness environment. Andrew became involved in professional surf photography through meeting Tasmanian big wave surfers James Polonowski and Andrew Campbell, with whom he travelled the state on surfing adventures, including Shipstern Bluff, which is now regarded as one of the world's best waves.

Once he had experienced the exhilaration of Shipstern Bluff, it was not long until Andrew wanted to capture the amazing feat endured by his mates, which has since captivated surfing enthusiasts worldwide. Andrew travels extensively to many great surfing locations throughout Australia and overseas, including Indonesia and Hawaii. Images from his travels have been published in surfing and lifestyle magazines worldwide, and he is a regular photographer for the renowned *Australian Surfing Life* magazine.

For the past decade, Andrew's love of the ocean has engulfed his whole life, whereby on any given day he can be found chasing waves, fishing Tasmania's coastline or frolicking out in Tasmania's wilderness, relishing in the solitude and enjoying all those perfect moments. His appreciation for Tasmania's unique environment and being a passionate advocate for its protection has led to a natural progression into landscape photography. Tasmania is blessed with some of the finest untouched wilderness on the planet and is one of the principal influences on his life. Andrew's powerful view of his home state is uniquely portrayed through his images.

andychiz.com

RAY COLLINS

'My aim is to show the ocean as a living, breathing thing; to document it in all its intimidating strengths; and to bring awareness to its quiet fragility.'

Since picking up his first camera in 2007 to shoot his friends surfing in his hometown — Thirroul, on the NSW South Coast — Ray has quickly progressed to having companies such as Apple, Nikon, United Airlines, Isuzu, Qantas, Mercedes, Patagonia, National Geographic and Red Bull using his ocean imagery.

'Ray is able to capture the power and essence of the ocean in a single snapshot...'

Mary Ann Potts, *National Geographic*

'In just eight years Ray has arrived as one of the most distinguished photographers of waves and the ocean in the world ...'

Diana-Florina Cosmin, *Forbes Magazine*

'Ray's awe-inspiring images have the power to bring the earth's primal force to a standstill; he's an up-and-coming creative talent set to be the next big name in culture and the arts.'

Mathew Ponsford, CNN

RayCollinsPhoto.com / @raycollinsphoto

JACK DEKORT

The long points and beaches of the Sunshine Coast play host to a large community of creative people. This creative environment is a deep influence on Jack, and this coastal community is where he finds a great deal of his inspiration to take what he's learnt and create content for his domestic and international clients.

jackdekortphoto.com

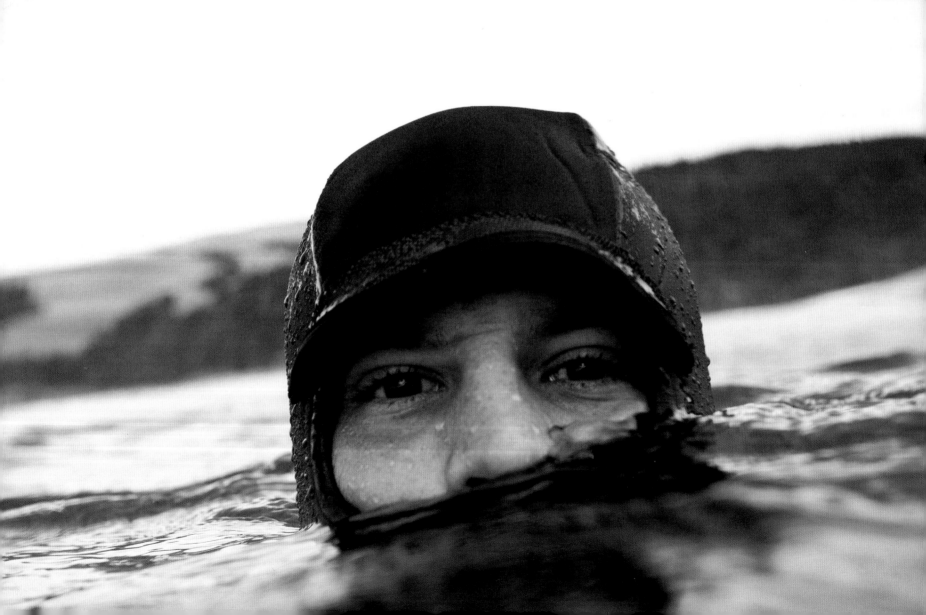

STU GIBSON

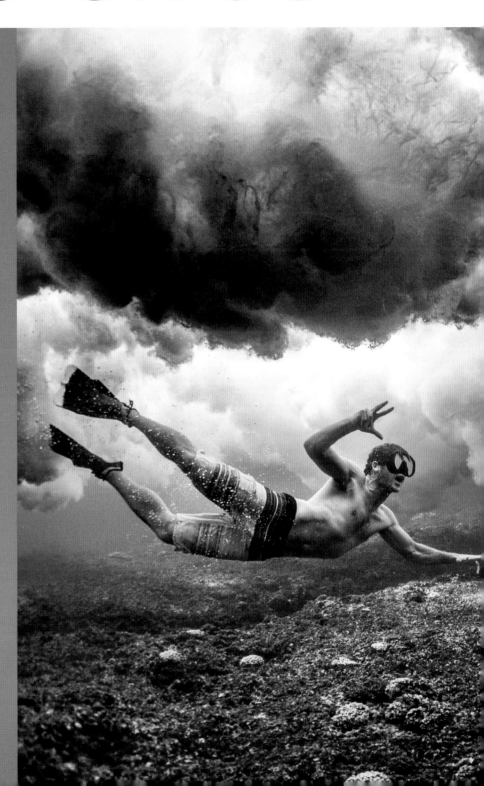

Born in Tasmania in 1983, Stu Gibson got serious about photography around 2003, although he had always loved cameras and filming. It wasn't until he borrowed a friend's Canon EOS 5 that he fell in love with still photography, and the amazing quality that could be achieved. Shooting on 35mm slide film was a great (but expensive) test to learn the skills to become a photographer. Stu specialises in action shots from the water. Surfing and kiteboarding are his passions, and aerial stills and video are also a large part of his work.

stugibson.net

WOODY GOOCH

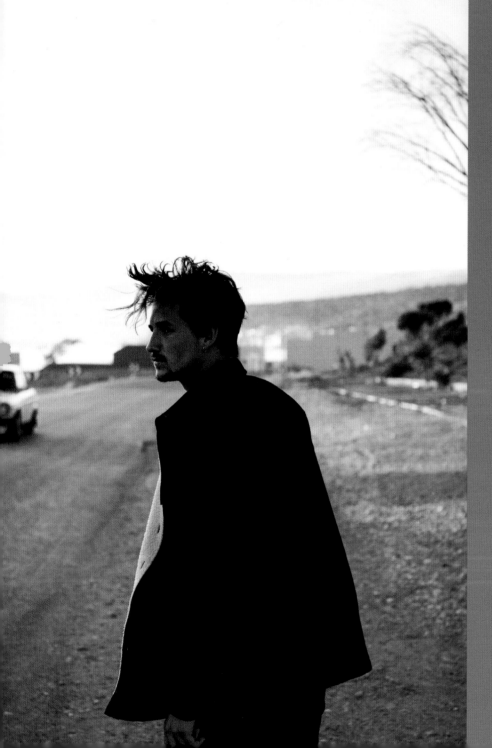

Self-taught by simple curiosity, Woody Gooch is becoming widely known for framing his focal subject with the natural world around it — adding a visual depth you won't find in run-of-the-mill photography. More artist than technician, he captures life in ways few seem to, uniquely utilising movement and negative space to communicate the emotions of any given moment.

woodygooch.com

TED GRAMBEAU

Ted Grambeau is an internationally renowned surf adventure photographer, shooting advertising, fashion and action in some of the most remote regions on the planet over the last 40 years. He has explored the globe for surf in the most unlikely areas, from Iceland to Russia and Mozambique to Madagascar.

Having studied at RMIT University in Melbourne, Australia, and assisted legendary Magnum photographer Burt Glinn in New York, Ted's style has a solid technical foundation, combined with the influence of photojournalism — capturing the integrity of a moment via the truth of an image.

Ted's commercial clients range from Apple, Rip Curl, Speedo, Red Bull, Nikon, Quiksilver, Zoggs, Billabong, BMW and lifestyle brand Patagonia to name but a few. With experience as a waterman from years of photographing in surf in the impact zone, Ted now translates this knowledge to abstract water photography, fashion, advertising and editorial assignments in and around the water.

tedgrambeauphotography.com

CHRIS GURNEY

Born in Perth, Western Australia, Chris became interested in photography after a series of broken bones kept him out of the surf, leading him to pick up a camera instead. He completed a journalism degree in 2014 and approaches photography with a reporter's eye: searching for narratives and interesting characters.

chrisgurney.com.au

BRODIE McCABE

'I hail from the Gold Coast, I like to press the button on my camera and be in, on, or around the drink.'

@brodie_mccabe

TRENT MITCHELL

'I connect with people through light, emotion, colour and movement so they experience an inspired perspective of the world around us. I'm grateful to play with this pursuit on an artistic and commercial level for people, brands and natural wonders I love and respect.'

trentmitchell.com

BILL MORRIS

Bill Morris grew up in Bondi and became a surfer at a young age. He pursued his passion for photography and forged a successful career as an award-winning freelance surfing photographer. Bill has travelled the world on assignment for numerous international media publications such as Australia's *Surfing Life Magazine* and *Surfing Magazine* (USA). His services have also been retained by companies such as Ocean and Earth, Oakley, O'Neill, Red Bull and Billabong for their advertising and promotional needs. Bill specialises in water photography: swimming with his camera and capturing the beauty and mood of an everchanging ocean.

billmorris.com.au

DEB MORRIS

A 35-year passion for photography encouraged Deb to turn pro in 2010. Rather than just capturing frozen moments from this beautiful landscape, she found a whole new, hidden world to investigate, that of the micro or mini wave, and DebM WAVEART was born. Deb's work has received awards throughout Asia, Europe, the USA and Australia. Her images have graced the pages of international publications, including the cover of the *Smithsonian Magazine*. Her works sell worldwide and have been exhibited through Europe and Asia.

debmwaveart.webs.com

MARK ONORATI

'I come from the northern beaches of Sydney, love my family, love life.'

@markonorati

RUSSELL ORD

'It's more than just moments in time, it's about the connection with people and the environment, creating content that reflects this very essence.'

From Rugby League player and fireman to award-winning ocean and lifestyle photographer, Russell Ord found his passion through adventure and the discovery of untouched/unseen wilderness.

Based between Australia's Margaret River and Auckland, New Zealand, Russell's photos blend the environment with real-life storytelling. His work has been published in magazines and books throughout the world, he was awarded the 2016 IPA International Sports Photographer of the Year at the prestigious Lucie Awards, and he exhibited in Germany at Photokina 2016 for FujiFilm.

His life and work has been the subject of the documentary *One Shot*, which was broadcast nationally by the ABC in a seven-part art series and internationally through film festivals and distributors. (oneshotdoco.com)

russellordphoto.com

CHRISTOPHER PEEL

This 25-year-old Australian native lives a lucid dream, working on a surf charter boat in Papua New Guinea. Because, as Chris puts it, 'If you want to see the most amazing things in the world, you won't find them online. They'll be out on the boundaries, away from roads, electricity, flush toilets and phone signal.'

chrispeelphoto.com

CRAIG DAVID PARRY

Craig Parry is an international multi-award-winning nature photographer based in Byron Bay, Australia. Specialising in marine, nature and aerial photography, Craig strives to capture the beauty of the world's natural environment and, in doing so, aims to connect his audience with nature to promote conservation.

craigparryphotography.com

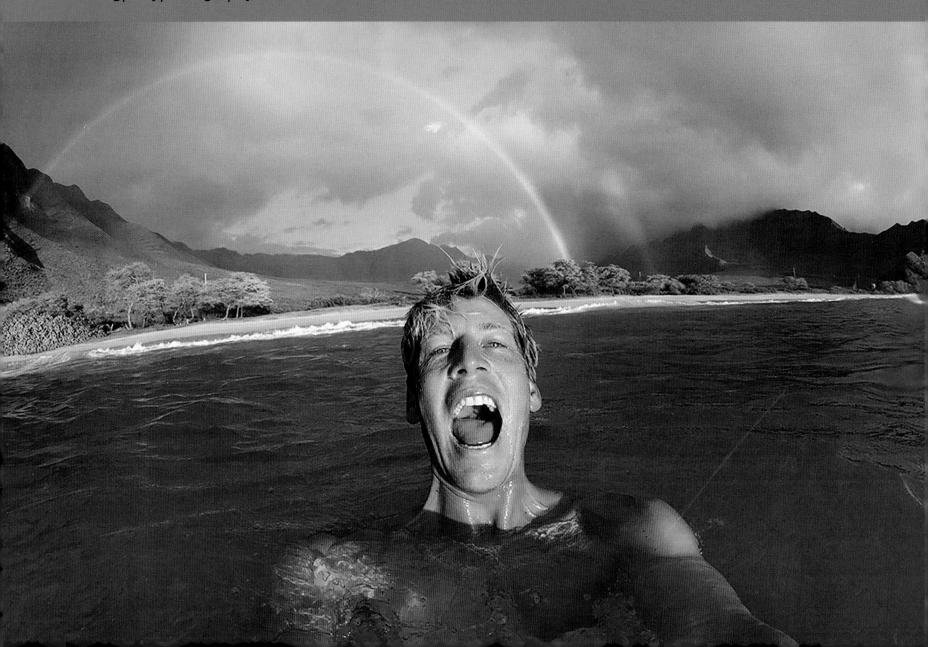

DANE PETERSON

As an accomplished surfer in his youth, Dane Peterson travelled the world. It was the unique people and places he encountered along the way that inevitably led him to first pick up a camera and begin documenting his journey. In that process, he developed an uncanny knack for finding beauty in the subtleties that surrounded him. Dane now lives and breathes his art. Residing in the Westside of Los Angeles, he is primarily focused on a variety of analog film mediums that act not only as his tools but also as his inspiration.

danepetersonphotography.com

RICH

LUKE SHADBOLT

Luke Shadbolt is a photographic artist and creative director from Sydney, Australia.

With a focus on the exchange, cycle and balance of power fundamental to the functioning of our planet and its oceans, he explores the symbiotic relationship between humanity and nature in a physical, sociological and evolutionary context.

He currently spreads his time between his fine art practice and commercial photography/creative direction in the action sports, travel, landscape and fashion industries.

lukeshadbolt.com

ED SLOANE

Ed Sloane is a freelance photographer with a focus on the surf and an ocean-based aesthetic. His work is best described as a mix of action and art and has featured in advertising and editorial throughout Australia and internationally. His artistic yet systematic approach to the photographic process stems from a prior career in environmental science. Former pursuits in this field have had great influence on his perspective, knowledge and ultimately creative vision as he blends a critical approach with aesthetically driven work.

edsloanephoto.com

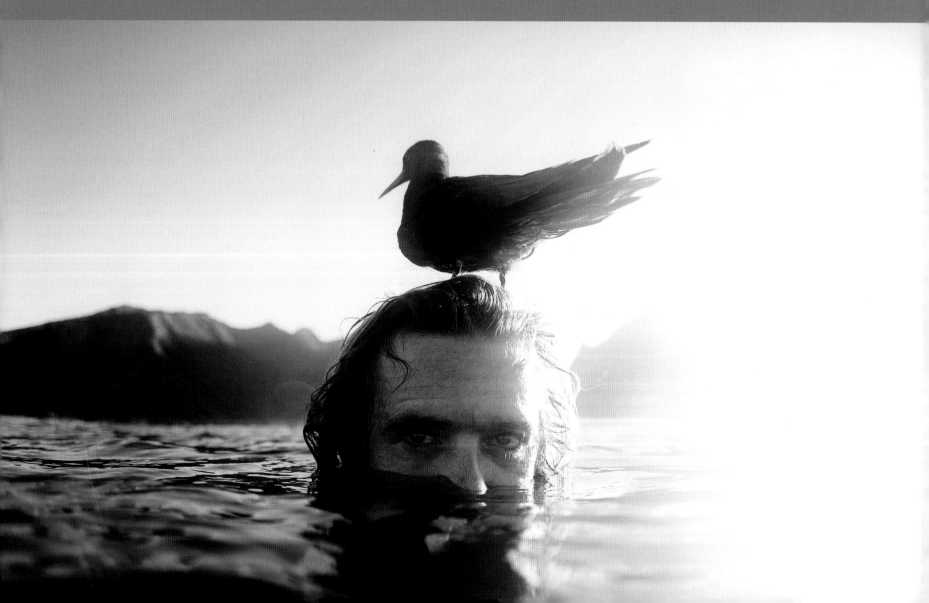

NATE SMITH

Over fifteen years, Nate Smith built his reputation as an acclaimed surf photographer. His photographic talent has seen him move into fashion, portraiture and landscapes.

@Nate_Smith_Photo

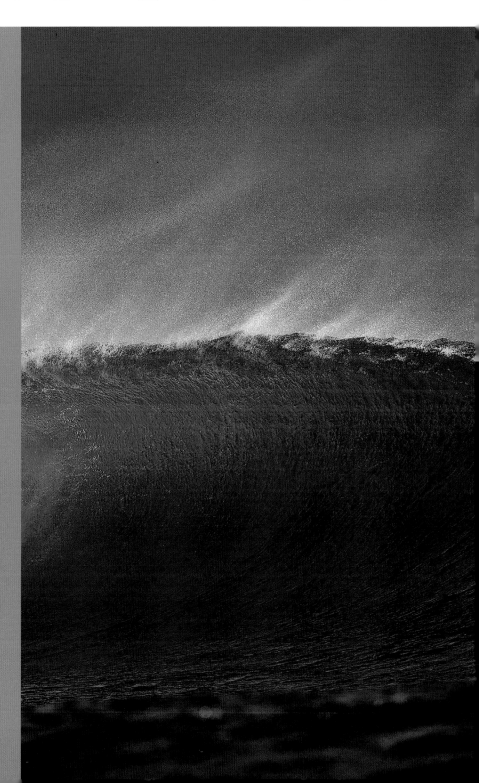

PHILIP THURSTON

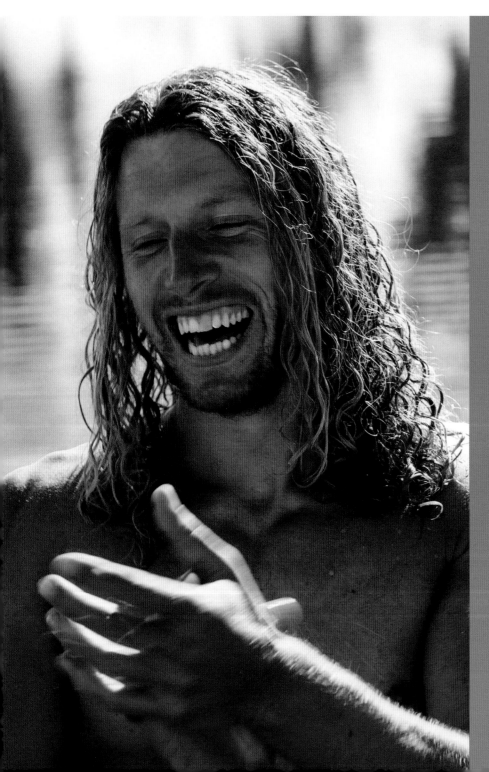

Philip Thurston is known to happily spend many hours in the ocean in pursuit of turning energy into art, or spontaneously launch himself into the wild in the hope of encountering and capturing the world in a new and exciting way. 'My goal with Thurston Photo is to create beautiful imagery and literature that provokes positive thought and inspires people to see life from a new perspective. Through my experiences and lessons learnt, I've come to know my purpose in life is to inspire others to live a life of fullness with an eternal perspective, and to help others realise their own dreams, potential and purpose that's worth pursuing with all their heart. I strive to be conscious of this with my words, output and actions. I really do enjoy what I do and I think that makes a big difference with the result.'

thurstonphoto.com

RYAN WILLIAMS

Ryan Williams is an award-winning surf photographer based in Australia, who specialises in surfing, lifestyle, travel, underwater and coastal landscape images. Growing up in the coastal surf town of Sunshine Beach in Queensland, Ryan picked up his first SLR camera seven years ago. He travels the world over, but these days keep an eye out for Ryan in Indonesia as he is generally there for six months of the year, working as a travelling photographer for different surf resorts and surf charter boats, while capturing amazing images from both the water and land.

ryzphoto.com
@ryzphoto

SIMON WILLIAMS

Simon 'Swilly' Williams is one of the world's best surf photographers, having produced many classic images which have featured on the covers and pages of countless surfing magazines over the last 20 years. Capturing amazing surf photography, stunning underwater imagery and mind-blowing photography from helicopters and jet skis, Swilly knows the ocean like no other. Swilly has worked with the surfing world's finest, including world champions Kelly Slater, Mick Fanning, Stephanie Gilmore, Joel Parkinson, Dave Rastovitch and Ry Craike. His talent has taken him across the globe from his base on Australia's Gold Coast through Indonesia, the Philippines, Micronesia, Papua New Guinea, the Maldives and the Australian coastline.

swilly.com.au

PETER JOLI WILSON

Peter Joli Wilson's initial interest in photography came from his grandfather, a successful amateur filmmaker and photographer. At the age of fourteen Peter processed his first roll of black and white film containing an image of him holding his first surfboard. His first published surfing image was of Narrabeen's Col Smith at the 1972 Bells Beach Easter Surfing Contest.

In the mid-1970s Peter was assistant photographer to a German photographer, a perfectionist, and it was two years before he shot a single frame, but he learnt all about studio work, lighting, flash, black-and-white processing and printing.

Since then he has pursued his professional photography career with various jobs, working at *Backdoor* surfing magazine, as head photographer at Deakin University and a stint with surfwear giant Quiksilver as Marketing and Promotions Manager. In 1989 he went freelance and formed Joli Productions with his wife, Jan.

Peter has spent the last three decades travelling the globe capturing the world's oceans, landscapes, beaches, surfing action, cultures and lifestyle. His youthful enthusiasm turned into a lifelong passion. 'Joli' photos have appeared in countless magazines, websites and books worldwide, with exhibitions in France, Hawaii, Brazil and Australia winning numerous awards. In 2009 he won Surfing Australia's Hall of Fame Awards Surf Photo of the Year and in 2013 he again won this award, the Nikon Surf Photo of the Year. He has been a Top-20 finalist in this award for the past five years.

joli.photoshelter.com
joliphotos.com

SURFING AUSTRALIA IS PROUD to play an important role in celebrating and recording the history, culture and lifestyle of surfing in this country.

Working with our valued partner, Nikon, to recognise the work of Australia's best surf photographers is something we have been doing for the past five years. Our annual Australian Surfing Awards incorporating the Hall of Fame recognise and honour great achievers across the sport and lifestyle of surfing. This includes recognising the best of the best of Australian surf photography through the Nikon Surf Photo of the Year Award.

Australia's surf photographers are among the best in the world and their work is seen and appreciated all over the globe. The idea for this book seemed a natural addition to the Nikon Surf Photo of the Year Award and cataloguing and sharing these brilliant photos with a wider audience will hopefully benefit the photographers and inspire those who read the book to get out and experience the ocean's many facets.

There are a number of people to thank for helping put the book together. First and foremost, thanks to the photographers. Your work is inspiring and seeing your photos in one place reveals the exceptional photographic talent that exists here in Australia.

Thanks to everyone at Nikon Australia, who have been a valued partner of Surfing Australia for more than five years and have been a true believer in the Australian surf photography community.

Thank you to Nikon Ambassador, six-times world surfing champion and photography enthusiast Stephanie Gilmore for her support of this project.

Thank you to everyone at Hachette Australia and finally thank you to Surfing Australia General Manager Jake White and the broader Surfing Australia team for their commitment to the annual awards and to this book.

Andrew Stark

Chief Executive Officer
SURFING AUSTRALIA

Published in Australia and New Zealand in 2017
by Hachette Australia
(an imprint of Hachette Australia Pty Limited)
Level 17, 207 Kent Street, Sydney NSW 2000
www.hachette.com.au

10 9 8 7 6 5 4 3 2 1

National Library of Australia
Cataloguing-in-Publication data:

Best of the best / Surfing Australia.

9780733639425 (hardback)

Subjects: Surfing—Australia—Pictorial works.
Surfers—Australia—Pictorial works.
Surfer photography—Australia.

Other Creators/Contributors:
Surfing Australia.

Cover and internal design by Christabella Designs
Front cover image: Woody Gooch
Back cover image: Ed Sloane
Image on pages 6–7 by Christa Moffitt
Images on pages 13, 15, 57, 99, 141, 183, 224, 252 and 254–255 courtesy of Shutterstock
Colour reproduction by Splitting Image
Printed in China by Toppan Leefung Printing Limited

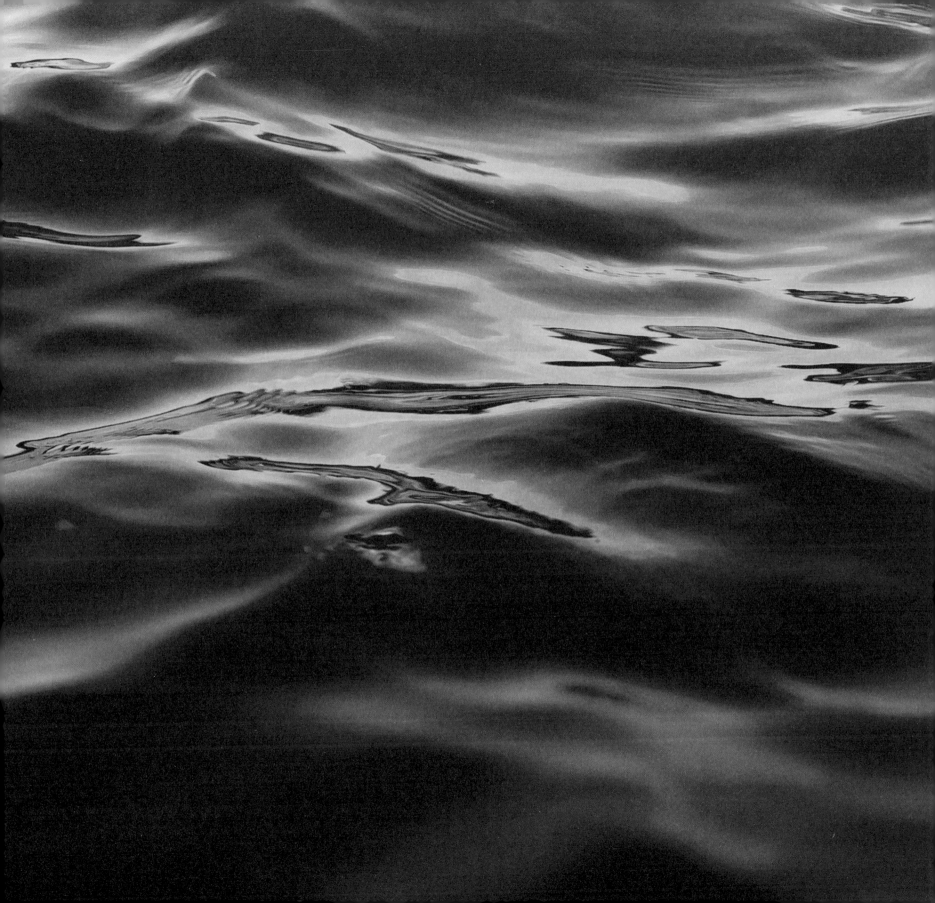